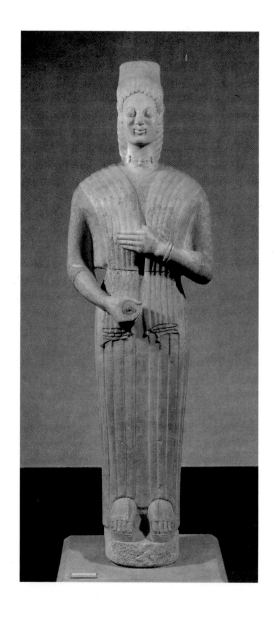

SCULPTURE

Carmela Thiele

BARRON'S

American text version by: Editorial Office Sulzer-Reichel, Rösrath, Germany
Translated by: Ann Jeffers-Brown, Cambridge, Mass.
Edited by: Bessie Blum, Cambridge, Mass.

First edition for the United States and Canada
published by Barron's Educational Series, Inc., 1996.

First published in the Federal Republic of Germany in 1995 by
DuMont Buchverlag GmbH und Co. Kommanditgesellschaft,
Köln, Federal Republic of Germany.

Library of Congress Catalog Card No. 96-83729

ISBN 0-8120-9775-0

Printed in Italy by Editoriale Libraria

Contents

Preface	7
The Beginnings in the Ice Age	8
• Prehistory	8
• Lions, horses, mammoths	9
• The first portraits	11
• Venus with the horn	15
Sculpture on the Nile	16
• Standing-striding figure	17
• The sitting figure ...	18
• Crouching cube	21
• Portraiture	22
Classical Antiquity	24
• Greece	24
• Archaic, classic, Hellenistic	26
• Phidias and the Parthenon Temple	29
• Proportion doctrine of Polykleitos	31
• Predilection for Greek sculpture	34
• Political meaning of the statue	36
• Original source of Roman portraits	38
Early Christian Sculpture	42
• Christian programmatic images	45
• The first crucifixes	47
🐦 *The Equestrian Statue*	48
The Middle Ages	52
• Romanesque crucifixes	52
• Images of Mary	54
• Expressiveness of the capital	57
• The Gothic is called barbaric	59
• Separation from architecture	62
Late Gothic and Reformation	66
• Mary the beautiful, Mary the protector	66
• A new complexity	69
• The expressive style of the Reformation	72

The Renaissance 74
- The early Renaissance 74
- The freestanding statue 75
- The freestanding group 76
- Monuments 78
- The high Renaissance 80

Baroque 84
- Transitional period: Mannerism 84
- The Baroque 87

Classicism and Realism 94
- Rococo 94
- Departure from the Antique 100

The Age of the Monument 102
- The national monument 102
- "Heroes of the intellect" and costume wars 105
- The cult of the monument 106
- The demise of the traditional monument 109

The Classic Modern 114
- The ugly is beautiful 114
- Painter/sculptor 119
- The Expressionists 121
- The unification of art and life 126
- Surrealism 133
- *German Sculpture in the Third Reich* 136

After 1945 140
- Existentialism 141
- Organic volume 143
- Moving in space 148
- Minimal art 152
- Back to sculpture? 157
- *Art in Public Spaces* 160

Glossary 170
Brief overview of the history of sculpture 171
Museums and sculpture gardens 175
Bibliography 177
Subject index 186
Index of names 187
Picture credits 192

Preface

"I must become blind and feeling, to put forward the philosophy of these thoughts. I believe, thereby I am already on new paths: let us see: from the art of sculpture for sensation . . . " As Johann Gottfried Herder wrote down these lines in 1769, he knew he was one of the few who persistently landed on the side of sculpture in its competition with the art of painting. His slim volume of 1778, *Plastik,* stands as a significant turning point in the history of sculpture criticism, and remains today a beautiful introduction to the aesthetic characteristics of sculpture. But let us leave aside the philosopher Herder, for whom the sense of touch was fundamental, without which "bodily sight" (spatial sight) would be impossible, the time-determined factors of sculpture, its various forms, and its continually changing meaning—or at least its recurring form in new functions.

This *Crash Course in Sculpture*, by contrast, is intended as a historical outline that will name significant problematic positions, with consideration of the function of works, and above all a survey of the changing meaning of artistic thought.

It is rare to find a thorough presentation of the history of sculpture. Attempts toward that end often comprise opulently illustrated volumes, with text offering little more than a stylistic history. In the recent past, such an undertaking was rendered particularly problematic because the art historian's distinctions between styles, methods, media, intentions, and forms have expanded to the point where distinction becomes an ever-changing discipline. Nonetheless, it is possible to assemble a canon of important works, important either in a local context or in the broader continuum of sculpture's history.

This crash course is organized on the principle of its actual content, and makes no claim to be a sculpture dictionary—biographical or otherwise. But for those who will find it useful to have certain ready information, it does contain a glossary, index, and a selective list of museum and sculpture gardens around the world. Still, this outline of the history of sculpture should be understood as something of a random sample, as a guide to the orientation of the passage of time through the centuries.

Carmela Thiele

The Beginnings in the Ice Age

35,000-28,000 years ago
Aurignacien: culture of the Paleolithic age, named after its discovery site—Aurignac in France; besides special stone wedges and bone points, graves of Cro-Magnon people in the Dordogne, and ivory statuettes in Southern Germany.

20,000-27,000 years ago
Gravettien; culture of the middle part of the early Paleolithic age, named after the discovery site at La Gravette in Bayac; known are flint "Grave Chimes," female statuettes, and relief carvings.

15,000-11,500 years ago
Magdalenien; peak of the Paleolithic cultural development in western and central Europe, named after the discovery site at La Madeleine; grave sites, weapons, and implements characteristic of a hunting-gathering society; most famous are the religious cave paintings of the Magdalenien at Altamira and Lascaux.

At the beginning of the 20th century, the professional world reacted with skepticism when the first prehistoric finds were made public. Anthropologists and art historians had been accustomed to crediting Egyptian and early Asian high cultures as the cradle of world art. Before the invention of writing, fashioned hand-held axes or idols were previously counted as artifacts of early human history, but not as art history. The common view was that the manufacture of objects out of a spiritual need in the case of the hunter-gatherer society must have been misleading, that Stone Age people must only have created objects in order to overcome basic needs.

In the Stone Age, however, lay the beginnings of sculpturally centered forms; what idea, what function these statuettes and animal figurines served is a matter for pure speculation. But the quality of many works is nonetheless striking.

In 1879, west of the Spanish city of Santander, Forscher discovered the realistic bison representations of Altamira. Because the colors looked fresh and no similar cave paintings were known from that area, the public considered them hoaxes. The first later findings—1902 in southern France and 1940 near Lascaux—delivered the incontrovertible proof of the authenticity of the paintings. Older than the Paleolithic cave paintings are the small sculptures made of mammoth ivory found in central Europe. These 30,000-year-old figures are the first tangible evidence of the representational world of Homo sapiens.

Whether these carved animal and human representations actually predate works made out of wood or horn is unknown. Ninety-nine percent of the production of Ice Age people, such as pieces of clothing made of hides and furs or implements and wooden objects, is now lost.

1 *Wild Horse.* Mammoth ivory, 1 x 2 x ³/₄'' (2.5 x 4.8 x 1.7 cm). University of Tübingen. Vogelherd.

The oldest authentic dated community with recognizable sculptural works in the world lies in southern Germany. Since the 1930s, lifelike formed ivory figurines from the Aurignacien culture were discovered in three caves—Vogelherd, Hohenstein-Stadel, and Geissenklösterle. The less than 2''-long *Wild Horse* from the cave at

2 *Mammoth Figure.* Mammoth ivory, 2 x 2 x 1'' (5.15 x 5 x 2.7 cm). University of Tübingen. Vogelherd.

Vogelherd (**1**) shows a stallion in impressive form. Horses belonged to hunting games, as did the *Mammoth* (**2**). A tiny ivory *Lion's Head* (**3**) was also found; it is probably a fragment of a full sculpture. Lions, like bears, appeared as a

3 *Lion's Head.* 1 x ³/₄ x ¹/₄'' (2.5 x 1.8 x 0.6 cm). Fragment of a full sculpture. Württemburg Regional Museum, Stuttgart. Layer of the Vogelherd, a cave site in the Swabian Alps, excavated since 1931. Aurignacien.

menacing natural enemy of humans; they lived near reindeer and woolly rhinoceros in the

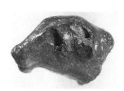

region between the two glaciers that covered Scandinavia and the Alps.

The *Lion's Head* (**4**) of fired clay belonging

4 *Lion's Head.* Fired clay, 1 x 1 ³/₄'' (2.8 x 4.5 cm). Moravian Museum, Brno. Dolní Vestonice.

HOHL-ST 2

6 X ray of the *Lion Man*.

5 Right: *Lion Man*. Mammoth ivory, 11 ¼ x 2 ¼ x 2 ½'' (28.1 x 5.6 x 5.9 cm). Ulm Museum. Found in Hohenstein-Stadel, a cave site in the Lonetal, excavated 1935–39. Aurignacien.

to a later epoch has a puncture, as though it had been speared in a hunt. This find confirms speculation about the art of hunt magic, as it is still practiced in hunting societies today. Animals symbolized supernatural powers. This also accounts for the easily 32,000-year-old *Lion Man* (**5** and **6**). These figures, approximately 12'' (30 cm) high, fall outside the more common production of the usual animal sculptures and Venus statuettes. In 1988 experts were first able to definitively reconstruct the *Lion Man*, which had to be assembled from 200 individual fragments. Xrays show that it was cut from one tusk from a small mammoth. The *Lion Man* is, with the *Anthropomorphic Half-Relief* from Blaubeuren (**7**), one of the oldest known representations of the human form.

 The transition between abstract and realistic illustration is often fluid. Seldom are finds endowed with individual characteristics, as is

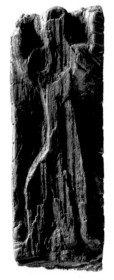

7 *Anthropomorphic Half-Relief* (Adorant). Ivory, 5 x 1 x ⅓'' (14 x 3.8 x 0.45 cm). Württemburg Regional Museum, Stuttgart. Found in the Geissenklösterle, a cave site at Blaubeuren, excavated since 1973. Aurignacien.

8 *Woman's Head*. Ivory, 2 x 1 x 1'' (4.8 x 2.4 x 2.2 cm). Earliest known portrait of a person. Moravian Museum, Brno. Found in Dolní Vestonice.

The First Portraits

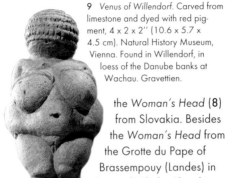

9 *Venus of Willendorf*. Carved from limestone and dyed with red pigment, 4 x 2 x 2" (10.6 x 5.7 x 4.5 cm). Natural History Museum, Vienna. Found in Willendorf, in loess of the Danube banks at Wachau. Gravettien.

Prehistory – ca. 500 B.C.

the *Woman's Head* (8) from Slovakia. Besides the *Woman's Head* from the Grotte du Pape of Brassempouy (Landes) in France (10), the Slovakian find is probably the first portrait in world history. One half of the face droops and appears to be injured or impaired. A similarly distorted mask was found at the same site. In addition, researchers uncovered a slender skeleton with a cranium deformed on one side.

The best-known prehistoric works are the Gravettian Venus statuettes. With these figures, the sculptors of the Ice Age accentuated the secondary sex characteristics: heavy breasts and expansive hips. The *Statuette of a Woman* (11) found near Brno in central Czechoslovakia is made out of fired clay and stands as the first ceramic find overall. The *Venus of Willendorf* (9) is one of the first limestone sculptures, whose detailed formation from coiffure to kneecaps is a marvel. The narrow arms lying over the breasts and the ornamental hairstyle are characteristic.

The womanly figure stands as a symbol of fertility and the source of life. Findings of these little mother-fetishes extend from northern Italy to Siberia.

Naturalism of representation of the human body appears to be timeless. In the *Ivory Statuette* (13) from Slovakia we see the almost marked shifting of balance with a slight rotation to the side, a posture that probably came about

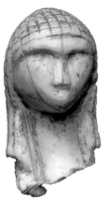

10 *Woman's Head*. Ivory, 1 x 1 x ¾" (3.5 x 2.2 x 1.9 cm). National Antiquities Museum, St.-Germain-en-Laye. Found in 1880 in the foothills of the Pyrenees. Gravettien.

11 *Statuette* of a Woman. Fired clay, 4 x 2 x 1" (11.5 x 4.4 x 2.8 cm). Moravian Museum, Brno. Found in Dolní Vestonice, a large open site south of Brno, excavated since 1924. Gravettien.

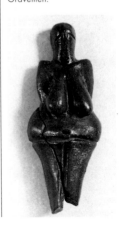

13 *Statuette of a Woman.* Ivory, 3 x 1 x 1 ¹/₃'' (7.1 x 2.4 x 3.0 cm). Archaeological Institute, Nitra. Found at Moravny-Podkovica, Loess Wilderness station in Slovakia.

14 *Abstract Woman's Figure.* Ivory, 3 ¹/₃ x 1 x ²/₃'' (8.6 x 2.2 x 1.4 cm). Moravian Museum, Brno. Found in Dolní Vestolnice.

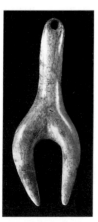

12 *Statuette of a Woman.* Jet (bituminous coal used as gemstone), 1³/₄'' (4 cm) high. Museum for Pre- and Early History, Freiburg. Found in Peterfels, a cave with forecourt at Engen-Bitterbrunn in the Hegau, excavated since 1927. Magdalenien (end of the Ice Age).

by chance, though rendering the figure more lifelike. We have also found some fully abstract sculptures from the same region. The simplified figure with the exaggerated buttocks and opening in the upper end (**12**) was probably worn around the neck. Of these amulets, stylized examples are widespread. In the case of the Gravettian figurines found near Brno, the exaggerated breasts are removed, and a womanly figure is characterized by a rod. In another abstract ivory pendant (**14**), the spread legs suggest a female figure.

During this time schematic animal figures also suddenly appear. The carved ivory silhouette of a pouncing *Lion* (**15**) shows the interplay between naturalistic and abstract representation that characterize the thousand-year composite prehistory. The *Head of a Musk Ox* (**16**), with a later date, is made of reindeer antler, and unlike the *Lion* and other pseudo-naturalistic finds, is represented in detail down to its curly fur. It is

15 *Lion Sculpture.* Silhouette, carved from ivory, 8'' (21.5 cm). Archaeological Institute, Brno. Found in Pavlov, underneath the Pollauer mountains. Gravettien.

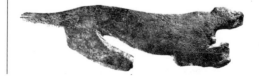

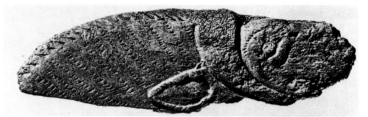

believed that the head part was a spearhead that was decorated with other hunt motifs and animal figures.

While the known figures may only reflect a small fraction of the sculpture produced during that time, they nevertheless show that prehistoric people did have a playful creativity. This playfulness is revealed, for instance, in the outpouring of abstract women figures in multiple forms. From the early Neolithic period, we have found so-called *Idols* (**17**) of fired clay in the Danube River region. The stylized, standing figures are a step forward from the Paleolithic Venus statuettes. They form a bridge to the *Marble Idols* (**18**) dating from 2000 B.C. from the Cycladean culture in the South Aegean.

17 *Female Idols.* Fired clay, 8'' and 8 ¾'' (21 and 22 cm) high. Moravian Museum, Brno. Found in the settlement at Strelice.

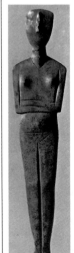

18 *Idol of Amorgos.* Marble, 30'' (76 cm) high. Ashmolean Museum, Oxford. Around 2500–1100 B.C.

The production of the beloved in the Paleolithic animal figures takes off during the middle Stone Age. Found near Berlin, the *Woldenberger Horses* (**19**) were nearly judged from the Neolithic, consequently as a phase in the dawning agricultural society. Settled people were no longer dependent on the magic of the

19 *Young Horse.* Amber, 4 ³/₄″ (12 cm) long, copy. Museum for Prehistory and Early History, Berlin. Found in Woldenburg, Kreis Friedeberg, Brandenburg. Neolithic.

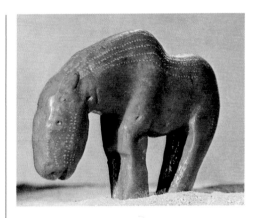

hunt for their animal representations. They refined the manufacture of ceramics and decorated their households with ornaments worked in metal or wood. At this time in Near Asia the first works of monumental architecture were erected, but in Middle Europe only megalithic grave mounds and passages covered with earth were built. In the French Carnac region in Brittany stands a row of nearly 23 ¹/₂-foot-high menhirs, hewn elongated stone monoliths forming a prehistoric boulevard. Sculptures such as the *Figured Menhir* (**20**) found in France, with its stylized representation of a goddess fitted into the shape of the stone are rare, however. The solitary representative of large sculptures from the Hallstein or Bronze Age (800–500 B.C.) is the *Warrior from Hirschland* found in Austria. The

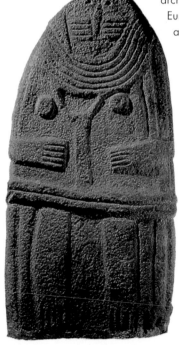

20 *Figured Menhir.* Sandstone, 46″ (120 cm) high. Lapidary Museum of the Society of Arts and Letters, Rodez. Found in Sernin-sur-Rance, Aveyron. Around 3000 B.C.

Venus with the Horn

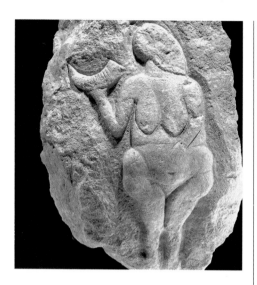

21 *Venus with the Horn.*
Limestone relief, 21³/₄ x 14''
(54,5 x 36 cm). Museum of
Aquitaine, Bordeaux.
Unearthed between 1908
and 1914. Gravettien.

Prehistory – ca. 500 B.C.

grave stele shows the exaggerated thighs of
Etruscan influence. Before the first high
cultures, the Nordic megalithic culture
developed ceramic drinking cups around
3000 B.C. These cups, like other objects from
the Bronze Age, served a religious purpose.
The ritual chariot on which the vessel carrier
and warrior are represented schematically
stands as an example of the overthrow of nature
worship in favor of deities. Sculptures, lifelike
or larger than life, are found first in Sumeria
and ancient Egypt.

Glossary

Fetish: Portuguese-French, from Latin *facticius* = imitation, artificial; an object that
characterizes a supernatural force. A believer can activate the force through
thoughts or sacrifices, to help oneself or to hurt others.
Idol: Latin from Greek *eídólon* = figure, picture, illusion; pagan religious symbol;
designation for abstract or naturalistic figures of clay, stone, bronze, ivory, or other
material, that were found as grave artifacts.
Menhir: French from Breton *maen-hir* = long stone; freestanding, up to 67' (20 m)
long stone with religious significance.
Stele: Greek = column, pillars; in early cultures, freestanding, rectangular or
natural disk formation or pillar from stone; as a rule decorated.

Sculpture on the Nile

3000 B.C. – 395 A.D.

3500–2185 B.C. 1st and 2nd Dynasty, the Archaic Period

2750 B.C. Legendary King Gilgamesh of Uruk

2705–2155 B.C. 3rd to 6th Dynasty, Old Empire

2155–2135 B.C. 7th to 10th Dynasty, First interim

2134–1785 B.C. 11th to 12th Dynasty, Middle Empire

2100 B.C. Prince Gudea of Lagash founds a new Sumerian empire in Mesopotamia

1950 B.C. Conquest of Babylon by the Palestinian Amoriter

1781–1550 B.C. 13th to 17th Dynasty, Second interim

1550–1070 B.C. 18th to 20th Dynasty, New Empire

1350–1330 B.C. Amarna Period

1070–750 B.C. 21st to 24th Dynasty, Third interim

750–332 B.C. 25th to 30th Dynasty, Late period

332–395 A.D. Greco-Roman period

Protected from their Arab enemies by mountains to the east and the Libyan desert to the west, the ancient Egyptian empire was free to develop along the Nile River over a period of 3,000 years. The Egyptian draftsmen, stonemasons, and plasterers created works of art in teams, which marks an important cornerstone for the history of sculpture. Even if the sculptors of the Renaissance and the Classical period referred mostly to the Greek canon, the Egyptians were the first to carve life-size—even though composed from a single viewpoint—round portraits from stone, and to establish an artistic tradition, which was to become the foundation of early Greek sculpture.

Despite the endless possible positions in which one can represent the human body, the Egyptians limited themselves to few, always frontal viewpoints: among their favored positions are the standing-striding figure and the sitting figure, as well as the writing and the cubic figure. Later came representations of figures praying or sacrificing. The most famous head

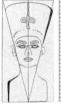

22 Modeled Bust of *Nefertiti* (right), Amarna, around 1340 B.C. Limestone and plaster, 19 1/4″ (48 cm) high. Egyptian Museum, Berlin.
23 *Proportional diagram* (left) with grid and symmetrical proportions of the bust of Nefertiti. In the Old Empire, these proportions became a system of coordinates from which the Middle Empire developed a system of squares as the basis of a figure. The Egyptian proportional canon was based on the standardized length of certain body parts. Also, the manner of representing body parts and their relationship to one another were strictly determined.

of a prominent Egyptian is the bust of *Nefertiti* (**22**) in the Egyptian Museum in Berlin; this bust is believed to be part of a complete figure. Its beauty, however, corresponds to neither the style of the particular Amarna period nor the traditional ancient Egyptian canon, but owes its fame to its agreement with modern ideals of beauty.

Archaeologists of the 19th and early 20th century have gathered almost all the evidence of ancient Egyptian culture, especially of the Old Empire, from the graves of the Pharaohs and their followers. Or they found their artifacts in the temple buildings of the Middle and New Empire. The cult of the Dead stood in the center of social life and art. After the soul had exited from the mortal body, the statue erected in the grave served as a seat in the Empire of Death. Only if a so-called *Ka* statue took the place of the mortal body could the deceased refresh himself (or herself) with the grave offerings. Servant statues were supplied whose realism reflected the earthliness of their tasks without regard to the proportion canon. Although the painted limestone figure of a *Woman Brewer* (**24**) is engaging on account of its animation, it cannot be counted as a prime example of ancient Egyptian sculpture, whose most important characteristic is the portrayal of internal agitation and outer peace, rather than signs of eternal life.

How do we infer consistency and unity from such contrasts? The *Standing-Striding Figure of an Unknown* (**25**) portrays no momentary movement, but preparedness for action. With the shoulders slightly lifted, the muscular arms stretched, and the hands clenched, the concentration of the man becomes obvious. With one foot slightly forward, the inclusion of this figure in the tomb allows the deceased

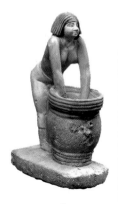

3000 B.C. – 395 A.D.

24 Statuette of a *Woman Brewer*, Giza, ca. 2325 B.C. Limestone, paint, 11 1/4" (28 cm) high. Egyptian Museum, Cairo.

25 *Standing-Striding Figure of an Unknown*, origin unknown, ca. 2400 B.C. Gneiss, 13 3/4" (34.5 cm) high. Egyptian Museum, Berlin.

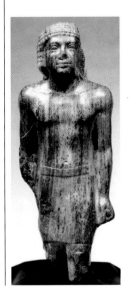

17

26 Statuette of *King Akhenaten*, origin unknown; ca. 1340 B.C., wood, 10 ¼″ (25.5 cm) high. Egyptian Museum, Berlin.

the use of his limbs in the realm of the dead. The other leg, however, remains imaginary—sometimes also presented—in the rear plane that forms the scaffold for the figure. This pattern of the standing-striding figure from the Old Empire of the pyramid builders remains obligatory in the New Empire and in the reign of Akhenaten. The *wood statuette of that king* (**26**) strides symbolically to illustrate his power over the enemies presented on the rear-facing plane of the platform.

In his novel *Joseph and His Brothers*, author Thomas Mann expresses the standing-striding symbolism clearly: "On both soles he goes, in going standing, and standing in going." Actually, Akhenaten's wife Nefertiti is found in an ambiguous position. Even though it remains in the stand-stride posture, Akhenaten's body shows features of an ideal, which were typical only for the Amarna period and ignored for the outward-pressing power of the sculpture of the *Unknown* (**25**). The pushing-pulling stand-stride motif is fully adopted in his well-worked knees.

The relationship to the mandatory cubical frame of reference becomes more clear in the sitting figures. In heiroglyphic writing, the symbol for "handsome" or "exalted" is a man sitting on a stool. Evidently, the sitting motif, which stood for only kings and members of the elite, symbolizes the transfigured condition of the person represented after death. The oldest

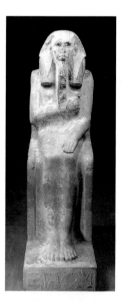

27 *King Zoser*, Sakkara, 2690–2660 B.C. Painted lime-stone, 56 ¾″ (142 cm) high. Egyptian Museum, Cairo.

known life-size statue from Egypt is such a sitting figure; it shows the dismal-looking *God-King Zoser* (27), who is considered the real founder of the Old Empire. The artificial chin beard and striped head scarf identify him as a sovereign. The inscription states his identity, so that the likeness did not have to be exact. The parallel legs, the angular, bent body, and the symmetry disturbed only through one raised hand described the coordinates of an invisible constructed chamber, for which the throne offers only a suggestion.

A changed kingly portraiture, which, however, respects all features of the sitting figure, is found over one hundred years later in the relaxed, smiling likeness of the pyramid builder, the king Cheops. His statue (28) is one of twenty-three similar figures found in 1860 in the Valley of the Kings Temple in Giza. With its explanatory relief uniting lower and upper Egypt on the sides of the throne, it is considered one of the most splendid king figures of the Old Empire. The former rigor has softened into a more relaxed idealization, which still includes the expressiveness of the *Unknown*.

The goal of the Egyptians was to live on in the afterlife in eternal youth. The king therefore appears young and beautiful in all works of art. Compared with this apogee, the painted limestone likeness of *Mentuhotep II* (29), the second ruler of the Middle Empire, is a reduction to a few basic forms and a setback. Mentuhotep carries the red crown of lower Egypt and holds his arms in an Osiris gesture, crossed over his chest.

Osiris was the god who ruled the realm of death, so that the representation of the deceased as Osiris symbolizes his passage into the afterlife. Also, the coloring of the almost

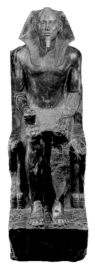

3000 B.C. – 395 A.D.

28 *Chephren,* Giza, ca. 2540–05 B.C. Diorite, 67 ¼" (168 cm) high. Egyptian Museum, Cairo.

29 *Mentuhotep II,* Thebes, ca. 2061–10 B.C. Sandstone, paints, 55 ¼" (138 cm) high. Egyptian Museum, Cairo.

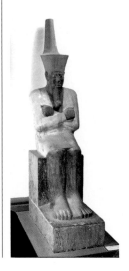

Sculpture on the Nile

3000 B.C. – 395 A.D.

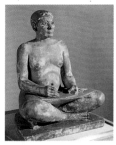

31 *Figure of a Scribe,* Sakkara, ca. 2520–2360 B.C. Painted limestone, 21 ½" (53.7 cm) high. Musée du Louvre, Paris.

32 Cubic figure of *Senmut,* Karnak, ca. 1470 B.C. Granite, 40 ¼" (100.5 cm) high. Egyptian Museum, Berlin.

always painted figures conformed to a prescribed canon. The black skin of Mentuhotep II represents fertility and resurrection. Normally, men were painted with brown, women with a light yellow skin color (**30**).

We also see this careful painting in the *Figure of a Scribe* (**31**). The artist even applied the customary eye lines. Since a special type of statue developed in honor of these officials, they

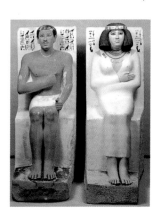

30 *Rahotep and Nofret,* Meidum, ca. 2620 B.C. Painted limestone, 48 ½" (121 cm) high. Egyptian Museum, Cairo. Prince Rahotep, as son of King Snofru, took the office of high priest and many other positions. These two statues are especially valuable because of the preservation of the paint.

must have played an important role in the society, which corresponded to the meaning of the writing. Important personalities had themselves presented as scribes. With crossed legs, the scribe is shown at work, with reed pen and papyrus in his hand. The realism of the figure conceals its strict formal construction. The kernel of the composition forms the outline and elevation of a pyramid.

The cubical space perception of the Egyptians shows itself most clearly in the cube figure, which first emerged during the Middle Empire. Also called the "cubic stool," this type of form appears more often in the private tomb sculpture. The block of stone symbolizes the

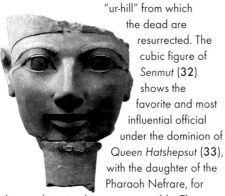

"ur-hill" from which the dead are resurrected. The cubic figure of *Senmut* (**32**) shows the favorite and most influential official under the dominion of *Queen Hatshepsut* (**33**), with the daughter of the Pharaoh Nefrare, for whose upbringing he was responsible. The inscription enumerates his approximately eighty official and honorary titles. For this double figure there are no precursors. The princess's head, with child's hairstyle and ancient symbols, peers out of the mantle covering his arms and knees. Seven such statues of Senmut are known. This is astonishing, especially since the builder evidently fell into disgrace in the eleventh year of the queen's reign. After his death, his name was removed from all monuments and his second stone tomb in Thebes was destroyed.

33 *Queen Hatshepsut*, Deir el-Bahari, ca. 1475 B.C. Painted limestone, 24 ½" (61 cm) high. Egyptian Museum, Cairo.

3000 B.C. – 395 A.D.

34 Tomb-temple of Hatshepsut in Deir el-Bahari.

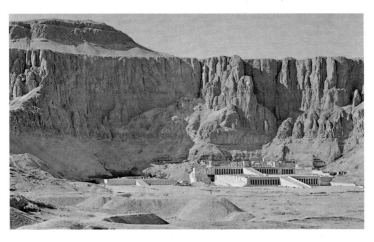

35 Portrait head of *Queen Tiy*, Medina el-Ghurob, ca. 1355 B.C. Yew wood, 3 ¾″ (9.5 cm) high. Egyptian Museum, Berlin.

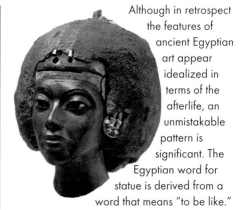

Although in retrospect the features of ancient Egyptian art appear idealized in terms of the afterlife, an unmistakable pattern is significant. The Egyptian word for statue is derived from a word that means "to be like." The assignment of the mass-produced private tomb sculptures to a specific person could only be guaranteed through an inscription. A few later masterpieces bring out the personality of the subject in the face. The portrait head of *Queen Tiy* (**35**), Akhenaten's mother, does not exaggerate the furrows of the mature, self-confident woman or her pulled-down mouth with full lips. The small yew-wood head was covered with a silver hood, with two symbolic snakes from the crown to forehead.

After Tiy had to relinquish her title to Nefertiti, the hood was covered with the headpiece of the goddess Hathor. The sculpture was thus adjusted to new conditions. A similar alteration was made to the statue of King *Amenemhet III* (**36**) from the Middle Empire. His face was simply reworked about six hundred years later. The slightly melancholy features typical of the late Middle Empire were smoothed, as a later king claimed the statue for himself.

The different ancient Egyptian statue types, the standing-striding figure, the sitting figure, the scribe, and the cubic figure, are all similarly idealized likenesses. Surely it would be wrong to maintain that there has been an Egyptian portrait sculpture tradition for over three

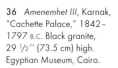

36 *Amenemhet III*, Karnak, "Cachette Palace," 1842–1797 B.C. Black granite, 29 ½″ (73.5 cm) high. Egyptian Museum, Cairo.

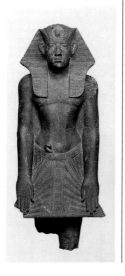

thousand years; nonetheless it is fair to assert that portraiture flowed repeatedly in streams into the canon of representation. The peak and at the same time the termination of this tradition comes with the so-called *Berlin Green Head* (**37**), a portrait of a bald man carved from a gray conglomerate material. The sculptor animated the severe form of the head through slight asymmetries and created a surface tension that emanates from the interior, which betrays an exact knowledge of anatomy.

Around 500 B.C., when the Persians had already taken control of the Nile, we find allusions to the existence of some Greco-Roman portrait sculptures. Some date this around 50 B.C., which means that this tradition would follow the Roman Caesar portraits, which were first painted in the first century A.D.

37 Portrait of a Bald Man, the *Berlin Green Head*, origin unknown, around 500 B.C. Gray conglomerate material, 8 ½" (21.5 cm) high. Egyptian Museum, Berlin.

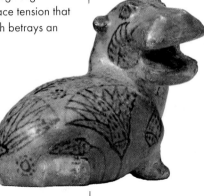

38 Figure of a *Hippo-potamus*, origin unknown, ca. 1800 B.C. Faience, 3 ½" (9 cm) long. Egyptian Museum, Berlin. The small figurative sculptures are a religiously motivated guarantor of eternal life. The unnatural coloring and the aquatic plants allude to the living space of the hippo-potamus, the Nile, which however means the Ur-ocean Nun, from which all life sprang. The open mouth serves to warn away evil.

Glossary

Sitting figure: With the sitting figure, the position of the person represented is confirmed, for only the elite were privileged to sit upright.

Standing-striding figure: Display of the figure in a posture between walking and standing. The vertical line proceeding from the head over the right leg up to the foot established stability, the forward left leg suggested readiness for movement.

Cubic stool: The sitting figure simplified to a cube; the wrapping robe has room for inscriptions.

ca. 600 B.C. Height of Babylonian art: Ishtar Gate in the Pergamon Museum, Berlin

549 B.C. Sparta unites southern Greece in the Peloponnesian League

500 B.C. Peak of the culture and political force of the Etruscans in Italy

490–430 B.C. Philosopher Empedocles

480 B.C. Death of the Buddha Siddhartha, founder of the Indian religion that spread throughout Asia

479 B.C. Death of the Chinese scholar Confucius

470 B.C. Birth of Socrates

450 B.C. Pit ovens for smelting metals from the Latène culture (early Ice Age in northern and western Europe) are found

431 B.C. The population of Greece includes over 3 million slaves

429 B.C. Ezra gives Judah a sacred law (the present *Pentateuch*)

406 B.C. The Chinese manufacture large bronze-covered vases as well as jade jewelry

400 B.C. Esoteric doctrine of the Druids by the Celts, at the top of the hierarchically arranged society stand priests, doctors, teachers, and judges; offering of sacrifices

336–323 B.C. Alexander the Great founds his empire; peak of Hellenism

Anyone who has already spent any time in a sculpture collection will remember images of heroes and of gods that are larger than life. The preserved plaster replicas we most often think of as "classical forms" are primarily Roman copies of Greek works—antiques in their own right—that were produced as luxury items. The only very rarely preserved statues shone for over two thousand years in a luminous array of colors that had been painted over the bronze or the marble. One example is the colossal *Athena Parthenos* (**39**), made, as we know from written sources, of ivory and gold; or the *Zeus of Olympia monument* (**40**) of Phidias. This opulent painting style, for lack of preserved originals, has fallen into oblivion.

As cultures from the Renaissance down to the 18th century looked back at Antique sculpture, the history of the classic sculptural style, based on studies of a few originals, of Roman copies, and of written sources, tended sometimes to be influenced by the era undertaking the study. The basic framework, the division into the three periods of the Archaic, the Classic, and the Hellenistic, however,

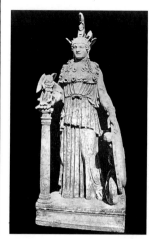

39 *Varvakion Athena.* Roman marble copy of the Parthenon Athena. National Museum, Athens. To support it in the cella of the Parthenon, 40' (12 m) high upright statues were supposed to be blocked up with one ton of gold poured into the clad parts of the goddess. The bare limbs were carved from ivory, so that her sheltering building can be understood as a gigantic treasure house in the form of a temple.

remains constant and uncontested, and offers sufficient criteria to place these unequaled statues within a chronological and a critical context. The Archaic austere boy and girl statues of classically harmonious

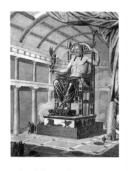

athletes are easily distinguished from the Hellenistic-influenced goddesses. It is well worth examining the style characteristics of the three ages closely, for the sculptors of the Renaissance and of the Classical era have always understood the Antique as a plumb line.

In the period of 600 years from 700 to 100 B.C. sculptures emerged that still inspire viewers from all over the world. Perhaps the most beloved are the *Venus de Milo* (**41**) and the *Nike of Samothrace* (**42**)—both now in the Louvre in Paris—closely followed by the *Pergamon Altar* (**44**) at the Berlin Museum. Altogether

41 The Venus de Milo. Musée du Louvre, Paris.

Hellenistic, larger-than-life human figures, they embody in the course of the half-millennium the anthropomorphic god-images of late Greece. Through the facial features and the restrained turn of the body, the *Venus de Milo* reflects the Classic period, while the windblown goddess of victory, *Nike,* typifies the emotionalism of the late Hellenistic.

In a frieze unearthed at the end of the 19th century, the *Zeus Altar of Pergamon*

40 Reconstruction of the *Zeus in Olympia* (A.-C. Quatremère der Quincy, 1814). The Roman author Lucian (2nd century A.D.) described the interior of the ill-maintained Zeus of Olympia: "I ... felt very moved and I came before the colossal sculpture by Phidias ... which from the outside appeared to be worked from bright gold and ivory. When I looked inside, however, I saw nothing but wooden rafters, brackets, nails, chunks and wedges, pitch and clay and a quantity of such refuse ... not to mention the mice and rats, whole families of which often nest therein and make themselves a nuisance" (*Gallus* 24).

600 B.C. – 400 A.D.

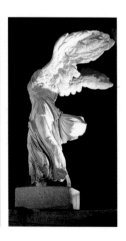

42 *Nike of Samothrace.* Musée du Louvre, Paris.

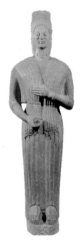

43 The *Berlin Goddess*. Attic, between 580 and 560 B.C., marble, 77'' (193 cm) high. Antique Collection, Berlin.

44 The northern peristyle and frieze of the *Pergamon Altar* of Zeus. Antique Collection, Berlin.

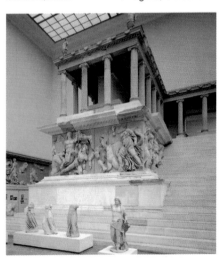

passionately depicts the fight of the gods against the giants, representing the war of the Pergamenes against the Galls.

Most museum visitors listen through headphones or read guidebooks for explanations of the meaning of works of art—especially the overwhelming construction of the *Pergamon Altar* (**44**)—for often one may see only what one knows to look for. Gradually, however, the viewer may move beyond images of the conquest of the ancient world, and may begin to discern its change from a canon of statuary god-images through the harmonious ideal to more expressive scenes.

If one takes, for instance, a tour through the left wing of the Pergamon Museum in Berlin, the Archaic, smiling kore, the so-called *Berlin Goddess* (**43**) receives—in the truest sense of the word—the wanderer. The strictly symmetrical and stiff girl's figure owes its fame to the preserved residues of color, which reveal that for more than two millenia she bore a red coating. The larger-than-life marble figure, dated between 580–560 B.C., was buried in antiquity with a lead covering to protect it from the Persians.

Its meaning is obscure. Beside its function as a religious image, it was probably a grave sculpture, since a comparable piece, in which the girl also holds a pomegranate in her hand, was found with a corresponding inscription. The numerous kore statuettes were dedicated mostly to aristocratic girls, to emphasize their

gracefulness, precious clothing, and dignified reserve.

While the girl figures of the Archaic Antique are always clad, the male counterparts are typically nude. Since the gods were presented in human form, symbolizing the ideal of the human body, the sculptures captured in imperishable stone the eternal splendor of the divine. With his broad shoulders and narrow hips, the *Kuros of New York* (**45**), found at the end of the 7th century in Attica, is reminiscent of Egyptian models. We also see the endurance of the standing-striding motif, although the balance no longer rests only on the back leg but shifts to the front. Muscles and joints are implied schematically; in the literature as well, reference is made to the geometric style of urn painting.

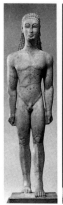
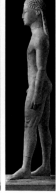

45 *Kuros of New York.* Allegedly from Attica. Mottled marble, 73 ½'' (184 cm) high. Metropolitan Museum of Art, New York.

600 B.C. – 400 A.D.

The *Creisus of Anavyssos* (**46**), a tomb statue that emerged one hundred years later, appears quite lifelike. It represents a commemoration, not a portrait. The inscription on the base of the sculpture tells of its function: "Stay and mourn by the gravestone of the dead Creisus, who in the front lines of the battle the violent Ares has carried away." The figure's overdeveloped thighs and body musculature add an organic element to the otherwise severe and straight body.

Mighty thighs and an exaggerated backside such as those seen in the *Creisus*, combined with childlike skin and skillful coiffure, also dominate the erotic scenes of urn painting (**47**). Sexuality between mature men and young boys

46 *Creisus of Anavyssos.* Marble, 77 ½'' (194 cm) high. National Archaelogical Museum, Athens.

47 *Love Solicitation,* ca. 550 B.C. Vase painting. Martin von Wagner Museum, Würzburg.

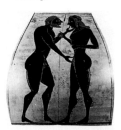

600 B.C. – 400 A.D.

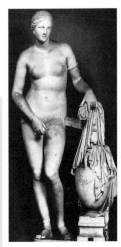

48 Praxiteles, *Aphrodite of Knidos*. Vatican Museum, Rome.

49 *Kritios Boy*. Marble, 47″ (117 cm) high. Acropolis Museum, Athens.

50 Head of the *Charioteer of Delphi*, ca. 470 B.C. Bronze. Archaelogical Museum, Delphi.

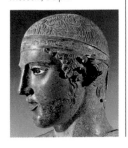

was a part of social life, and the sculptures can be understood as symbolic of this erotic ideal. In the 4th century, feminine figures appear for the first time without clothes; one of the first known nude goddess representations is the *Aphrodite of Knidos* of Praxiteles (**48**). How frequently in the history of art does the pretense of the imminent bath justify nudity?

Marking the passage from the Archaic period to the early Classic is the counterpose, a shifting of the weight of a standing figure to one leg while the other is lifted. The *Kritios Boy* from the Acropolis in Athens (**49**), dated 480 B.C., illustrates this break with the conventions of the Archaic Kuros figure. The limbs of the statue appear relaxed, the skeleton is slightly more apparent, and the head is slightly turned to identify the front leg clearly as the active one. Besides the *Charioteer* (**50**), the only preserved large bronze from that time is the *Zeus of Cape Artemision* (**51**) which combines with the image of youth an ideal and harmonious corporeality. The bearded hero is poised to throw with one leg drawn back, his eyes fixed on the target. Today the work is considered one of the first sculptures to indicate room and direction.

Although the figure rests—classically—in itself, it bespeaks an expansive continuum of space. These so-called "strict style" numbered works lead to the high Classic masterpieces of the now nominally known sculptors.

Among these sculptors, perhaps the most outstanding is Phidias, who under Pericles between 448 and 438 B.C. helped rebuild the Acropolis after it had been destroyed by the Persians. To Phidias are attributed not only numerous colossal divinity sculptures, but also the only partially preserved figures of the Parthenon Temple, which is outstanding in its unified, harmonious proportion. Of the monumental god representations, which after the official introduction of Christianity were shipped to Constantinople where they met an unknown fate, only reconstructions after smaller replicas and written sources are known. At the very entrance to the capital, the Athena and Zeus of precious materials are mentioned; one may assume, thus, that many Byzantine ivory tablets were cut from Athena's white flesh.

Even though it is attributed to the workshop of Phidias, a *Goddess Group* from the east wing of the Parthenon (**52**) is preserved in the British Museum (London), which reflects the knowledge of the master. In this piece one can clearly see the shift from purely ideal body positions to natural poses. Also new is the richly folded garment, which for the first time instead of merely veiling now emphasizes the womanly body form—this is also known as the wet style.

The somewhat later Myron, by contrast, created the more severely styled bronzes,

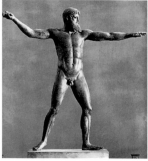

51 *Zeus of Cape Artemision.* High gloss bronze, 83 ½" (209 cm) high. National Archaeological Museum, Athens.

600 B.C. – 400 A.D.

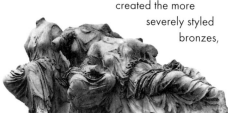

52 *Goddess Group* from the east wing of the Parthenon. British Museum, London.

600 B.C. – 400 A.D.

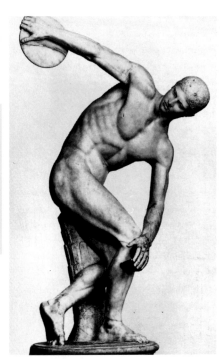

53 *Discus Thrower Lancelotti*. Marble, 62'' (155 cm) high. Museo Nazionale Romano, Rome.

54 Roman reproduction of the *Doryphoros* of Polykleitos, from the Palace in Pompeii. Marble, 85'' (212 cm) high with plinth. National Archaeological Museum, Naples.

which—in Lessing's interpretation—depict the so-called "fruitful moment," therefore bringing a time element into sculpture. In a traditional Roman marble style, Myron's *Discus Thrower* (**53**) shows a youthful athlete in competition. Beside the ingenious anatomical representation of the body in bent posture, the sharpened realism of the momentary with the simultaneous virtuosic idealization is attained. From this frozen point in time one can reconstruct the previous activity and foresee what will follow.

As a further advancement in the search for harmonious rules of sculpture stands the *Canon* of Polykleitos. Unfortunately, only two theses, and little content remains, for example: "Beauty sets itself out in accordance with the assembling of small masses that yield a symmetry externally themselves in many numerical proportions." This outlook is represented by the *Doryphoros* (**54**) or *Spear-Bearer*, shown here in a Roman copy, which depicts a larger-than-life nude youth.

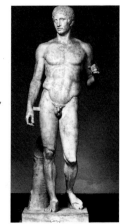

For sculptors to realize Polykeitos's rules of proportion, they explored the proportions of the human figure. The arrangement corresponds to the golden mean, from which a harmoniously felt division of a line emerges, if the smaller segment relates to the larger as the larger does to the whole. In this way, the living figure was transformed according to temple architecture through clarity and regularity of proportions to an overarching ideal form. Polykleitos created a timeless, mathematically grounded standard of beauty, which later ages took for a model and heralded as "timeless."

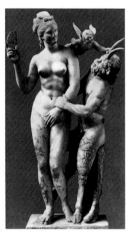

In the Hellenistic era, between 323 (the death of Alexander the Great) and 31 B.C. (the beginning of the reign of Augustus), sculptural groups took on an increasing complexity, interest in physiognomic types, and accurate reproduction of details. The previous development of sculpture formed a reservoir that was changed seasonally. A prime example of this development is the *Aphrodite-Pan-Eros Group* (**55**) from Delos. In this statue, the goddess of love is turned sideways, in the posture seen in the Knida cupid, which is fixed, doll-like, behind the model.

While the eroticized sacred image unites several styles, the representation of *Demosthenes* (**56**) concentrates on the features of age. The head lowered, in the hands a scroll

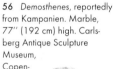

55 *Aphrodite-Pan-Eros Group*, from Delos. Parischer marble, 52″ (129 cm) high. National Archaelogical Museum, Athens.

600 B.C. – 400 A.D.

56 *Demosthenes*, reportedly from Kampanien. Marble, 77″ (192 cm) high. Carlsberg Antique Sculpture Museum, Copenhagen.

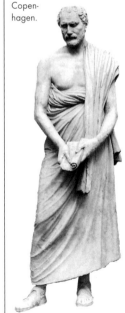

600 B.C. – 400 A.D.

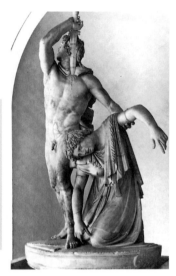

57 Gallic Group Ludovisi, ca. 230 B.C. Marble, 85'' (211 cm) high. Thermen Museum, Rome.

with a prepared speech—the sculptural portrait unites the monument and the allegory.

Sometime between 180 and 159 B.C. the mighty Zeus *Altar of Pergamon* was built. The Romans had already expanded their sphere of influence and domination to Greece, so that the famous sculptural frieze mentioned at the beginning of this chapter may be seen as one of the last large-scale Greek-Macedonian projects in history. The passionate emotionalism of the Pergamon figures is weakened in the so-called *Gallic Group Ludovisi* (**57**), whose original is also supposed to have been found in Pergamon. After the Gaul kills his sinking wife, he stabs himself in the chest with his sword. The sculpture takes several viewpoints simultaneously, and is complexly constructed—the couple's limbs bracing each other.

A further example of a form animated through light and shadows is the *Barberini Faun* (**58**), which the Bavarian Crown Prince Ludwig I acquired in 1813 from the estate of the Barberini family. Seen as decadent in the 19th century, the figure of the sleeping satyr emphasizes the heaviness of sleep, the total relaxation from consciousness, which exerts its demands upon the human body, which rests on a

58 Barberini Faun, ca. 220 B.C. Marble, 86'' (215 cm) high. Antique Sculpture Museum, Munich.

panther skin. The figure cuts a concave form, which can be interpreted today in its original function as an abstract space-opening sculpture. Over the figure arches its own continuum of the dream, the inner world of sleep, the empire of unconsciousness.

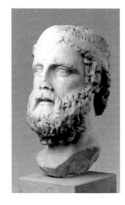

59 Likeness of *Anacreon*. Marble copy after a Greek original, ca. 450 B.C. 15'' (37.5 cm) high. Antique Collection, Berlin.

600 B.C. – 400 A.D.

While the Faun's face has sunk entranced on his left shoulder and hardly displays individual features, the *Anacreon* (ca. 572–487 B.C., **59**) reflects the absent-minded, intoxicated poet. Although the head is dated two centuries older, here the characteristic Greek portrait sculpture is indicated. Pausanius remarked that *Anacreon* is presented as "a drunk man would sing." The individual features hark back to the type of the "enraptured singer."

While the classic Attic ideal recedes, forms, emotion, and drama are incorporated and their importance grows; the tendency toward physiognomical individualization in the 4th century paved the way. The bust of *Epicurus* (341–270 B.C., **60**), one of numerous copies that can be traced back to a sitting statue in the garden of the philosophers, shows a domed intellectual forehead which becomes part of the formula and emerges in portraits of leaders of the time. The oblong head and the deep-set and close eyes betray the identity of the person presented, without any unexciting realism overturning how he happens to become significant as a part of Roman portrait sculpture.

60 Bust of *Epicurus*. Marble copy after a Greek statue, ca. 270 B.C. 10'' (25.5 cm) high. Antique Collection, Berlin.

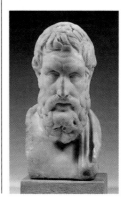

600 B.C. – 400 A.D.

ca. 700 B.C. Establishment of Rome

286 B.C. The library of Alexandria is said to have stored 700,000 scrolls

ca. 300 B.C. Over 100 necropolises with more than 5,000 cultic shallow graves in France

209 B.C. A central archive in China allows an exact historiography

202 B.C. A Germanic helmet inscription is the first known central European written text

ca. 165 B.C. *The Book of Daniel* of the Old Testament is written

ca. 100 B.C. Oldest known Bible manuscript

58 B.C. Julius Caesar, *The Gallic War*

ca. 0 Prime of Chinese astronomy and calendar reckoning

9 A.D. Battle in the Teutoburger forest, Prince Hermann defeats the Roman commander Varus

98 A.D. Tacitus reports that the Teutons worship the gods Thor and Odon

164 A.D. Oldest dated Mayan monuments

With the Colosseum, several imperial forums and villas, bridges and the aqueducts, the Romans left architectural monuments. One cannot speak, however, of a stylistically logically developing Roman sculpture. The exception to this rule, however, is portrait sculpture, of which the following gives the kernel. The many Roman copies of Greek statues, which we have already gotten to know, attest to the increased demand for sculptural works in ancient Rome. Chiefly there were Greek stonemasons, who copied the masterpieces of Praxiteles or Polykleitos. The function of the sculptures had changed indeed: these statues did not represent gods, or stand in shrines, or model a desirable ideal, but were used purely as decoration for the buildings, gardens, and hot springs (**61**) of wealthy Romans, who collected Hellenic art as luxury goods. The key point for this change of meaning is the year 212 B.C., when large numbers of works of art were carried off for the first time from Syracuse, the Greek settlement on Sicily, and brought to Rome. When the Greek originals could no longer satisfy the market, copies of the desirable antiques were manufactured, usually in the style desired by the customer. The offering was large: from the classic nude youth, to the moving dancing girls and lusty satyrs.

So we inevitably must wonder: What is Roman, what is Greek? The boundaries are

61 Wall of the *Cold Baths from the Stabian Hot Springs* with two urns clearly of Greek influence, Pompeii documentation by G. Abbate. Tempera on a box, 23 x 33'' (51 x 81 cm). National Museum, Naples.

fluid. The Roman appeared to the first archaeologist as only a decadent segment of the previous period known as the classic Antique. Johann Joachim Winckelmann (62), with his *History of Antiquity* (1764), originated the doctrine of the cyclical ascent and decay of cultures. In a challenge to his own time, the late Baroque, he established for Rome a "style of imitators and the decrease and fall of art." Even if he discussed the chief works of the time of the Caesars favorably, he avoided the idea of "Roman Art." Alois Riegl contradicted this thesis in his *Late Roman Art Industry* and emphasized the collective—and with it unique—element of the Roman artistic production. Nationalistic models of explanation at the beginning of the 20th century led to attempts to distill the Roman from Italian and Etruscan roots, to recognize structuralist attempts as a dualism, a plastic-dynamic tendency (the Alban Fossa pottery) and one geometrically linear culture (the Villanova culture). The result of all these efforts was that no continuous development can be described for Roman art. Moreover, it was accompanied by no significant art criticism, and was rather dominated on the whole by diversity, the coexistence of the non-coexistent.

The art history profession has in the example of the Roman art worked over, relativized, indeed thrown out its theoretical foundation, its underlying assumptions of development. Out of such efforts, it has been possible to extract a few typical trends in Roman sculpture, though with more difficulty than was involved in defining the characteristics of the Greek sculpture. In contrast to the Greeks, the Romans preferred to portray actual personalities or historic events. Greek ideal sculpture, which originally served religious purposes, was known

62 Johann Joachim Winckelmann (1717–68).

600 B.C. – 400 A.D.

63 *Ildefonso Group*, end of the 1st century B.C. marble, 65″ (161 cm) high. The Prado, Madrid.

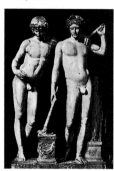

35

600 B.C. – 400 A.D.

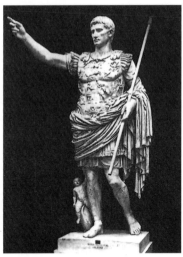

64 *Augustus of Primaporta,* 20–17 B.C. Marble, 82'' (204 cm) high. Vatican Museum, Rome (*below:* detail of the breastplate).

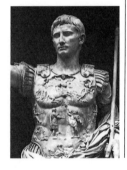

and prized by the Romans. However, they reproduced it for purely decorative artworks. Such eclectic (Greek = "chosen," "selected") sculptures can be analyzed for their Greek components. Three different examples are offered here: The *Ildefonso Group* (**63**) shows a pair of boys, with the figure on the right resembling the *Sauroktonos* of Praxiteles, and that on the left modeled on the work of Polykleitos. The work originates from the Villa Ludovisi in Rome and appeared first in Swedish, then in Spanish private property. The quality and overall impression of this work make it stand out from the bulk of purely copied pieces.

The sculptor of the *Augustus of Primaporta* (**64**) also reworked a Greek model, the *Doryphoros* of Polykleitos (**54**). Besides the outstanding fusion of Greek forms with the individual trends of the *princeps*, this statue adds a political dimension because of the worldwide distribution of this type. For the first time in Roman history there arose a form of art that was influenced by the state in both its form and its content. The *Statue of Augustus* reflected the self-image of the autocrat and reduced the hitherto obligatory Hellenistic representation of the Caesars, which the warlike heroes after the model of Alexander had favored. The *Augustus of Primaporta* corresponds to the original version of a likeness, which counts as the peak of Augustan classicism and is known in approximately 160 versions as a bust or a statue.

More recent research has pointed out that the images of the emperors were erected in all the

important public places of the
Roman cities: on the forums, in
the theaters, in the hot springs,
and in the villas. Moreover, they
also adorned household goods as
well as weapons and jewelry.
Emperor statuettes were even found
on house altars alongside the
likenesses of gods.

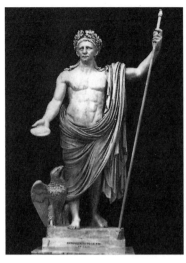

600 B.C. – 400 A.D.

This statue glorifies Augustus
as a triumphant and wise world
leader. His carriage, physique,
and massive proportions
correspond to the balanced Greek
ideal figure. The armor refers
solely to his military power, and
serves again as background for a
political statement carved in relief. The once-
painted marble statue was found in the villa of
the Empress Livia and is thought to be a copy of
an original, which was supposedly molded of
pure gold.

65 *Claudius as Jupiter,*
42–43 A.D. Vatican Museum,
Rome.

Clearly the sculptor of *Claudius as Jupiter*
(**65**) placed less emphasis on the idealization
of the sovereign and more on classical harmony.
This statue from 42–43 A.D. shows the emperor
with a bare upper body of Greek model in
beautiful proportion. The face with its broad
nose and receding chin do not conform with
the crown of laurel and the heroic gesture.
Claudius is supposed to have been, according
to surviving information, a stammering
bookworm, who made a name because of
his reform of the legal system, but otherwise
was dependent on his women and court
officials.

The realism in the countenance of Claudius
suggests the true domain of the Romans: the
portrait. This preference has its source in the
ancestor worship of the patrician families. In

600 B.C. – 400 A.D.

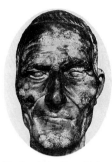

66 *Head of a Man*, third quarter of the 1st century B.C. Stone, 11″ (27.7 cm) high. Museum of Antiquity, Turin.

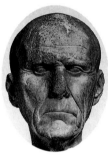

67 *Portrait Head of a Man*, 1st century B.C. Marble, 11 ¼″ (28 cm) high. Chieti, National Museum of Antiquity, Rome.

68 *Portrait of Gaius Julius Caesar*, Roman-Egyptian, 3rd century A.D. Green slate from northern Egypt, eye inlays of marble, 16 ½″ (41 cm) high. Antique Collection, Berlin.

their religious practice, the deceased, symbolized by a wax mask worn by a person who resembled him, took part in his own funeral. These masks were preserved in a shrine in the house. The transformation of these likenesses into more durable materials would naturally permit the development of the portrait, especially under the influence of Hellenistic sculpture. The death mask influence is easily discerned in the *Head of a Man* (**66**) from Turin. The eyes remain sightless, every detail of the face is rendered in the marble, so that the work can be understood by no artistic model. The marble *Portrait Head* from Chieti (**67**) represents a qualitative leap in the trueness of its wrinkles and the tracks of age, although it is overall realized as a unitary form. The ruthless realism joins with the expression of pride and stubbornness, so some experts assert, to symbolize the innate Italian character.

While rigorous realism remains characteristic of portraits used in the tradition of the death mask, the portraits of rulers, like the portraits of affluent Roman citizens, are distinguished through some form of idealization. The posthumous *Portrait of Gaius Julius Caesar* (**68**) is characterized by a classical smoothing of the distinctive features, which expresses the subject's power and eminence. The irregularly arched skull, the throat covered with many folds of clothing,

and the strong Adam's apple leave—as the comparison with contemporary coins shows—no doubt of the identity of the subject.

. Women's portraits can be dated by hairstyle and other stylistic features. While the men's portraits—for instance, the high type of the Augustus portraits—can be identified solely by the "pincer and tendril style" of the forehead locks, the feminine counterparts show greater variation. The middle part as well as the crown of curls, among other things, of the *Head of a Roman Woman* (**69**) identify this as a portrait of Livia, the wife of Augustus, and therefore allows us to date it as ca. 20–30 A.D. The warm, organic look of the physiognomy emphasizes the lovely features. The hairstyle and the "Claudian mouth form" may not be purely realistic details, but rather mark the head's inclusion within the form of courtly portraits. That there are several versions of this sculpture indicates that Livia was much-honored in her time.

The marked display of curls around the face identifies the subject of *Portrait of a Roman Woman* (**70**) as Julia Titi, daughter of the Emperor Titus. She styled her hair into a diadem, which was an obligatory fashion for many ladies-in-waiting. This hairstyle remained in fashion from the Flavian to the Trajanic time. A toupee was used to create the curls that frame the face, while the remaining hair was woven and bound in a nest at the nape of the neck. Julia Titi's portrait is also an example of the somewhat welled-up eyes and highly arched eyebrows that are marks of private portraits which were eventually incorporated into official court portraits.

The reign of the *Emperor Hadrian* (117–138 A.D.) marked a particular stylistic change. Hadrian was the first Roman emperor to be

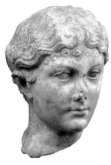

69 *Head of a Roman Woman*, 20–30 A.D. White marble, 11″ (27.5 cm) high. Antique Collection, Berlin.

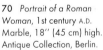

600 B.C. – 400 A.D.

70 *Portrait of a Roman Woman*, 1st century A.D. Marble, 18″ (45 cm) high. Antique Collection, Berlin.

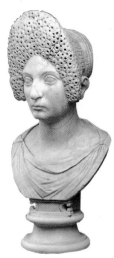

600 B.C. – 400 A.D.

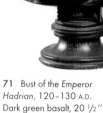

71 Bust of the *Emperor Hadrian*, 120–130 A.D. Dark green basalt, 20 ½'' (51 cm) high. Antique Collection, Berlin.

72 Bust of the *Emperor Caracalla*, 212–217 A.D. Marble, 23'' (58 cm) high. Antique Collection, Berlin.

represented with a curly beard (**71**) to show his worship of Greek culture. The emphasis in this bust on contentment and balance marks one of the many classical style phases of the Roman Empire. Realistic points such as the knitted eyebrows and the folds at the base of the nose, along with the philosophical expression, give his portrait the air of an imperator—a wise, powerful, but moderate leader.

The bust of the *Emperor Caracalla* in contrast was carved in stone as a warlike soldier-Caesar. The portraits of Caracalla are similarly innovative, since his portraits evidently rejected consciously idealizing beauty and moved brutality and animal intensity into the foreground (**72**). Caracalla, here seen grimly looking to the side, even had his own brother removed in order to maintain his authority. Animated by a hunger for world domination, like Alexander the Great, the emperor arose as early as his soldiers and hurried from battlefield to battlefield; as table companions he supposedly kept lions. Caracalla also wore a beard. His dramatic self-staged presence, however, corresponds with his restlessly up-welling sideburns as new stylistic elements, which gave Roman portrait sculpture new impulses.

The expressivity of the *Caracalla* portrait is not typical of portraits of its time, but first shows up consistently at mid-century, when the portraits of *Philip the Arabian* (**73**) or his successor *Trajanus Decius* (**74**) surface. An anxious, turbulent state of mind speaks from these images. Christianity had gained ground, and Decius wanted to turn back the wheel of history and revive the Roman religion.

At the beginning of the 4th century, a radical change occurred as sculptures were no

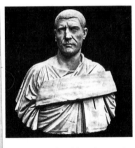 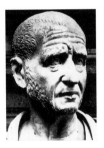

73 *Philip the Arabian* (left), 244–249 A.D. Vatican Museum, Rome.

74 *Trajanus Decius* (right), ca. 250 A.D. Capitol Museum, Rome.

longer marked by the multiple stylistic influences of Greek sculpture and Roman portrait tradition. Physiognomic particularities fused with abstract formulations, so that the lifelike realism that had characterized ancient sculpture was pushed into the background. The portrait of *Constantius Chlorus* (**75**) unites elements of expressivity such as the head turned to the side and the far-gazing eyes, with characteristic details such as the projecting chin, though all these elements are overshadowed by the angularity of the face with its barely modeled cheeks. In 293–306, Constantius Chlorus was part of the tetrarchy, where the Roman Empire was divided into east and west, and a separate leader (tetrarch) with his designated successor controlled each province.

The somewhat later colossal (8' high) portrait head of *Constantine the Great* (**76**) confirms the tendency to abstract standardization of the features—the emphasis on symmetry, and the transfixed eyes. As ruler over the eastern and western Roman Empire, Constantine guaranteed Christians equal rights to worship. For sculpture, which for the following 500 years continued to consist of reliefs or small pieces, new purposes and forms emerged with the early Christian and Byzantine art, which broke completely with the ancient three-dimensional sculpture.

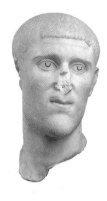

75 Portrait of *Constantius Chlorus*, early 4th century. Marble, 15" (38 cm) high. Antique Collection, Berlin.

76 Portrait of *Constantine the Great*, ca. 330 A.D. Bronze, 74" (185 cm) high. Palace Conservatory, Rome.

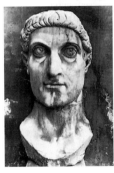

300	Monumental Mayan buildings Uaxatan, Tikal
330	Constantine the Great proclaims Christianity the official religion of the Roman Empire
340	Double Roman Empire: Western Rome, with its capital at Rome, and Eastern Rome, with its capital at Byzantium
356	The Franks conquer Roman forts on the Rhine: Xanten, Cologne, Bonn, Andernach
360	Beginning of the golden age of Indian sculpture
395	Augustine becomes bishop of North Africa
452	Venice founded by inlanders fleeing Attila the Hun
522	Oldest Chinese pagoda still standing today
534	Justinian Law: *Corpus iuris civilis*
620	First authenticated porcelain ceramic
711	The Arabs free Spanish Jews from persecution by the Goths, bringing about a blossoming of Jewish culture
795	The Normans penetrate into Ireland, whose cloister schools have been centers of European learning since the 6th century

300 – 800

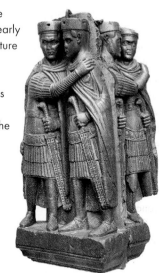

Hardly anyone can name an early Christian sculpture without some hesitation; the period that falls between late Antiquity and the early Christian era is most closely associated with Byzantine mosaics. Examples of sculpture from this period are in fact scarce. The fully formed statue that was characteristic of

77 *Porphyry Group of the Tetrarchy, ca. 300 A.D. Southern façade of St. Mark's Cathedral, Venice.*

the classic Antique disappears and is replaced chiefly by small transportable sculptures and ivory reliefs.

Even though no outstanding sculptural innovations would be recorded for the 500 years following the accession of Constantine the Great and the shifting of the capital of the Roman Empire to Byzantium (now Istanbul) in 330, the exceptionally represented sarcophagus reliefs and ivory carvings that survive from this half a millenium form a bridge in our understanding of the later development of sculpture. Christian scenes first appear using the ancient formal vocabulary: Christian figure types including the crucifix and the Madonna are recognizable in early attempts.

How did the motif of the dying Christ on the cross win acceptance? Which historical religious circumstances favored a portrait motif, which still appeals to artists today—though under other

circumstances? The explanations lie in the early Christian era.

Nevertheless, the roots of the early Christian sculpture touch upon the nonclassical portrait understanding of later Antiquity, for which the juxtaposition of styles also marked the receding importance of the stiff, frontally oriented figure. Historians invoke influences from Asia and other eastern lands to explain this phenomenon, but no doubt these trends were also strengthened by "subantique" currents, local plebeian traditions, which were absorbed by the ancient form canon.

One of the few preserved examples is found embedded in the outer wall of the Cathedral of St. Mark in Venice. The *Porphyry Group of the Tetrarchy* (**77**) shows Diocletian and Maximian with their corulers Galerius and Constantius Chlorus in the formal canon from around 300 A.D. On one hand this quartet reaches back to the imperial statue tradition of dark red porphyry, which comes only from Egypt. On the other hand, freestanding rounded sculpture is abandoned. All four figures are closely huddled together, rigidly knit together and attached, which may indicate political unity. Their garments, moreover, are no longer the fluidly draped robes of the earlier sovereigns, but are angular and cleanly cut.

This work, conceived to have a public effect, stands in striking contrast to a small sculpture, which, of course, illustrates a Christian theme but uses Hellenistic forms. *Jonah Cast Up* (**78**) (and its companion piece, *Jonah Swallowed*) is one of four marble groups that tell the story of the sea adventures of the prophet Jonah. This particular sculpture, dated from the second half of the 3rd century, takes as its subject a

300 – 800

78 *Jonah Cast Up.* Marble, 16 x 7 x 15" (40.6 x 21.6 x 37.6 cm). Eastern Mediterranean region, probably Asia Minor; early Christian, ca. 260–275 A.D. The Cleveland Museum of Art, Cleveland, Ohio, 1995, Johns L. Severance Fund, 65.238.

300 – 800

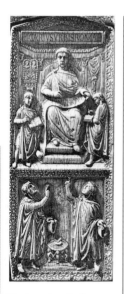

79 Ivory diptych of *Probianus*, ca. 400. Berlin, National Library.

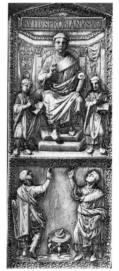

popular early Christian theme, but its antique formalism suggests that it must have been made for a member of the Roman aristocracy.

Christian imagery and ancient concepts of form are similarly mixed in sarcophagus friezes, one of the few true formal inventions of early Christian style. To be able to show as many possible events from the life of Christ, the stonemasons divided the sides of the sarcophagus into two horizontal bands. From the 4th century we see staggered, plane-bound figures pliably modeled to represent scenes to be viewed, and "read," together.

This classic phase of early Christian art culminates in the sarcophagus of the *Two Brothers* (**80**) from the Roman Church of San Paolo di fuori di mura, in which, for example, the nonchalant posture of "Daniel in the Lion's Den" looks more like an ancient Ephesian than like a believer hoping for salvation. The same tendency is apparent on the sarcophagus of *Junius Bassus* (**82**), in which each episode from the Old and the New Testa-

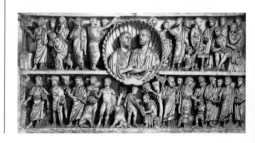

80 Sarcophagus of the *Two Brothers,* ca. 330– 350. Museo Pio Christiano, Vatican, Rome.

ment has its own niche inside a framework of decorated columns. Bassus died in 359 as Roman city prefect. This work of Constantinian classicism also reflects the taste of the Roman aristocracy.

81 Ivory diptych *Priestesses Performing Pagan Rites*, ca. 400. Left panel: Museé Cluny, Paris; right panel: Victoria and Albert Museum, London.

The influence on art of the powerful Roman families stemmed not only from their enforcement of their aesthetics, but from a focus on reviving of old rites. On each upper wing of an ivory diptych on pagan themes (**81**), the name of a leading family is engraved: "Nicomachi" and "Symmachi." The lively priestesses presented in their intricately modeled robes appear on a picture panel, which was thought originally to have served as a notice of the authority of annually installed consuls. The hinged tablets were carried to the farthest provinces of the empire. Accordingly, Probianus presents himself powerfully head-on in his ivory diptych (**79**).

The honored personage, thus, was in principle represented twice. The ivory diptych, long re-

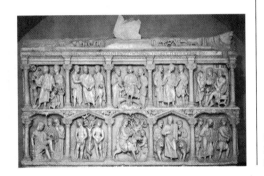

82 Sarcophagus of *Junius Bassus*, ca. 359 A.D. Vatican Museum, Rome.

45

corded under the title *Christ and the Mother of God* (**83**), shows Christ on the left as a somewhat carnal figure with bloated face and round stomach, and on the right as the divinely born Savior in His mother's lap. The gesture and position of both Christ figures are the same, while the architecture in the background is also identical.

For a long time previously, this contrast was understood as a sign of a particular worship of

83 Ivory diptych *Christ and the Mother of God*, 546–556 A.D. 12 x 5″ (29 x 13/12.7 cm). Sculpture Gallery, State Museum, Berlin.

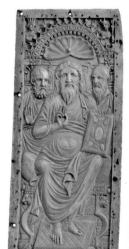
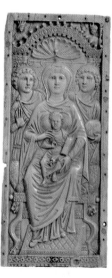

the Madonna, who had been strengthened by the council of Ephesus in 431. The meaning of this diptych, however, is more likely grounded in the dogma of the dual nature of Christ: the question raised by the Council of Chalkedon in 451—whether Christ is a person or God, or both at once. Up to this time, the display of the crucifixion was only conceivable in connection with the resurrection, but the dual-nature doctrine enabled the isolated depiction of the crucified.

The prelate of Cologne and dean of the Cathedral Alexander Schnütgen (1843–1918) acquired the oldest known crucifix in the fine art

trade. Dated to ca. 600 by reason of its ancient body structure, this small sculpture (**84**) shows Christ peacefully passed away in the full-bodied depiction seen previously on the ivory tablet. The display transfigures the death by torture, which in its gruesome cruelty first became interesting for the Gothic period. The death on the cross promises the believer a life after death and possibly substantiates, according to Church Father Augustine, the source of the church: "But where did he die? On the cross. There on the cross he died, he accomplished something symbolic, or rather, he fulfilled it, which in Adam was symbolized. For as Adam slept, his rib was taken and given to Eve. So the Lord, when he died on the cross with his side pierced by the lance and the sacraments flowing out, founded the Church."

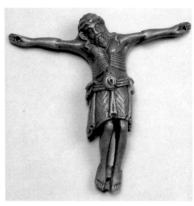

84 Bronze crucifix, ca. 600 A.D. 6 x 6 ¼″ (14.5 x 15.5 cm). Schnütgen Museum, Cologne.

300 – 800

Recent research has uncovered a further example of early Christian sculpture: the crucifix from the Gotthard Chapel of the Mainz Cathedral had previously been attributed to the 12th century, but carbon–14 dating has revealed that it originated between 610 and 780. The life-size crucifix bears the same stylistic characteristics as the example we have seen from the Schnütgen Museum.

Although one would have expected Christian sculpture to be fairly common during the Byzantine Empire, in the conflict of the year 726 over how the form of Christ ought to be represented, almost all works were destroyed. The East subsequently developed the tradition of icon painting, while the image of the crucifix became established in Western education after 800. In the Romanesque art of the early Middle Ages, the departure from classical views of form finally prevailed, as originally begun in the late Antique.

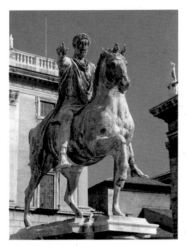

85 *Marcus Aurelius*

Since antiquity, sovereigns have felt it fitting to be immortalized on horseback. This particular form of monument symbolizes military or political power. Even outstanding artists such as Donatello, Verrocchio, Leonardo da Vinci, and Bernini did not scorn commissions for equestrian statues, but evidently felt honored to give contemporary meaning to a monument. In the 19th century, the overproduction of equestrian statues rather diluted the artistic value of the form, but in the Renaissance, stylistic changes and artistic thinking were still manifest in the equestrian statue.

No equestrian statues from Greece are preserved, although they have been prominently mentioned in written sources as a common type of statue. The earliest preserved and therefore most influen-

tial work of this kind is the Roman emperor *Marcus Aurelius* (**85**), which has since antiquity looked out from the Capitol in Rome. The emperor, riding *all'antica*, without a saddle, is seen without armor on a powerfully striding horse. Then, around 200 A.D., twenty-three such statues supposedly stood in Rome. Up to the Middle Ages, the noble horse remained the attribute of the emperor, the king, the nobleman. The *Bamberger Horseman* or the bronze statue of Charlemagne are among the few sculptural examples that are known from that time. Around the year 1400, the figure of the commander becomes prominent in this squad of the richly famous. In the Italian Trecento, this type of statue was common, especially in combination with tomb sculptures, and also began to appear in fresco paintings. The panoramic portrait of Simone Martini in the Palazzo Publico in Siena is a good example.

With Donatello's *Gattamelata* ("spotted cat," **86**) on the plaza in front of the Church of San Antonio in Padua, the form takes on a new meaning. The shrewd commander, known as a great warrior, wanted a modest monument inside the church; his heirs, however, wanted him depicted as a king in a glorious outdoor sculpture, which required the consent of the Venetian signoria. Donatello oriented his sculpture toward the *Marcus Aurelius* and the Antique: the

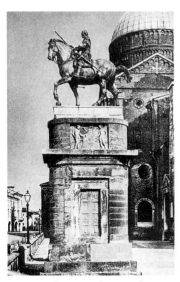

86 Donatello, *Gattamelata*, overall view with pedestal.

costume is a mixture of contemporary and ancient costume, the emphasis on the physiognomy of the head refers back to the late Roman Empire portrait style, horse and horsemen form an integrated whole. The statue is at a distance from the façade of the church, but its raised pedestal with gleaming doors is clearly reminiscent of the

87 Plaza of the *Colleoni*, etching after Canaletto, 1742.

Italian tradition of the equestrian statue as monument, which may be traced back to the Roman sarcophagus.

A short time later, another Florentine, Andrea del Verrocchio, created the equestrian statue of *Colleoni* (88) next to the Church of Saints Giovanni i Paolo in Venice. The "condottiere" had wished himself memorialized in a famous column in the Plaza of St. Mark and provided the money for it. The Venetians moved the monument to a slightly less central, but by no means insignificant location. Verrocchio

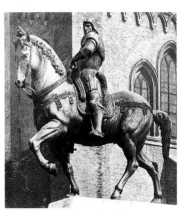

88 Andrea del Verrocchio, *Equestrian Monument of Bartolemmeo Colleoni*, Venice.

first created a clay model of the horse. Giorgio Vasari, the first to write extensive and systematic biographies of artists, reports that, because of the delay in the statue's completion, a Paduan sculptor was assigned to complete the horseman instead of Verrocchio. Verrocchio

thereupon cut off the horse's legs and head, and traveled back to Florence in anger. Only when his contract was honored did he complete the work. The presentation of the commander standing proudly in his stirrups wearing contemporary armor no longer functions as a memorial, and this marks Verrocchio's statue as the earliest European monument erected exclusively to glorify the deeds of the subject.

Aside from the equestrian statues modeled after the *Marcus Aurelius*, in all of which the trotting horse always has one raised foreleg, Leonardo da Vinci introduced a second type that subsequently inspired not only Gian Lorenzo Bernini but also such painters as Peter Paul Rubens.

After his apprenticeship with Verrocchio in Florence, Leonardo worked independently from 1471 to 1472. Some time later he applied in Milan to Lodovico il Moro to erect a statue for his father, Francesco Sforza. In fact, in 1489 Leonardo secured a commission for a colossal equestrian statue 24 feet (7.20 meters) high, though the statue was never actually executed. The ore for the statue was needed to manufacture cannons and guns. In 1499, Marshal Gian Giacomo Trivulzio drove Lodovico out of Milan, with the ironic result that in 1506 Leonardo was again entrusted in Milan with a life-size bronze statue in honor of the new hero.

This work was also never executed; all that was produced was an estimate of the cost, together with Leonardo's plans and contracts.

In his own notes, Leonardo never mentions a concrete project, but speaks of "the horse." Leonardo, who is supposed to have loved horses, shifted the emphasis of the display from the horseman to the immenseness and expressivity of the animal. He had already used the motif of the rearing horse in 1481–82 in the unfinished painting *Adoration of the Kings*, which hangs today in the Uffizi Gallery. Several examples are also found in the bundles of his drawings preserved in the Royal Library in Windsor. For bronze casting, the figure of a horse standing on its hind legs presents a technical problem. In the drawings

89 Leonardo da Vinci, pen-and-ink drawing, 1506/10. Windsor No. 12355.

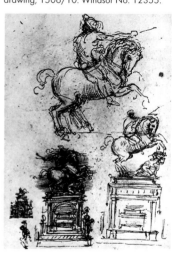

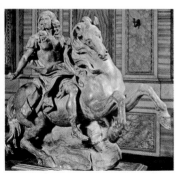

90 Bernini, *Bozzetto for the Equestrian Statue of Ludwig XIV*, ca. 1670. Terra cotta. Galleria Borghese, Rome.

In the Roman high baroque, Leonardo's work gained new popularity. Bernini, in his *Equestrian Statue of Ludwig XIV* (90), harked back to Leonardo's rearing horse, as did Falconet in his monument for the Russian tsar, Peter I. For most baroque representational purposes, however, the trotting horse prevailed.

92 Andrea del Castagno, *Niccolò da Tolentino*, 1456. Fresco. Florence Cathedral.

for the Trivulizo monument, Leonardo had set a fallen warrior under the horse's front hooves, which balances the monument.

A small bronze attributed to Leonardo (91) posed another solution to the problem: The heavily baroque group dates to the period when Leonardo created the mural *Battle of Anghiari* in the Hall of the Five Hundred in the Palazzo Vecchio in Florence, where he used the same motif.

91 Leonardo da Vinci, *Bronze Statuette*, ca. 1506. 9 ½" (24 cm) high. Art Museum, Budapest.

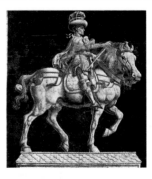

bozzetto: from the Italian *bozza*, "rough working out, sketch, first artistic draft." Since the Renaissance, sculptural drafts in different materials (clay, wax, stucco, and others) have been known as *bozzetti*. They can represent different stages of completion. Since the bozzetto shows the master sculptor's first artistic idea, it is often valued more than the final work, which was usually realized in cooperation with helpers. During the Baroque, the prime of the bozzetto, whole collections of bozzetti emerged. In Germany they first became common in the 18th century, at the time of Gottfried Schadow.

800 Coronation of Emperor Charlemagne in Rome

814 Death of Charlemagne

973–983 Otto II; Ottonian renaissance; height of the convent schools in St. Gallen, Reichenau, Hersfeld, Fulda, and Corvey

1001 Clunian reform movement: poverty and piety become standard vows; flowering of scholarship

1050 Sophia Cathedral of the Kremlin in Novgorod

1054 Final separation of the Greek and Roman Catholic churches

1066 William the Conquerer comes to the British isles

1096–99 First crusade

ca. 1120 Development of the guild system

1142 Death of the scholar Abelard, who had been castrated because he fell in love with his student Heloise

1201 First evidence of the Inca culture in Peru

1215 English barons force King John to sign the Magna Charta, a first constitution, in which their rights are set down in writing

1225 Thomas Aquinas, Italian scholar, enters the Dominican order

1270 Jacobus of Voragine, *Legenda aurea*, the first collection of holy myths

800 – 1500

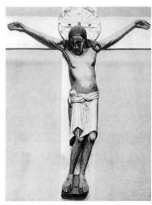

93 *Crucifix* of the Archbishop Gero, ca. 980, Cologne. Wooden, colorfully painted. Body height: 75″ (187 cm). Cologne Cathedral.

Romanesque

The term "Romanesque" is used by art historians as an expedient way to distinguish the art emanating from Rome (and the area comprising the Roman Empire) from the art that preceded it and the Gothic art that would follow. In general, the term is applied to the art of the 11th and 12th centuries.

For the most part, only wooden Roman crucifixes placed over the high altar have survived the centuries of modernizations that have elapsed, much less the destruction of churches. For a millenium these crucifixes have embodied the Christian religion. In Cologne Cathedral in Germany, a painted wooden crucifix is set up in a niche to the left of the altar, visible to everyone in a baroque setting. The life-size *Crucifix* of the Archbishop Gero (**93**) is the oldest surviving Roman monumental work of this type. As in the early Christ on the cross representations described in the preceding chapter, in this crucifix Christ's stomach unmistakably arches out, and the motif of grief remains only implied, with the drooping mouth wrinkles looming over the heavily hanging body.

Another type of the crucified Christ is the image of the Savior (**94**) dressed in a long tunic. The composition of the crucifix and the shift from a three-nail image to a four-nail type represent only one basic pattern of Romanesque sculpture.

The Romanesque is not just from Rome: it includes the Ottonian era, with centers in Magdeburg and Hildesheim, which concentrates on objects made of bronze, gold, ivory, or wood; it also includes the statues of the Roman churches in northern Spain and France, which concentrate on stone reliefs that are fused with the architecture. The intersecting epochs reflect specific functions of art. The Ottonian sculpture, produced on command from the king or a bishop, was a symbol not only of Christian redemption, but also of worldly force and refined artistic taste. The figures on the capitals and doors of the churches of France served to admonish and to edify wandering pilgrims, who may have passed on their way from Santiago to the grave of St. Jacobus, through the crossed paths, stopping at the churches of the convents as waystations on their pilgrimage.

Art historian Hans Jantzen has described the Ottonian era as the origin of the Christian occident and as the first German national style (cf. p. 35). He also called it the spiritual basis of the entire Romanesque period. The Christian state, the fusion of worldly and more spiritual power, saw itself as God's kingdom on earth, circumscribed by the tasks of the mission and by the spiritual quest. Jantzen describes the background of the images used in Christian teaching: "Christ is a powerful hero and victor, whose life and miracles are the promise for the overcoming of all evils. Through the relics of the martyrs he works miracles." The Christians honored the belief in miracles just as they honored dreams and fantastical ideas. And the martyrs, as blood testaments of Christ, were imbued with an immense political and religious meaning.

In this way we can understand the splendid design of the oldest preserved sculpture of a saint, the reliquary statue of *St. Fides* (**95**) from Conques. The gilded silver wooden statue

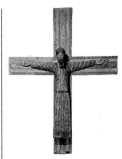

94 *Crucifix*, 12th century, northern Spain. Wooden, colorfully painted, 37" (92 cm) high. Museum of the Arts of Cataluña, Barcelona.

800 – 1500

95 Reliquary statue of *St. Fides*, 9th/10th century. Gold and gilded silver over wood, enamel, pearls, precious and semiprecious stones, 34" (85 cm) high. The Abbey of Conques-en-Ronergue.

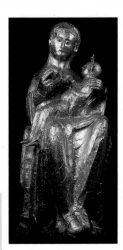

96 *Golden Madonna*, Cologne, ca. 980. Gold over wood, gilded enamel and jewels, 27'' (74 cm) high. Cathedral collection, Essen.

800 – 1500

97 *Madonna of Bishop Imad*, 1051–76. Wooden, 49'' (122 cm) high. Diocesan Museum, Paderborn.

adorned with jewels was created in the 9th or 10th century for the skull reliquary of the saint. The sculpture restores wholeness and corporeality to the bone, which is in itself insignificant; it gives the honored object a context and a meaning.

The purpose of the reliquary statue of the *Golden Madonna* (96), which is also worked over a wooden base, can be understood by its secret compartment for the dedicated host. This Madonna, erected in the Essen Cathedral in the 10th century, launches a new type of statuary. She stands at the beginning of all sculptural images of Mary, still comprehended here as a descendant of Eve, who extends an apple directly to the Christ child. Jantzen saw in this figure a new independence from ancient models. The antique definition of sculpture was broadened with a new dimension: "The expressive intent of this art aims at the invisible, the unknowable, not the circumscribed. The figure wrapped in gold is not merely trying for an artistic effect of physicality."

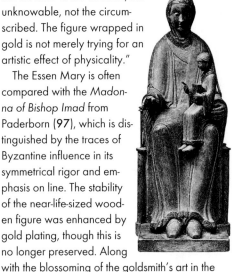

The Essen Mary is often compared with the *Madonna of Bishop Imad* from Paderborn (97), which is distinguished by the traces of Byzantine influence in its symmetrical rigor and emphasis on line. The stability of the near-life-sized wooden figure was enhanced by gold plating, though this is no longer preserved. Along with the blossoming of the goldsmith's art in the Ottonian era, the production of cast bronzes becomes of central importance. During the building of the Church of St. Michael, the world-traveling Bishop Bernward commissioned several

monumental exterior bronzes, which may be seen today, however, inside the cathedral. The nearly 13 ¹/₂′ (4 m) high *Bernward Column* (**98**) was designed as a substructure for a cross. The relief, which coils in an endless band around the column with depictions of the life of Jesus, harks back to Roman triumphal columns (such as those of Trajan and of Marcus Aurelius). The partitioned *Bernward Doors* (**99**) also derive from Italian models. The representation of the pictorial message, however, which contains the kernel of the religio-historical ideas, is unique.

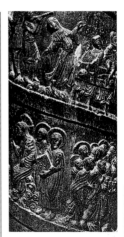

98 *Bernward Column,* 1015–22, Hildesheim. Bronze, 12 ¹/₂′ (379 cm) high. Hildesheim Cathedral.

800 – 1500

The drama of the fall of man is reflected in the body language of the figures. Thus, when Adam and Eve are expelled from the Garden of Eden, according to Jantzen, Eve turns back "with an indescribable demeanor of care, doubts, pensiveness, fear and despairing." Jantzen finds expressionistic trends in the high relief: "Not [in] the bodily forms, which at first stand in themselves as wholes of sculptural presentation, but [in] the richness of gesture and bearing, accurate mimicry."

The "bronze miniatures" refer back

99 *Bernward Door,* 1015, Hildesheim. Bronze, 7 ¹/₂′ (228 cm) high. Hildesheim Cathedral.

TORUMIPSIUS·ADIACIIN DUMIA:

DIIINDAMUOCIMSIRMO NUMIIUS

BIINDICANIMAMIADNO

CIII IPSIOAUIO
Benedicanima
MIADNO DNIDIMIUS
MAGNIFICAIUSISUIHE

PIRIINNASUINTORUM
QUIFACISANGILOSIUOSSIS

A BINCRIIATIONITUAFUGI
INT· AUOCITONITRUITUI

800 – 1500

100 *Utrecht Psalter*, ca. 830, Reimser School. Whole figured pen-and-ink drawings to Psalm I, organized after an ancient model in three columns, taken from framed area, summarizing individual passages, diagonally formatted overviews. University Library, Utrecht.

to illustrations in Carolingian manuscripts. The most famous example, which today appears especially modern in its expression, must be the *Utrecht Psalter* (**100**), which is known to date back to at least 830 in the Reimser School.

Modern interest in the Romanesque awakened toward the end of the 19th century, just as Paul Gauguin was inspiring and spreading interest in the primitive art of the South Seas and Pablo Picasso, among others, was first showing an appreciation for African sculpture. In 1923 the art historian A. K. Porter published a ten-part work on Roman sculpture in which he called for the establishment of a discipline of artistic geography. Porter's attempts to convince Americans of the signs of nationalism in the Romans were ineffectual, as were similar efforts from Jantzen and French historian Emile Mâle in the aftermath of World War I.

On the figured column capital, which emerged with the Christian art of the 11th century and disappeared with the rise of the Gothic period, biblical stories appeared in more symbolically expressive forms; these were understood at the time by everyone. The motif of the centaur hunting a deer (**101**), here observed on a capital from St. Aignan-sur-Cher, combines ancient and

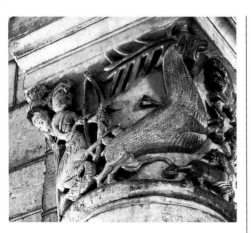

101 Figured capital, *Deer Hit by a Centaur's Arrow.* St. Aignan-sur-Cher, Loire-et-Cher.

800 – 1500

Christian symbols: the centaur pursuing the deer is the persecutor oppressing the religious neophyte, who hopes to escape the arrow of lust.

A tremendous surge in construction accompanied the mass pilgrimage organized by the Cluny Monastery to the grave of St. Jacobus in Santiago der Compostela in northern Spain. Along the four routes through France many convents sprang up, with increasingly refined architecture. Local schools developed different styles. Thus, the capital dating back to before 1029 in Orléans (**102**), ringed by two beasts and a naked man with his head in his hands, holds up well in comparison with the expressionistic works from the formal languages of the 11th-century capital from Saint-Benoît-sur-Loire (**103**), which were influenced by small art forms such as ivory reliefs.

Thorsten Droste, an art historian who has studied Romanesque art extensively, has noticed that, with the help of the figured capitals, the church interiors appeared to break away from the defining characteristic of regularity: "The weight-bearing block disappears behind a multitude by ornamental and figura-

102 Figured capital, before 1029. Crypt of Saint-Aignan, Orléans.

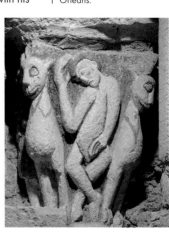

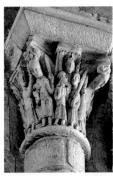

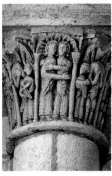

103 Figured capitals, second half of the 11th century, Saint-Benoît-sur-Loire.

tive decorative motifs, so that this component loses its static building function and appears extraneous to the structure." Droste stresses that Romanesque sculpture is always interlocked with the architecture, with smaller-than-life figures always in relief.

The portal, or front entrance of the church, offered more room for the depiction of Christian teaching. At the gate to another world, the church as embodiment of God's kingdom on earth, Christ sits enthroned as Lord of the Earth, surrounded by the evangelists, apostles, and fantastical creatures of hell. On the left we see a representation of evil, on the right one of good. One of the most outstanding examples may be found at the tympanum of the *Southern Doors* of the monastery church of Moissac (**104**). The program corresponds to the text of *Revelation 4*: "At once I was in the Spirit, and lo, a throne stood in heaven, with one seated on the throne. And he who sat there appeared like jasper and carnelian, and round the throne was a rainbow that looked like an emerald. Round the throne were twenty-four thrones, and seated on the thrones were twenty-four elders, clad in white garments, with golden crowns upon their heads ... and before the throne burn seven torches of fire, which are the seven spirits of God; and before the throne there is as it were a sea of glass, like crystal./And round the throne, on each side of the throne, are four living creatures, full of eyes in front and behind: the first living creature like a lion, the second living creature like an ox, the third living creature with the face of a man, and the fourth living creature like a flying eagle." The relief shows a supernatural, visionary phenomenon: Christ is seated on a throne in the Mandorla with the sealed book in His hand. Each of the twenty-four elders is depicted differently and a powerful movement sweeps through the artistic space.

800 – 1500

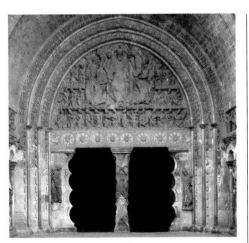

104 Tympanum of the *Southern Doors, St. Pierre,* Moissac, ca. 1120. Shows scenes from the apocalyptic return of Christ.

800 – 1500

The Gothic

"The Gothic is overall tasteless extragavance in works of art, in which the creators violated not the essential, nor always matters of greatness and splendor, but certainly the beautiful, the agree-able, and the fine," Johann G. Sulzer wrote con-temptuously in his *Theory of the Beautiful Arts* in 1771. Since the 16th century common knowl-edge seems to hold fast to an historical impression that the centuries between shining antiquity and the all-consuming Renaissance constitute the trough of the dismal Middle Ages. The word "gothic" was considered synonymous with "bar-baric." Even thinkers such as Goethe adhered to this humanistic historical understanding—that is, until he took a good look at the Strasbourg Cathedral, after reading about it in another crit-ique dating from 1771, *Of German Architecture.*

It was for the romantics of the 19th century to rediscover the "Past of their Fatherland." In 1797, a volume entitled *Outpourings from the Heart of an Art-loving Monk* appeared; in it, Wilhelm H. Wackenroder found true art "not only under Ital-ian heaven" but also "under peaked and arched, heavily ornamented buildings and Gothic towers."

800 – 1500

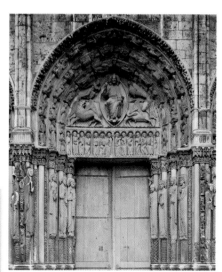

105 Tympanum of the *Royal Portal at Chartres Cathedral*, 1145–55. Christ as Lord of the World, surrounded by the 24 elders.

106 *Prophet, Patriach, and Queen* from the left jamb of the middle doors of Chartres.

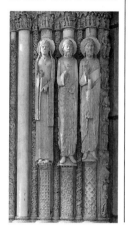

France

Sculpture was rare in the interiors of French Gothic cathedrals, but figures were common on the façade, the doors, the towers, and the roofs. Gothic sculpture essentially was born in 1135–45 with the construction of the *Royal Portal of Chartres Cathedral* (105). On the tympanum of the middle doors, Christ sits on a throne as Lord of the World, as in the Moissac example, surrounded by the twenty-four elders. This theme, the apocalyptic vision of the Second Coming of Christ, was actually current. The view of the old men, however, is different: they attend Christ unmoved, as if from the boxes of a theater. And, of course, as Willibald Sauerländer notices, they are "not beside themselves in ecstacy, but attentive spectators, fulfilled by dignified worship." Sauerländer sees the Christian drama as "subdued and recast as a heraldic symbol."

This observation is consistent with the developing early scholarship at the end of the 11th century. Medieval rationalists such as Anselm of Canterbury or Abelard held the view that belief must be carried through the faculty of reason. The Gothic stylized figuration actually corresponds to an increasing regulation of the affects, readable in the codified gesture and the formal conduct of the people carved on the portals.

The figures from the left jamb of the middle door of Chartres (106), probably Old Testament kings, queens, and prophets, can no longer be definitely identified, but refer back to models of the monastery church of Saint-Denis (107). The lifelike faces and the contemporary courtly clothes of the queen

with the long braids stands in complete contrast to the mechanical (for that time), equally angled raised forearms of the adjacent figure, just as in the vertically elongated figures. This, along with the visibly nascent carved-out posterior bodies, feigns the quality of a free-standing sculpture, though they are clearly not conceivable without their architectural connection. In the figures built fifty years later on the transept portals, Sauerländer observed more natural proportions. He interpreted this as the beginning of a natural school, marked by the fact that the stonemasons now had access to the Canon of Polykleitos (see p. 30).

The Antique appears to be the measure of all things, not only for art historians, who have plumbed the depths of the matter, but for the sculptors as well. The artists who sculpted the *Visitation* Madonna, on the jamb of the west façade of the Cathedral of Reims (**108**), must have educated themselves in the styles of the Antique by means of surviving manuscripts. In comparison with the *Annunciation* Madonna (**109**), whose robes hang down in long, static folds, the *Visitation's* hip pushes forward, giving her form more movement and making her clearly more interesting than her counterpart. The motif of the "Belle Madonna" found throughout Europe achieved great popularity in the 12th century. The standing *Vierge dorée* with the child on the arm (**110**) traces its roots back to Byzantine models. This figure from the southern portal of the Cathedral of Notre Dame in Amiens convinces through the bold swing of the cloak drapery, whose S-shaped flourishes anticipate the Madonna styles of the 16th century.

107 Old Testament figures from the door of the Abbey Church of Saint-Denis. Engraving from the *Monuments of the French Monarchy* by Montfaucon after the statues, removed in 1771.

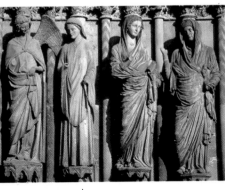

108, 109 *Visitation* and *Annunciation*: Western door of Reims Cathedral; Mary and Elizabeth (on the right) are presented in an Antique-influenced style, the Virgin in the *Annunciation* scene (second from the left) refers to a figure in Amiens. Before 1260–74, when the façade was completed.

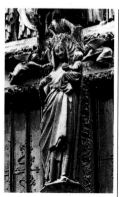

110 *Vierge dorée.* Formerly gilded panel of the southern doors, not before 1250. Cathedral of Notre Dame, Amiens.

800 – 1500

111 *Visitation:* Mary (left), second pillar of the north side of Bamberger Cathedral, 1225–37.
112 *Visitation:* Elizabeth (right), second pillar of the north side of Bamberger Cathedral, 1225–37.

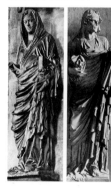

Germany

The German stonemasons worked with completely different requirements: the mostly Roman-style churches hardly offered space for costly programmatic figures. A good hundred years after the Royal Portal was built at Chartres, sculpture attained independence from architecture. Though the Bamberger *Mary* (111) certainly bears reference to its counterpart at Reims, the Visitation appears more animated, Mary becomes part of the scene. The figures of Mary and Elizabeth were designed for two adjacent pillars so that it was not possible to construct a closed group. Each figure had to stand on its own. The Bamberger *Elizabeth* (112) was conceived, thus, as a seer, who at the moment of her encounter with the pregnant Mary has a vision of the mystery of the incarnation and salvation.

Hardly a word has been lost up to now over the medieval symbolism of the figure systems of the cathedrals. While in the cathedral sculpture of France, the Last Judgment developed into a diverging hierarchy, the sculptors working in Germany strove increasingly to sharpen their delineation of individual characteristics. The figures of *Ecclesia* (113) and the *Synagogue* (114)—up to now only minor characters in the stonemason's symbology—in the Strasbourg Cathedral, placed in an exposed position on the south portal, symbolize the conciliation of Christians and Jews in the sense expressed in the Song of Solomon. Not only has the appearance of the object changed, but the theme has as well. The statues in Bamberg, Magdeburg, Strasbourg, and Mainz were commissioned by bishops in order of their political rank among the party of the emperor. The equality of the royal pair with Adam and Eve, for example, is grounded in the imperial theology of the Staufers.

Around the middle of the 13th century, the middle class took over the role previously confined to the Church and secular authorities. The fa-

çade of Strasbourg Cathedral reflects the ironic treatment of the courtly ideal, which was the fashion in France. The *Lord of the World* (115) appears from the front as a smooth, beautiful youth, but his back reveals the gnawing of worms, a symbol of his vices. The time of the Inquisition, the Schism, and the virulent plage that swept through Europe led to a fundamental change in what was deemed worthy of representation: in the Tirolean *Pietà* (116) what was once depicted as the girlish mother has become a matron sunk in pain; the innocently playing Savior has become a dreadfully distorted corpse. Sorrow and frailty, once identified with the pious, belong from now on to the display of Christian figures.

113, 114 *Ecclesia* (left) and *Synagogue* (right), ca. 1235. Strasbourg Cathedral.

800 – 1500

The trends toward portraiture, which in the work of the extended Parler family (117) became typical in 14th-century German sculpture, had already emerged during the rule of the Staufers in the choir respond figures of Naumburg Cathedral (118). The presentation of worldly personalities in the choir of a church was until that time considered unorthodox. The programmatic sculpture with the military governors Ekkehard and Hermann along with their wives Uta and Reglindis first put their seal on the Zeitzer capital overhanging the right cathedral in 1230. The demonstration of political power clearly motivated artistic execution for the "Naumburg Masters." These statues are notable not only for their contemporary robes, but for their impressive psychological portraiture as well. Although the

115 *Lord of the World*, from the western façade the Strasbourg Cathedral, late 13th century. 5 ½′ (170 cm) high. Today in the Notre Dame Museum, Strasbourg.

116 *Pietà*, Tyrol. Late 14th century. Alder wood, 31 ½″ (79 cm) high. Suermondt-Ludwig-Museum, Aix-La-Chapelles.

800 – 1500

117 *Anna von Schweidnitz,*
ca. 1385. Parler Workshop.
Stone. Triforium of the
Veitsdom, Prague.

118 *Ekkehard and Uta,*
ca. 1250. Sandstone, 6 ¼'
(186 cm) high. West choir of
St. Peter and Paul, Naumburg.
119 Nicola Pisano (ca.
1225-84), Crucifixion of
Christ, chancel, 1266-68.
Marble. Siena Cathedral.

figures stand together like free statues, they are
joined by the pillar that looms behind them and
form part of the supporting structure for the arch.

Italy

While the minnesang, a German tradition of
courtly song, and the cathedrals of the German
emperor in Worms, Mainz, and Speyer demon-
strated the general blossoming of culture under
the Staufers, Italy also migrated toward a renewal
of Antique formalism. Under Frederick II von Ho-
henstaufen (1212–50), the emphasis of the em-
pire shifted toward the south. Science and philo-
sophy gained a new appreciation at his Castel
del Monte. Nicola Pisano, the first Italian sculptor
with an individual figure style, is believed to have
been a court guest of the open-minded sovereign.

Nicola created the two famous chancels of the
Pisa baptismal font and the Siena Cathedral. If
Roman sarcophagi, early Christian ivory reliefs,
and the sculpture of the transalpine Gothic were
invested with the artistic language of their respec-
tive ages, Nicola supplied a fruitful basis for Tus-
can sculpture, which climbed to masterful heights
in the Quattrocento and Cinquecento. His *Crucifix-
ion* relief in the Sienese chancel (119), created in
1266–68, demonstrates a softening of forms, as
well as a relaxed harmony of space and rhythm.
His earnest figures show an Antique *gravitas*.

Under the commission for the completion of the
chancel from Fra Melano, the administrator of the
Sienese cathedral building works,
Nicola not only decided how and
where to acquire the marble, the
financing, and the schedule, but also
arranged for the employment of his
pupils, among them Arnolfo di Cam-
bio and Nicola's own son Giovanni
Pisano. From an anonymous stone-
mason, Nicola became an entre-

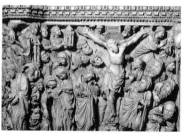

preneur. The aspiring Tuscan city-states, especially after the death of Frederick II and in the face of the expanding disputes between empire and church, kept the best for themselves. Nicola worked not only in Siena, but at the same time in Pisa, the mightiest Italian city and trading power of the 12th century. The fountain still seen today in Perugia's cityscape—an example of a secular work—emerged a good ten years later and is signed jointly by father and son. Giovanni Pisano followed in his father's footsteps: in 1287 he was named master cathedral builder in Siena. He raised the expression of the Antique-influenced figures to a degree of vehemence which he owed to his knowledge of the Gothic period of the Ile-de-France. His *Simon*, a figure on the façade of Siena cathedral—the first example of a programmatic figure integrated totally into the building's façade—illustrates his sense of drama.

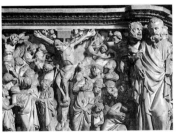

120 Giovanni Pisano (ca. 1245–1320), *Crucifixion*, 1297–1301. Detail of the pulpit in St. Andrea, Pistoia.

800 – 1500

Among the later work of Giovanni Pisano is a *Mary with Child* (**121**), which was created for the Arena Chapel in Padua. Previously Giotto di Bondone had painted the chapel with a fresco depicting the *Life of Christ* (**122**), whereby the currently revised understanding of figures and space were translated into another medium. With Giotto and Giovanni Pisano, the art of the Trecento reached its peak. Arnolfo di Cambio and Tino di Camaino further developed the sculptural style of Pisano,

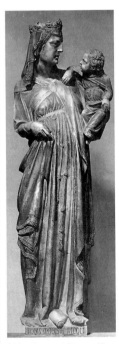

but he only succeeded in arresting the spread of the Gothic influence in Florence for a decade.

121 Giovanni Pisano, *Mary with Child*, 1305–06. Arena Chapel, Padua.

122 Giotto (1267–1337), *Scene from the Life of Christ* ("Noli me tangere"), early 14th-century painting from the Arena Chapel, Padua.

1450 Gutenberg invents the printing press

1515-56 Reign of Emperor Charles V

1517 Martin Luther's 95 Theses against the corruption of the church, including the abuse of indulgences, begin the Reformation

1521 Martin Luther translates the New Testament into German

1532 Destruction of the highly advanced Inca civilization by Francisco Pizarro

1540-42 Pope Paul III establishes the Jesuit order, and intensifies the Inquisition

1571 With the 39 Articles of the Protestant Creed, the English Reformation under Henry VIII is complete

1450 – 1550

122 Hans Baldung Grien, *Witches' Sabbath*, 1514. Feather and ink, with white highlights, on red paper, 11 x 8'' (28.7 x 20.6 cm). Albertina, Vienna.

While Dutch pictures were in demand in Quattrocento Italy, and were brought in over trade routes to the south, the sculptors of the period remained faithful to their traditions: the Italians rediscovered the beauty of the ancient body representations while the stonemasons and figure carvers north of the Alps drew more inspiration from the Gothic period. Nevertheless, the study of nature produced a kind of loosening from the earlier canon, and with this loosening came a stream of artistic invention that gave new meaning to European art. The end of the Gothic period brought a process of artistic emancipation, which led to complex image creation in all art forms. While in Italy observation of nature and the idea realized in sculpture were already on the agenda, with the late Gothic these trends attained independence, even if this was not immediately obvious in any stylistic uniformity.

Outwardly this period encompasses the passage from the itinerant Gothic peasant workshops to local bourgeois guilds; formally it marks the passage from the "softened" to the "angular" style, from classicism to the "international" styles of late Gothic realism and late Gothic Baroque. Sacred themes dominated art.

Mary the beautiful, Mary the protector

Mary worship and witch hunting, the elevation and demonization of the feminine (**122**) crystalized also in the art of the late Middle Ages. The "virtues of weakness"—obedience, love, humility, poverty—were associated with the statue image of Mary. She was the figure identified with the powerless, the protector of the disenfranchised. While at one end of the spectrum, the church stood ready to torture and burn women for practicing the "magical crafts"—such as contraception and abortion—it strove at the other extreme to prove Mary's virginity. These

efforts went to such lengths that Mary was exonerated from original sin when her mother, Anna, was declared to have conceived Mary herself immaculately. The Council of Basel in 1438, after a theological quarrel, officially sanctioned the "Immaculate Conception." Mary worship was already strong in the 11th and 12th centuries and had produced countless statues, but their popularity reached a new height in the 14th and 15th centuries.

123 *The Beautiful Madonna of Cesky Krumlov, Bohemia, ca. 1400. Painted limestone, 45'' (112 cm) high. Museum of Art History, Vienna.*

The type of statue coming out of Salzburg and Prague was the "Belle Madonna," which represents a manifestation of the "international" or "softened" style and in such stylization betrays the vehement national search for the feminine object of adoration. Formally the figure shows an increasing dematerialization. The body is overformed through its garments. The drapes of the outer garments are formed mostly of thick materials, gathering themselves to the midsection in molded folds, touching the figure and then running out to the base in a moving play of lines. Two-sided cascades of folds, which efface the contrapposto of Mary's position, diminish the sense of the Holy Virgin's corporeality. The *Krumnauer Madonna* (**123**) is an important example of this type, which emerged around 1400. Mary inclines her head gracefully toward the struggling Christ child. The heartfelt relationship between mother and child may be read,

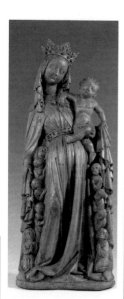

124 *Seeschwaben Madonna with the Protective Cloak,* ca. 1430. Linden wood, 4' (117 cm) high. Suermondt Ludwig Museum, Aix-La-Chapelles.

however, not only as a sign of a new sentimentality, but also as an indication of the increasingly rigid prescription of a woman's role in the late Middle Ages. First, the absorption of religion into the church took power away from women, who were then compensated with the adoration of Mary. The church interfered in the marriage contract, which from this time could no longer be broken by the woman.

As a special type of portrayal of the Virgin Mary, the "Madonna of the Protective Cloak" exhibits the qualities projected onto women. Legends told of the incarnate Christ's divine rule, while it was to Mary one prayed for miracles of pardon. J. Hero begins with such legends in the history of the utopian hopes of women: "In practice, the actual legally effective operation of the protective cloak was based on the fact that women did not as a rule participate in legal processes and thus could accomplish extraordinary acts of mercy."

The historically privileged women of high rank found their counterpart in this statue type, which changed with social change: with the *Protective Madonna from Seeschwaben* (**124**), all sinners equally found mercy and were not individually personified. A full half-century later the *Mary* (**125**) attributed to Michael Erhart immortalized the church patrons under the protection of her blue cloak. This sculpture dilutes the equalizing character of Mary's works: the groups of supplicants on her right and her left are now

125 Michel Erhart, *Mary of the Sheltering Cloak,* 1480. Linden wood, 54'' (135 cm) high. Sculpture collection of the State Museum, Berlin.

highly individualized and arranged according to their social rank; the melting pot effect of the earlier protective Marys is totally missing.

A new complexity

With his contemporaries, Hans Multscher mastered the "international style" (**126**) before he broke its rules. The inventive spirit of this highly regarded citizen of Ulm is clearly revealed in the painted alabaster relief (**127**), an individualistic, contemplative, devotional image depicting the Holy Trinity in what was, for his time, an illuminating form. At the beginning of the 15th century Multscher had a workshop with sixteen helpers in the prosperous city of Ulm, and could well afford to break ground with a new pictorial style, which also satisfied the quest for personal inspiration and rapture. He combined the type of the "Angel's Pietà," in which an angel holds Christ in her arms, with the "Seat of Grace," in which God the Father takes over this role. It is not only the stylistic mixing in a complex scene that makes this relief special: the court painter of the Duke of Burgundy, Jean Malouel, undertook a similar representation in a tondo (**128**) that gives the angel a subordinate role, but introduces Mary and John into the scene.

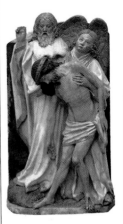

1450 – 1550

127 Hans Multscher, *Threefold Relief* from Sandizell Castle, ca. 1430. 11 ½ x 7'' (28.5 x 16.3 cm). Liebieghaus, Frankfurt.

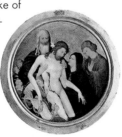

128 Jean Malouel, *Pietà*, ca. 1400. Wooden, 21'' (52 cm) diameter. Musée du Louvre, Paris.

129 Claus Sluter, the *Well of Moses* in the former cloister of the Chartreuse de Champmol at Dijon, 1395–1403. Limestone, 6 ¹/₂′ (200 cm) high. Sluter (ca. 1355–1405), who came originally from Haarlem near Amsterdam, is a giant among late Gothic sculptors, who in the service of Duke Philipp created audacious, monumental, impressively lifelike sculptures. His *Well of Moses* (**129**) can still be seen today in the Chartreuse de Champmol. The over 6 ¹/₂-foot-high (2 m) sculpture of Moses, whose horned appearance expresses the entire drama of the divine message, is suggestive of the coming monumental quality of Michelangelo. Sluter's *Head of Christ* (**130**), a fragment of a crucifix, also found in the Chartreuse de Champmol cloister, underlines the psychological depth of the figure. The garment drapings none-theless point to a vocabulary inspired by the "softened style."

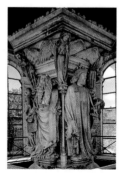

Multscher, who is supposed to have spent his apprenticeship in the Netherlands, went further than Malouel: instead of depicting Christ already dead, he summons the very moment of His passing: even God the Father looks on in fright as his son dies while the angel mourns to heaven. The figures overlap, the group stands out as a single unit, although the Father and the angel fuse with each other toward the rear wall and Christ comes forward in the relief in an almost three-dimensional sculptural form.

Around 1430–40, the beautiful curves of the "international style" began a radical reversal to the unyielding crumpled folds of the late Gothic. With the "angular style," dra-matically modeled garment folds become a dominant feature of the composition, while the motion of the figures becomes exaggerated. The seemingly independent existence of creases in the garments were consistent with a new taste for realistic reproduction of figures.

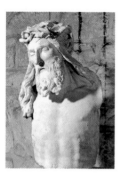

130 Claus Sluter, fragment of a *Crucifix* (Calvary scene of the Chartreuse de Champmol cloister), 1396–99. Limestone with colored markings. Ar-chaeological Museum, Dijon.

Angular style, also called the "crumpled fold style": hard, corporeal, brittle form developed in reaction to the "softened style," characterized by frenzied, exaggerated, expressive, dynamic qualities
International style, also "softened style": in contrast to realistic statuary (such as the sculptures of Peter Parler or Claus Sluter), a smoothing-out and de-materializing of the human figure prevails; marked by an increasing importance of garments (with an underlying principle of the "holiness of fabric"), the transfiguration of the material, and at the same time novel symbolism of the sacral content

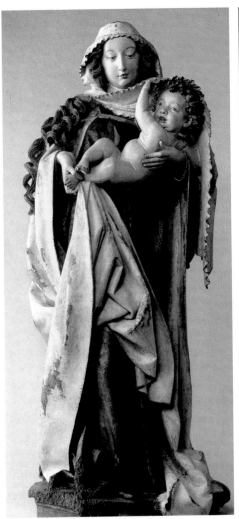

The graphic replaces the pattern book: The *Mother of God of Dangolsheim* refers to a 1450 copper engraving of *Mary with the Lily of the Valley*, marked on the back with the monogram "E.S."

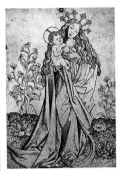

132 Master E.S., *Mary with the Lily of the Valley,* ca. 1450. Copper engraving. Albertina, Vienna.

1450 – 1550

131 *Mother of God of Dangolsheim*, attributed to Nicolaus Gerhaert van Leyden, ca. 1465. Nut tree wood with old setting, 41" (102 cm) high. Sculpture collection, State Museum, Berlin.

Nicolaus Gerhaert van Leyden was born ca. 1430 in Leyden and died 1473 in Vienna. Little is known of his life. He worked in Strasbourg from 1463 to 1467. From this time we also have the *Stone Crucifix* in the Baden-Baden parish church of St. Peter and Paul. The complete absence of the realistic body and the fluttering shawl refer back to Rogier van der Weyden. Gerhaert later served Emperor Frederick III in Vienna.

133 Attributed to Nicolaus Gerhaert van Leyden, free standing *Figure of a Man*, ca. 1467. Red sandstone. Museum of the Works of Notre Dame, Strasbourg. The usual self-portrait of the sculptor enters new artistic territory. Peter Parler had already immortalized himself in 1375 in bust form in the Prague Veitsdom. Ultimately, Anton Pilgram installed his self-portrait on the pulpit of St. Stephan's in Vienna.

1450 – 1550

134 Michael Pacher (ca. 1435–89), *Crowning of Mary*, middle shrine of the high altar of the parish church St. Wolfgang am Abersee, ca. 1481. Wooden, gilded, and colorfully painted, 13 x 10 ½' (3.9 x 3.2 m).

The expressive style of the Reformation

The most common works of the 15th century were the carved altars furnished with wings. Gilded, painted, or left as natural wood, they formed the center of every church; painting, small-scale architecture, and sculpture fused into a unified work of art. The procession of the saints became the dramatically presented scene.

The *Wolfgang Altar* (**134**) by the Tirolean painter and sculptor Michael Pacher is a significant work from this period. Pacher truly stretched out the crowning of Mary with the flanking saints through the vertically aligned, gilded arrays in the background, while simultaneously, for the first time, breaking the pattern of symmetry in the primary scene.

Veit Stoss, who was long employed in Krakow, increased the drama in a previously unseen way. The figures in Stoss's works appear to be momentarily frozen in

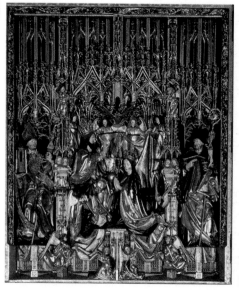

the middle of an impulsive movement. For the first time in the tradition of the Gothic carved altar, the *Death of Mary* (**136**) is treated as the central theme of a high altar.

In contrast to the Italian Renaissance, the south German sculptors on the eve of the Reformation were carving complex programmatic figures. Stoss's scenes, as well as the luxuriant plant-covered limestone carvings of Heinrich Douvermann, are known as the "elevated style of the time of Luther." In 1517, Martin Luther had formulated his theses against the abuses of selling papal indulgences, and in so doing launched a relaxation of the traditional links to the late Middle Ages. Among other things, the pulpit as the place for the sermon gained new meaning in Protestant church buildings. In the Freiberg *Tulip Pulpit* (**135**), by Hans Witten, the architecture disappears behind the Gothic vinework. Tree trunks support the staircase, on which Daniel sits as patron of the miners, while a younger man carries mountain climbers and struts on his shoulders. The conception of the pulpit can be traced back to a fable in which Daniel sought bronze on trees, and was first advised by an angel to look for treasures underground. The pulpit becomes the mythical tree, and a symbol of the axiom that preaching the word of God leads to true piety. Witten's pulpit is one of the grandest artistic monuments of the Reformation.

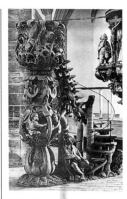

135 Hans Witten, *Tulip Pulpit* in Freiberg Cathedral, ca. 1510. Volcanic limestone, 13′ (3.9 m) high

136 Veit Stoss (ca. 1448–1533), *Death and Ascension of Mary*, middle shrine of the St. Mary's Altar in the Marienkirche in Krakow, 1477–89. The figures are approximately 9′4″ (2.8 m) high.

1450 – 1550

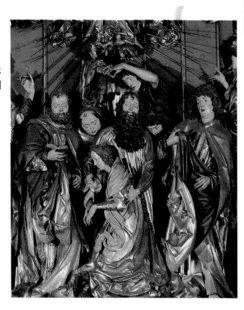

1431 Burgundian-Dutch painting school founds new oil painting, *The Old Ghents* of the van Eyck brothers

1435 The first copper engraving displaces the woodcut

1471–1528 Painter, engraver, and draftsman Albrecht Dürer brings the Italian Renaissance north

1488 First expedition of Christopher Columbus to Cuba and Haiti

1495–1553 François Rabelais, author of the satirical novel *Gargantua and Pantagruel*

1562 Counter-Reformation begins by order of Emperor Ferdinand of Austria

1587 Execution of the Scottish queen Mary Stuart

1500 – 1600

The important South German painter and sculptor Michael Pacher almost certainly traveled in Italy, but did not bring back any obvious signs of Italian influence or inspiration. Horst Janson, a specialist in Renaissance sculpture, recognizes therein an indication of a spiritual gap between the north and the south that must have prevailed around 1400. For Janson, all of medieval sculpture comes under the category of applied art, since it was designed to serve a devotional function. To be able to distinguish it from the "heathen idols" of the late Antique, around the year 1100, large sculpture was reintroduced within a framing device—either enclosed within a niche or integrated into architecture. In the relaxation of this strict functionality, Janson sees sculpture serving the early Florentine Renaissance.

The early Renaissance

Florence was already a center for the arts in the 13th century. The poet Dante Alighieri (1265–1321), the poet and humanist Petrarch (1304–74), and poet/storyteller Giovanni Boccaccio (1313–75) all wrote in a colloquial style that was nonetheless clearly influenced by the Classical Antique; their poetry and other works paved the humanist ground for the Renaissance. Interrupted by their fear of the plague, the wealthy Florentines of the 14th century continued the process begun earlier of embellishing public buildings.

Renaissance: French, from the Italian *rinascimento* = rebirth. Designation for European art of the 15th and 16th centuries. The idea of a classical rebirth was originally found as a basis for the contemporary writings of theorists such as Leon Battista Alberti, who traced the path of the antique through the supposedly artless Middle Ages. The word was first used to describe a stylistic idea by Voltaire in 1756, and from 1830 in France.

The freestanding statue

Sculpture assumed an important function in the early Renaissance. No longer merely a decorative figure or group of figures, sculpture now could represent—with direct reference to the Antique—the self-confident, free individual who is at home in a new world alive with new strands of thought in science and philosophy and with the power bestowed by new sources of wealth.

137 Donatello, *David*, ca. 1430. Bronze, 63 ¼" (158 cm) high. Museo Nazionale del Bargello, Florence.

The bronze *David* (**137**) by Donatello, which is by most accounts the first freestanding nude figure created after the Middle Ages, marks a stylistic return in European sculpture to the Antique. The original meaning of the king represented in boyhood, who stood in 1469 in the Medici palace, is unclear. His nudity is motivated neither by Old Testament history nor by its iconography. Donatello portrays his David in the moment of triumph over Goliath. The noble body could, as in Antique sculpture, represent his divinity, designating him as a tool of God. The reconciliation of the new Platonic philosophy with Christianity undertaken by Marsilio Ficino (1433–99) appears to find an analogue here.

The niche figures for the Orsanmichele in Florence demonstrate the significant changes in early Renaissance sculpture. Each guild was obligated to provide a niche to change the function of the building from a granary to a devotional

138 Donatello (Donato di Niccolò di Betto Bardi, 1386–1466). First educated as a stonemason, Donatello worked between 1404 and 1407 in Ghiberti's workshop. Around 1430 he traveled to study antiquity in Rome. His extensive work reflects the pathbreaking value of the Florentine early Renaissance in the history of sculpture.

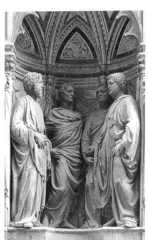

139 Nanni di Banco, *Four Crowned Martyrs*, 1410–15. Marble, 74" (185 cm) high. Orsanmichele, Florence.

140 The goldsmith Lorenzo Ghiberti (1378–1455) designed and managed the most important Florentine bronze castings. He joined a pleasing Gothic rhythm with the new ideals of the Renaissance, without attaining the psychological realism of Donatello. The versatile artist assembled one of the first collections of ancient art. He devoted his last years to the *Commentarii*, a history of art since the Antique.

room for a patron saint. In 1410, Nanni di Banco created the *Four Crowned Martyrs* (**139**). These figures of the four patron saints of the stonemasons may be traced back to four Christian sculptors who suffered a martyr's death under the Emperor Diocletian. Nanni dispensed with the curved ornamentation of many other draped images also found in the Italian room, which were still reminiscent of the "softened style." The heads and facial expressions of the saints suggest late Roman portrait sculpture, though they are still conceived in a niche. Donatello's earlier St. George, however, had already dispensed with its frame.

The freestanding group

Donatello's client Cosimo de' Medici, whom he also considered an obsessive worker and devoted servant, was the son of a banking family who made his fortune by the administration of church funds and decided to become a patron of the arts. The group *Judith and Holofernes* (**141**),

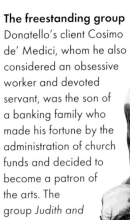
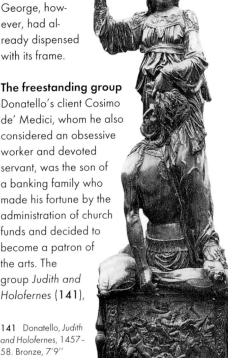

141 Donatello, *Judith and Holofernes*, 1457–58. Bronze, 7'9" (236 cm) high. Piazza della Signoria, Florence.

1500 – 1600

142 Donatello, *St. George Kills the Dragon*, 1417. Marble, 15 ½″ x 48″ (39 x 120 cm). Orsanmichele, Florence. This relief in the Predella of the George Tabernacle has a particular meaning. The extremely delicate carving suggests a nearly unbounded use of space. Donatello is known as the inventor of the *relievo schiacciato*, the flattened relief.

143 Lorenzo Ghiberti (above) and Filippo Brunelleschi (below), *Sacrifice of Isaac*, 1401. Competition reliefs for the bronze doors of the Baptistery. Museo Nazionale del Bargello, Florence.

Bronze doors for the Baptistery of Florence

In 1401–02, a competition was held among Florentine sculptors for the design of the second bronze doors of the Baptistery. With the erection of the first door in 1336, Andrea Pisano had set the scale. The collapse of the Florentine Imperial Bank, political turmoil, and then in 1348 the Black Plague thwarted the plan to execute both the other doors in bronze, so that a half-century passed before anything further was done for the building. With Lorenzo Ghiberti's design, the commissioning Calimala decided on a version of *The Sacrifice of Isaac* (143), which accepted the frame of quatrefoils; its depiction of Abraham still shows the influence of the "softened style." Filippo Brunelleschi, who built the dome of the cathedral but had lost the competition for the second door design to Ghiberti, more than doubled the amount of bronze needed for his design. In 1452, Ghiberti completed the third bronze door of the Baptistery, the *Gates of Paradise* (144), in which he broke from tradition and summed up several biblical scenes in one picture. His differentiated relief and casement work, their groups, statuettes, and busts, landscapes and architecture took entire generations to execute.

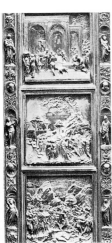

144 Lorenzo Ghiberti, *Gates of Paradise*, 1452. Bargello, Florence.

1500 – 1600

Donatello's last statue, was discovered in the 1460s in the Medici palace. The twisted composition suggests that the group may have been conceived as the centerpiece of a fountain. The work is to be understood symbolically: Judith, who looks at the viewer, represents *humanitas*, while Holofernes embodies *luxuria-superbia*—that is, vice.

The temporality of the group includes a sense of timelessness as well as the transitory moment of the scene. Medieval simultaneity, ancient body representation, and a Christian theme fuse into an organic whole. In addition to the stylistic return to human body proportion, this creative synthesis of form, content, and function characterizes the Renaissance.

Monuments

The early Renaissance appreciation for personal achievement was reflected in the emergence of new functions for sculpture. The tomb monument combined with the equestrian statue (see p. 48) to produce a new type of monument: the monument in public space. The church tomb monument also had to adjust to the demands of the time. The remembrance of the dead now included recognition of his wealth.

The transition from the international Gothic period to the Trecento, which in Italy was already overlaid with ancient forms, is formally embodied in Jacopo della Quercia's monument the *Ilaria del Carretto Guinigi* in the Cathedral of Lucca (**145**). The *tumba*, decorated by angels of death holding garlands, reveals the Sienese sculptor's knowledge of Roman tomb art. On the top lies Ilaria,

145 Jacopo della Quercia (ca. 1374–1438), sarcophagus of *Ilaria del Carretto*, ca. 1406. Marble, 97 ½ x 37″ (244 x 93 cm). San Michele in Foro, Lucca.

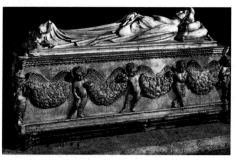

who died during childbirth. At her feet lies a small dog as a sign of loyalty.

The new interpretation of content and form of the tomb monument, however, first sprang up in Florence. In 1444, the city chancellor, historian, and classicist Leonardo Bruni died. Bruni had wanted a simple grave plaque in the church. Inspired by Bruni's personality, however, the commissioned sculptor, Bernardo Rossellini, created a work that was to revolutionize the form of niche monuments. The monument (146) appears as a wall niche, sealed on the top with a round arch over fluted corinthian pilasters and it opens through a pedestal from the floor. The head of the deceased is garlanded with laurel, and an example of his important works, the *Storia Fiorentina*, lies across his chest. The monument is grasped—as Erwin Panofsky asserts—in retrospect: It celebrates the achievements of the deceased on earth, and does not particularly express any hope of salvation in the afterlife. The only Christian elements, the Madonna tondo and the praying angels in the lunette, are subordinate to the harmonious, intellectual/ideal concept of the monument.

A good ten years later Antonio Rossellini, Bernardo's younger brother, raised the humanistic agenda to a dramatic level. His monument to the *Cardinal of Portugal* (147) in San Miniato is the earliest statue we know of that is conceived as an independent part of the architecture. While it naturally takes in elements of the humanistic tomb monument, it liberates them from strict rules. The most important innovation lies in the two hovering angels, who carry

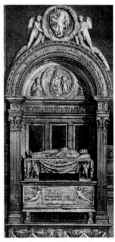

146 Bernardo Rossellini (1409–64), Monument of *Leonardo Bruni*, 1445–50. Marble. 20'4'' x 10'10'' (610 x 328 cm). San Croce, Florence.

1500 – 1600

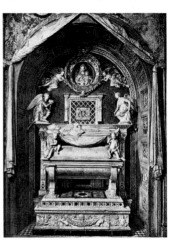

147 Antonio Rossellini (1427–80), monument of the *Cardinal of Portugal*, 1461–66. Marble, 18'9'' x 11' (565 x 370 cm) (size of the niche). San Miniato al Monte, Florence.

148
Luca della Robbia, *Personification of Composure*, 1461–66. Glazed terra cotta. Chapel of the Cardinal of Portugal, San Miniato al Monte, Florence. Luca della Robbia (1399/1400–82) began in the workshop of Nanni di Banco as a marble carver. From 1440, he worked with the glazing of large sculptures and founded the Robbia workshop, which was in great demand down to the 16th century, manufacturing colorfully glazed reliefs.

149 Daniele de Volterra, *Michelangelo*, 1564–65. Bronze, 11 1/4″ (28 cm) high. Civic Archeological Museum, Milan.

1500 – 1600

the wreath with the Madonna medallion, giving the impression of a sudden vision.

The high Renaissance

In the 16th century, the world outlook changed completely: in 1492, Columbus sailed to the East Indies and discovered instead the New World, thereby spurring the exploration of the seas in search of new continents. In the last year of his life, 1543, astronomer Nicholaus Copernicus's most important work appeared: in it he presented his heliocentric model of the solar system and the concept of the infinity of space. The gold flowing from the Spanish colonies fostered the development of early capitalism. Italy became the stage for the playing out of the rivalry between Francis I of France and the Habsburg Charles V. The popes surpassed themselves in the advancement of the arts, with which they hoped to raise worldly respect to increase the splendor of the church. Art and science experienced enthusiastic advancement in Florence under the influence of the Medicis.

Out of the humanistic view of the artist in the early Renaissance emerged the Italian notion of the *uomo universale*—what we today would call the "Renaisssance man" (or woman). Neither Leonardo da Vinci nor Michelangelo (**149**) would have described himself as exclusively a painter and a sculptor; both also were deeply engaged in mathematics and philosophy. While no sculptural work can be attributed to Leonardo with certainty, Michelangelo left behind many marble statues that document for us the transition from a balanced humanism to the increased sway of the passions in a less certain world.

Before Michelangelo went into papal service and painted the magnificent Sistine Chapel, he created a *Pietà* (**150**) during his first stay in Rome, when he was only 23 years old. The theme of the

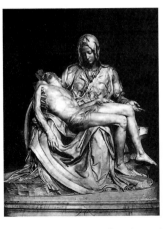

150　Michelangelo Buonarroti, *Pietà*, 1498–1500. Marble, 5′10″ (175 cm) high. St. Peter's Basilica, Rome.

grieving Mary holding the dead body of Christ was a standard motif north of the Alps for the display of grief and mourning. Michelangelo, however, transformed this theme, in a manner that was considered unorthodox in Italy, into a tranquil vision. The monumentally drawn figure of Mary appears to hold her dead son across her knees as if in acceptance of his death as a necessary sacrifice for the salvation of humanity. The harmonious group, which stands today in the entrance of St. Peter's Basilica in Rome, derives its stylistic features largely from Donatello and Jacopo della Quercia.

　　When he returned to Florence a short while later, the gifted artist obtained a 16 1/2-foot-high (5 m) block of marble that had been kept in storage in the cathedral workshop since 1464. A colleague had already bashed a hole in the stone for the legs, but had then shrunk away from such a (literally) monumental task. Out of this marble block, Michelangelo carved the famous *David* (**151**), which was installed ceremoniously upon its completion in 1505 by order of the city before the Palazzo Vecchio. A symbol of the self-confident middle class, David embodies the marriage of *ira* (anger) and *fortezza* (power). At first glance, he appears to correspond to the nude model of the ancient hero, but the piercing gaze and the powerfully prominent hands would not likely have been found in antiquity. In Michelangelo's

151　Michelangelo Buonarroti, *David*, 1501–04, marble, 16′10″ (505 cm) high. Accademia, Florence.

1500 – 1600

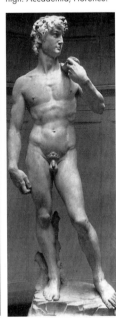

81

sculpture, the David who conquered Goliath has become the giant himself and no longer needs to be fettered by the attributes that speak of Old Testament tyrannicide.

Educated as a sculptor by the Antique conservator of the Medicis, Michelangelo studied human anatomy in detail: his drawings make this crystal clear. The organically realized human figure, conceived utterly in its physicality in a heroic-monumental form soon became his trademark.

In 1535, Michelangelo became the head architect, sculptor, and painter of the Apostolic Palace, but before he assumed this post he redesigned the Medici Chapel of San Lorenzo. The seated figures that stretch across the wall niche tombs of Giuliano and Lorenzo de' Medici embody the two different temperaments. In front of the niches recline a pair of figures representing the times of

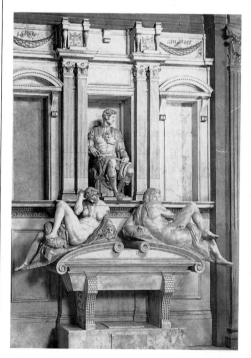

152 Michelangelo Buonarroti, *Night* and *Day*, figures on the tomb monument of Giuliano de' Medici. San Lorenzo, Florence.

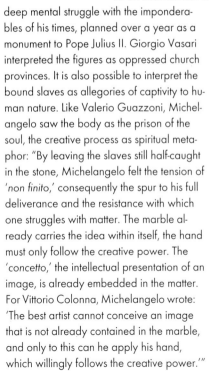

day: on the tomb of Giuliano (**152**), *Night* and *Day* symbolize the future and the past, while the niche for the tomb of Lorenzo is flanked by the figures of *Dawn* and *Twilight*. The concept and decoration of the monuments are not lost in a surfeit of allusions, but arise, as never before, as an organic whole.

Michelangelo's unfinished sculptures, *The Slaves* (**153, 154**), stand as an embodiment of the deep mental struggle with the imponderables of his times, planned over a year as a monument to Pope Julius II. Giorgio Vasari interpreted the figures as oppressed church provinces. It is also possible to interpret the bound slaves as allegories of captivity to human nature. Like Valerio Guazzoni, Michelangelo saw the body as the prison of the soul, the creative process as spiritual metaphor: "By leaving the slaves still half-caught in the stone, Michelangelo felt the tension of '*non finito*,' consequently the spur to his full deliverance and the resistance with which one struggles with matter. The marble already carries the idea within itself, the hand must only follow the creative power. The '*concetto*,' the intellectual presentation of an image, is already embedded in the matter. For Vittorio Colonna, Michelangelo wrote: 'The best artist cannot conceive an image that is not already contained in the marble, and only to this can he apply his hand, which willingly follows the creative power.'"

153 Michelangelo Buonarroti, the so-called *Awakening Slave*, post-1519. Accademia, Florence.

154 Michelangelo Buonarroti, *Slave*, ca. 1520. Marble, 7 ½' (228 cm) high. Musée du Louvre, Paris.

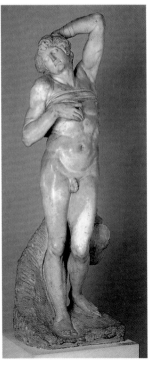

1500 – 1600

83

1550 – 1700

1564–76 Reign of Emperor Maximilian II von Habsburg

1572 Slaughter of 2,000 French Huguenots on St. Bartholomew's Night

1595 First penitentiary built in Amsterdam; Gerhard Mercator publishes the first atlas

1611 The money economy finally prevails against the natural economy

1618 Start of the Thirty Years' War, which gradually draws in all of central Europe, with massive loss of life

1644 Russia annexes Siberia up to the mouth of the Amur River

1648 End of the Thirty Years' War through the Westphalian Peace

1651 Thomas Hobbes's *Leviathan* defends rule by absolute monarchy, because otherwise, in the "war of all against all," no orderly society would be possible

1685 Birth of Johann Sebastian Bach and George Frideric Handel

1692 Opening of the London Exchange, establishment of numerous stock corporations

1715 Death of Louis XIV of France

"I knelt down and bade him, whether he would like to forgive me these death blows and the rest, that I had committed from here in the service of the church ... I went out again, continued to shoot and to strike ever better; but my drawings, my beautiful studies, my pleasant music all went up in smoke."

Thus, the artist Benvenuto Cellini reported his heroic exploits and won himself a place in history, not least because of his comprehensive autobiography. Cellini proved himself during the *sacco di Roma*, when the city was looted by the mercenary forces of Emperor Charles V; he fought on the side of Pope Clemens VII and the French king as a cannoneer on the Engelsburg. In the domain of sculpture, the goldsmith, coin-maker, and sculptor of the late Renaissance was accounted among the primary representatives of Mannerism, exceeded only by Giovanni Bologna and his school.

Mannerism, the transitional period between the Renaissance and the Baroque, must certainly be considered one of the most controversial periods of art history. While a small number of historians repudiate Mannerism as pure decadence, others point out the freer emotionality, the refined sensuality of the "time of crisis." The newly achieved self-confidence of modern society appeared contradictory to social imponderables: The city-states lost their independence and fell under the power of new hierarchical systems. On the eve of absolutism and in the spell of the counter-Reformation, the artistic type changed. From the independent *uomo universale* came the court artist who served the demands of his patron or employer.

Between 1545 and 1554, in the service of the Florentine Grand Duke Cosimo de'Medici, Benvenuto Cellini created the bronze figure of *Perseus and Medea* (**155**), which still stands

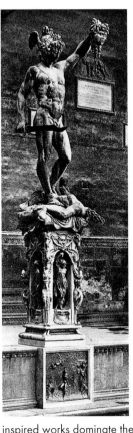

today in the Loggia dei Lanzi. Donatello's *Judith* (**141**), which stands not far away, had already captured the city's self-image: the ancient hero Perseus beheading the Gorgon could be understood as a warning from the prince to his subjects. The wax model (**156**) actually reveals the typical stylistic marks of Mannerism better than the final represented statue: The nearly dancing figure of Perseus focuses the fear of the people; the end justifies the means, just as politically inspired works dominate the frivolous. The elongated body and the dramatically bent head of the youthful hero work effectively in the pose, not in their concentrated corporeality, as might have been typical of Michelangelo.

The *figura serpentinata*, a composition of figures that imitates a spiral, is another hallmark of Mannerism, though it actually traces its origins back to the masters of the high Renaissance. In 1584, painter and art theoretician Giovanni Paolo Lomazzo passed on Michelangelo's statement: "one should always form the figure in a pyramid, *serpentinata* and with one, two, or three points of view." With the marble group, *The Ge-*

155 Benvenuto Cellini (1500–71), *Perseus and Medea*, 1545–54. Bronze, 10½' (3.20 m) high; the pedestal is 17'4" (5.19 m) high. Loggia dei Lanzi, Florence.

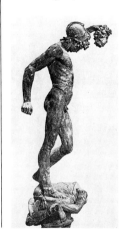

156 Benvenuto Cellini, model for the *Perseus and Medea*, 1545. Wax, 31" (78 cm) high. Museo Nazionale del Bargello, Florence.

1550 – 1700

85

157 Giovanni Bologna, *The Apennine.* The practice of forming artistic grottoes from natural stone and hewing sculptures out of the rocks was revived in the 15th century, though it dates back to antiquity. Now, modeled nature was seen as a work of art, and artists tried to produce a scenic effect. The god arises out of the rock and leaves the water bubbling out, like the life-giving Nile. This mystical sense makes this figure a major work of landscape sculpture.

158 Giovanni Bologna, *The Rape of the Sabine Women,* 1581–82. Marble, 13¹⁄₂′ (410 cm) high. Loggia dei Lanzi, Florence.

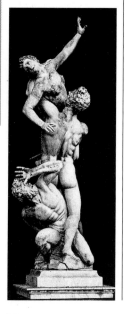

1550 – 1700

nius of Victory, which stands today in the Palazzo Vecchio in Florence, Michelangelo employed the serpentine principle for the first time: the heroic figure, without motivation, turns his shoulder to one side, his head to the opposite side.

To be equally beautiful on all sides! For Lomazzo, sculpture is the "paragon" of arts. How much more beautiful and more pleasant it is, "by traveling around a figure, to have the fullest enjoyment, to see it completely and with understanding."

Giovanni Bologna, or Giambologna, born in Douai in northern France, arrived on the scene an undisputed master of the sculpture created to be seen from multiple points of view. He came to Florence in 1556 two years after taking an educational trip to Rome. Florence became his home. His 1583 group *The Rape of the Sabine Women* (**158**) is an excellent example of the *figura serpentinata.* Over a bent old man rises a second, athletic man, who lifts the twisted form of a beautiful woman. The figures provide an

excuse, in a certain sense, for a purely sculptural language of form: for movement and counter-movement, roundness and concavity, contraction and expansion. The contemporary meaning of this work, which is installed in the Loggia dei Lanzi, however, lies in the triumph of youth over age. In contrast to the spiritual statues of the Renaissance, in the work of Giambologna the physical dynamic dominates.

From Giambologna's workshop emerged other sculptors who carried Mannerism to Germany and France. Hubert Gerhard, born around 1550 in Amsterdam, created a *St. Michael* in 1588. This sculpture, which adorns the façade of St. Michael's Church in Munich, shows the saint in triumph over the devil (**159**); this struggle against evil, however, is dramatically unconvincing. The overall effect is weakened by the elegance and beauty of the figures, especially of the devil, which are not sacrificed to enhance the expressive potential, as became more characteristic in the 17th century.

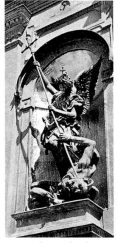

159 Hubert Gerhard, *St. Michael*, 1588. Bronze, larger-than-life. St. Michael's Church, Munich.

160 Gianlorenzo Bernini (1598–1680) was responsible for the design of St. Peter's Cathedral and the colonnades of St. Peter's Plaza.

The Baroque

Gianlorenzo Bernini was not only the most important sculptor of the Roman Baroque, he also wrote plays, appeared in them, designed stage sets, and composed music. Beyond the biographical interest in such a legacy, Bernini's diversity of talents carries further significance.

Movement, the conquest of the room, had been a hallmark of Mannerist sculpture; now sculptors began to deliver to the stage the monumental decoration of absolute sovereigns. In Rome, the popes unleashed a degree of worldly pomp that accordingly spurred the blossoming of the arts.

1550 – 1700

161 Gianlorenzo Bernini, terra cotta model for *Longinius* (the Roman centurion who pierced Christ's side during the crucifixion with his spear). Fogg Art Museum, Harvard University, Cambridge, Massachusetts.

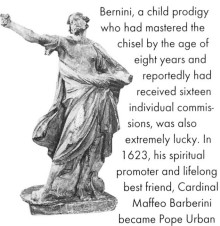

Bernini, a child prodigy who had mastered the chisel by the age of eight years and reportedly had received sixteen individual commissions, was also extremely lucky. In 1623, his spiritual promoter and lifelong best friend, Cardinal Maffeo Barberini became Pope Urban VIII. The chief of the Catholic world immediately entrusted Bernini with the design of the Church of St. Peter. Like a stage manager, Bernini at the age of forty directed an organization in which he employed independent, but for the time being less favored artists such as Francesco Mochi, François Duquesnoy, or his own greatest rival, Francesco Borromini. Bernini himself concentrated on the *concetto*, the idea. For the *St. Longinius*, a statue on one of the pillars of the cathedral's central cupola, Bernini is supposed to have shown the famous German painter and art writer Joachim of Sandrart twenty-four *bozzetti*, only one of which has been preserved (**161**).

162 Gianlorenzo Bernini, sketch for the portrait of *Scipione Borghese* (below left), about twenty years earlier than the bust. Pierpont Morgan Library, New York.
163 Gianlorenzo Bernini, *Scipione Borghese* (below right), 1632. Marble, 26'' (65 cm) high. Galleria Borghese, Rome.

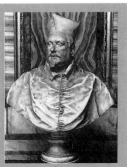

Bernini approached his subject by drawing. In quick sketches he recorded growing characteristics of the person in front of him, Scipione Borghese. Instead of then transferring the pattern to marble, Bernini used the sketches years later to remind himself of the cardinal's expressive eyes, as he had captured them on paper.

Between 1622 and 1625, Bernini had created a marble group commissioned by Cardinal Scipione Borghese that effectively cast a shadow over all previous works. *Apollo and Daphne* (**164**) represents the increased realism of reconstructed history and mythology, for tension-

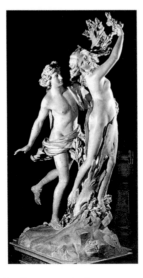

164 Gianlorenzo Bernini, *Apollo and Daphne*, 1622–25. Marble, 8' (243 cm) high. Villa Borghese, Rome.

filled dynamism and *bellezza*, in which proportion and physical and spiritual movement are harmoniously united. The god, who turned his beloved nymph into a tree, no longer embodies force and power, but the beauty and transport of the lover.

This classically inspired group already shows signs of liberation from the stifling interior space of the *figura serpentinata*. Twenty years later Bernini created *The Mystical Vision of St. Theresa of Avila* (**165**). This sculpture is completely integrated within the architecture of the Coronaro Chapel of the Church of St. Maria Vittoria. It is said that Bernini, after his liberation from the power of the papal bronze casting foundries in 1647, went through a crisis that raised his piety to a mystical fervor after he read the doctrines of Franz von Sales. It is to such sentimentality that we owe the representation of

165 Gianlorenzo Bernini, *The Mystical Vision of St. Theresa of Avila*, 1645–52. St. Maria Vittoria, Rome.

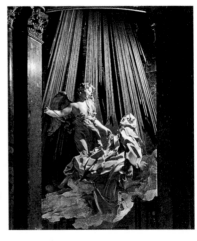

1550 – 1700

166 The façade of St.
Peter's Cathedral in Rome.

the golden halo, symbolizing divinity, surrounding the saints hovering in space. Bernini also practiced this stylistic mixture with the architecture at the Cathedra Petri, the largest *theatrum sacrum* of the Baroque period. Meanwhile, under Pope Alexander Chigi, the septuagenarian Bernini again was installed in the post of master builder of St. Peter's.

In 1665, the aged master traveled to Paris at the behest of the Sun King, Louis XIV, who had asked him for a design to remodel the Louvre. The diplomatic mission failed: Louis preferred the classic plans of the Frenchman Claude Perrault, and considered the equestrian statue **(90)** which Bernini personally created for the king, which was nonetheless delivered from Rome twenty years later, unfashionable. Still, Bernini's influence on his contemporaries as well as the next generation of sculptors is indisputable—and his influence spread not only through his lectures, which he gave at the Academy in Paris, but in his work, for in his hands, marble seemed transformed into wax, and looked like a living organism. Pierre Puget, who like many Frenchmen worked for a long time in Italy, adapted this virtuosity into a crass realism that would dominate sculpture in the 18th century. Louis then ordered from François Girardon a 23 ½-foot-high (7 m) equestrian statue, which was unfortunately destroyed during the French Revolution. Girardon

167 Pierre Puget (1622–94), *Milo of Crotona*, 1682. Marble, 9' (270 cm) high. Louvre Museum, Paris.

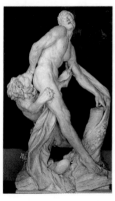

reached back to the motif of the trotting horse, which emphasizes representation instead of the Baroque penchant for movement. This prime exponent of the classic line of the French Academy had already fashioned the monument for Cardinal Richelieu (168) with courtly reserve and elegant spirituality.

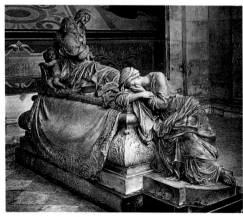

168 François Girardon (1628–1714), *Tomb of Richelieu*, 1675–94. Marble. Eglise de la Sorbonne, Paris.

The freestanding tomb, erected in the Eglise de la Sorbonne, sets the chancellor of Louis XIII, who died in 1642, on his path to God, in a manner according to his wishes. The figure of the chancellor rests on top of the sarcophagus and is supported by a woman; it bears some resemblance to the standard form of a pietà. At his feet lies the figure of the Christian doctrine (*doctrina*), whose outstretched figure was copied from Nicolas Poussin's painting, *The Last Annointment* (169).

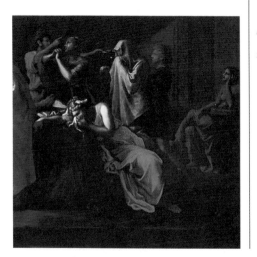

169 Nicolas Poussin, *The Last Annointment* (detail), 1644. National Gallery of Scotland, Edinburgh.

1550 – 1700

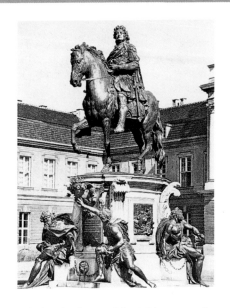

170 Andreas Schlüter (1660–1714), *Equestrian Statue of the Great Elector* at its original site on the long bridge near the castle, 1697–1700. Bronze, 9'8'' (290 cm) high. Today it is in the High Court at the Castle Charlottenburg in Berlin.

With the absolutism of the 17th century, the "national" style was fragmented into a cluster of regional preferences, although much was inspired by the Roman Baroque. In Berlin, Andreas Schlüter from Danzig created the *Equestrian Statue of the Great Elector* (**170**), a further expression of political power. Schlüter seized on Girardon's concept of monumentalization. On behalf of Frederick the Third, son of the subject, he glorified the Elector Frederick William (1620–88)—whom he had never personally known—as founder of the Prussian monarchy. The monument stood on the long bridge near the castle likewise tended by Schlüter, who was engaged to reconstruct the palace after the union of both German states using a sketch of the Palace of the Republic as a guide. Nearby stood an arsenal, obsolete in its time, which today houses the German Historical Museum. In the quadrangle of the former arsenal, the programmatic decoration included Schlüter's twenty-two masks of *Dying Warriors* (**171**). When the builder arrived in Baroque Berlin in

1705, he was at the peak of his powers, but fell into disgrace because of the increasingly flagrant technical shortcomings in his buildings. He left in 1713 to enter the service of the Russian tsar.

171 Andreas Schlüter, mask of a *Dying Warrior*, ca. 1696. Court of the Arsenal. Today it is in the German Historic Museum, Berlin.

Throughout Europe, sovereigns were eager to reflect their power in the design of their residences, roads, sculptures and monuments, and furnishings. This seemingly universal desire among rulers meant seemingly universal demand for the talents of sculptors. While such ambitious and monumental decoration puts sculpture within its service, it also frees the art form from a kind of arbitrariness, and expands the scope of sculptural ideas; now sculpture can move into the country garden, the plaza, the fountain, and sculptural forms can be fused with architectural elements, such as stairs, vestibules, or pavilions.

1550 – 1700

Glossary
Cathedra Petri: scenically designed high altar of Gianlorenzo Bernini in St. Peter's Cathedral, on which four Fathers of the Church of the first Christian century—Ambrose, Augustine, Athanasius, and John Chrysostom—support the throne of Peter.
Concetto: Italian for idea, or opinion. An important notion in aesthetics since the 16th century, it signifies the basic image, which can be infinitely varied.
Figura serpentinata: Latin, literally, twisted or spiral figure. Designation for a sculptural composition with many points of view, twisting around on itself, but opening. Lomazzo first mentioned Michelangelo's statement regarding the serpentinata in 1584; art historians apply it primarily to Mannerist sculpture.
Mannerism: Term applied to the art of the early Baroque period, sometimes considered a degenerate sequel to the high Renaissance.

1701–13 England, The Netherlands, and Austria fight the "Spanish War of Succession" against France, Bavaria, and Cologne

1721 Charles de Montesquieu writes his epistolary novel *Persian Letters against Absolutism*

1724–1804 Immanuel Kant, one of the most important German philosophers of the Enlightenment

1740–86 Frederick the Second rules Prussia, the first proponent of enlightened despotism on the throne

1776 The Declaration of Independence

1788 The Constitution of the United States of America takes effect

1789 Beginning of the French Revolution

1814 The Viennese Congress reorganizes European national lands after the dissolution of the Napoleonic Empire

1700 – 1850

Arcadia, a distant paradise, an "other" world, was the ideal natural home of pastoral poets and artists. The longing for a refinement of lifestyle, however, followed an economic cycle. Manufacturers marketed small, decorative sculptures whose figures mimicked the simple life, in the guise of shepherds and shepherdesses who freely acted out their natural feelings. The period from 1720 to 1750, which became associated with the Rococo, may be reasonably interpreted as a flight from the cultural dominance of the large castles, and as the origin of the flowering of the salon, where debate and reflection were indulged and respected. By the middle of the 18th century, the world thought, spoke, and read French. From Paris the beacon of the Enlightenment shone across Europe; the ideas of de Montesquieu, Rousseau, Voltaire, and Diderot lay the groundwork for the French Revolution.

The sculptors of the era, however, set their sights at a greater distance—Rome. Most, including Jean-Baptiste Pigalle, Etienne-Maurice Falconet, and Jean-Antoine Houdon, had spent several years in the papal city, where Antique, high Renaissance, and Baroque art had fed their nascent creativity. Their first master teachers in Paris, Charles-Antoine Coysevox and Jean-Baptiste Lemoyne II, had introduced into the form of Bernini's portrait busts the Baroque tendency toward the psychological. In 1688, Coysevox, Louis XIV's favored sculptor, created the bust of the *Great Condé* (172), a posthumously commis-

172 Charles-Antoine Coysevox (1640–1720), *The Great Condé*, 1688. Bronze, 30″ (75 cm) high. Musée du Louvre, Paris.

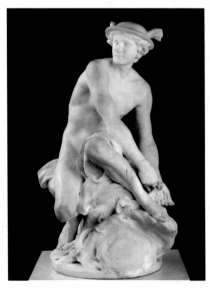

sioned work, which is reported to be from a terra cotta model. The realistic formation of the hardly beautiful features is joined with Antique costume, which adds to the wig and the turn of the head a lifelike representation. About twenty years later, the artist dispensed with the draperies and concentrated on his model's expression, which in Pigalle's portrait of Diderot (**173**) becomes a merciless realism. Lemoyne, the king's official portraitist, however, created classic busts of the Rococo style, with reserved coolness.

The sculptors of the Regency were not child prodigies springing up independently to fulfill their innate talents; rather, they had to work as apprentices or assistants for the giants of the Roman Baroque. Pigalle first impressed his teacher, the elder Lemoyne, as a mediocre adept of common origin. After his five-year sojourn in Rome, Pigalle presented a work full of witty allusions to classic formulations and of such sensitivity that he was finally admitted to the Royal Academy. On closer inspection, Pigalle's *Mercury Tying his Sandals* (**174**) reveals a new degree of complexity, even though the sculpture outwardly appears to follow the conventions of his time. Unlike the Greeks and his predecessor Gianlorenzo Bernini, Pigalle focuses on three points that explain the action: the hands on the foot of the god's boot, the

173 Jean-Baptiste Pigalle (1714–85), *Denis Diderot*, 1777. Bronze, 16 ¾'' (42 cm) high. The Louvre Museum, Paris. Philosopher and publisher of the *Encyclopédie*, Denis Diderot (1713–84) founded art criticism with his reports of the annual salons. Between 1765 and 1767 he argued in favor of the concept of realism with Winckelmann and the Antique orthodoxy: "It seems to me that one must study the antique, in order to see nature."

174 Jean-Baptiste Pigalle, *Mercury Tying his Sandals*, 1739. Marble, 23 ¼'' (58 cm) high. The model was ordered with its companion sculpture *Venus Delivering a Message* in large format for the king, who later gave the two marble statues to Frederick II. The Louvre Museum, Paris.

1700 – 1850

look, which betrays that Mercury's attention is directed elsewhere, and the banality of the action of tying the sandal, as well as the leg stretched unusually far behind the torso. Pigalle presaged—if he also forestalled—interest in realism, which culminated in the idea of representing the august Voltaire in the nude. During a banquet at the home of a Madame Necker in 1770, a group of philosophers—including Diderot and d'Alembert—decided to collect money to commission a marble statue of Voltaire. Pigalle had been contacted a few days before, and delivered a design that was in its time scandalous: to present a living author in the nude was outrageous. With this version, which was quickly withdrawn from public view, Pigalle anticipated Rodin's *Victor Hugo*. Voltaire himself was shocked, and feared that the sculpture would turn him into a laughing stock.

Although Pigalle did know success during his own lifetime, his sculptures did not correspond to the prevailing taste. Expression of the norm was left to the elegant creations of his classmate in the studio of Lemoyne, Etienne-Maurice Falconet. Thanks to Madame Pompadour, Falconet served from 1757 to 1766 as director of the Sèvres Porcelain Factory where he supervised the production of graceful statuettes, suitable for intimate rooms. Madame du Barry acquired his *Bather* (**175**), which was first shown in her salon in 1759. This sculpture became very popular and was immediately widely copied. Nonetheless, Falconet himself remained outside the established art world; at the age of thirty, he began to immerse himself in the writings of the Enlightenment, and to participate in the current popular disputes. His friendship with Denis Diderot brought him to the attention of the court of the Russian tsarina in 1766, where he was entrusted with monumental tasks like the equestrian statue of Peter the Great.

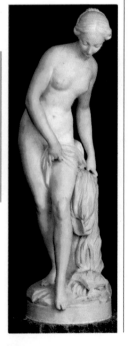

175 Etienne-Maurice Falconet (1716–91), *The Bather*, 1759. Marble, 33'' (82 cm) high. Musée du Louvre, Paris.

1700 – 1850

The tendency toward the classic, mixed with a degree of realism, became overt in the work of Jean-Antoine Houdon. As a scholar of the academy, in Rome Houdon studied anatomy and the Antique. In 1766 he produced his *St. Bruno* (**176**), the forbidding sculpture of the founder of the Carthusian order; its classical rigor established it as a key work for the classicism of the age. His later portrait of *Voltaire* (**177**), in contrast, joins the timelessly classic draping of the coat with the individualized rendering of the features.

176 Jean-Antoine Houdon, *St. Bruno*, 1766–67. Marble, 10 ½′ (315 cm) high. St. Mary of the Angels, Rome.

Noble simplicity, quiet greatness

177 Jean-Antoine Houdon, *Voltaire*, 1779–81. Marble, 66″ (165 cm) high. Comédie-Française, Paris.

At the end of the 18th and the beginning of the 19th century the young Roman scholars from Paris, Copenhagen, or Berlin, including along with Pigalle, Falconet, and Houdon, Berthel Thorwaldsen and Christian Daniel Rauch, found a thick network of academies and collections, from salons and artist circles. When Gottfried Schadow, in 1785 at the age of twenty-two, fled from the French Rococo-influenced workshop of the Prussian court sculptor Tassaert into the Italian metropolis, he frequented a private school where the students worked from live nude models. He soon found himself inside the studio of the prime representative of classicist sculpture, Antonio Canova. The credo of Canova's studio constituted a jumping-off point for Schadow. Canova turned against

1700 – 1850

178 Johann Gottfried Schadow (1764–1850), *Dancer*, 1822. Wax bozzetto, 14 x 4 x 4 ½" (35 x 10 x 11 cm). National Gallery, State Museum, Berlin.

Baroque emotionalism and held the view that the beauty of pure nature could only be attained through the study of the Antique. He thus fundamentally agreed with Johann Joachim Winckelmann, who had been appointed overseer of antiquities in and around Rome in 1763. Winckelmann, in many respects the founder of modern archaeology, had supplanted biographical and chronological approaches to art criticism and theory with philosophical considerations and considerably advanced the study of the Antique. The young Schadow stayed in Rome only two years before returning to Berlin to succeed the late Tassaert as Prussian court sculptor. The "Old Fritz," Frederick the Second died in 1788, and the new king, Frederick William the Second, strove to rejuvenate the stable of artists entrusted with official commissions. Theodor Fontane described the founder of the Berlin sculpture school as "double lively, as a tangle of sturdiness and beauty, of leggings and draperies, of Prussian militarism and classic idealism."

179 Johann Gottfried Schadow, *Self-Portrait*, ca. 1790–94. Fired clay, 16 ½ x 8 ¾ x 10" (41 x 22 x 25 cm). National Gallery, Berlin.

Schadow, known among other things as a specialist in monuments, originated the inquiry into wax bozetti modeled on human movement (**178**), which it is difficult to reconcile with Canova's credo of classicism. Moreover, his double standing portrait of the *Prussian Princesses Luise and Fredericka* (**180**) was praised for the naturalness of both noble ladies. Shortly after Schadow completed this sculpture in 1787, the man who commissioned it died; his successor considered Schadow's sculpture a frivolous display of his wife and his sister-in-law, which had the unfortunate side-effect of reminding him of the scandalous behavior of the younger Fredericka. The

181 Antonio Canova (1757–1822), *The Three Graces*, 1817. Marble. The Hermitage, St. Petersburg.

1700 – 1850

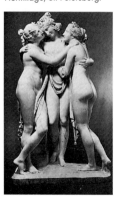

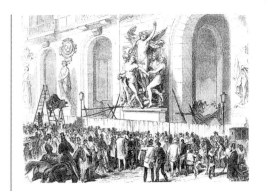

182 *Passers-by Marvel at the Ink-Stained Sculpture.* Woodcut. *L'Illustration,* 1869. National Library, Paris.

183 Jean-Baptiste Carpeaux (1827–75), *The Dance,* 1869. Stone, 14 x 10' (420 x 298 cm). Musée d'Orsay, Paris.

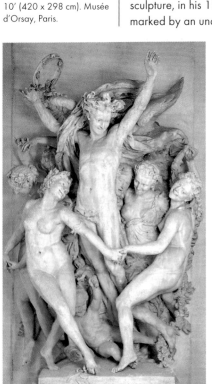

1700 – 1850

marble group, once praised as a symbol of moral grace, disappeared into the studio of the artist. Schadow's reflections upon the fate of the sculpture, in his 1805/06 autobiography, are marked by an undertone of bitterness: "This group has suffered much from the filth of the mice, which had nested in the chest, and the marble has developed hideous spots." The work was not displayed until 1893, when it could be seen in the Berlin City Castle, though public access was limited.

Departure from the Antique
The classicist canon scarcely took notice of the beginning of the industrial revolution, glancing over the harsh reality of social and political tensions that launched the modern era. The human figure as a symbol of divine ideas naturally still corresponded to convention, but the same could not be said of the ideas of many sculptors. Representative

buildings such as the Paris Opera were paid for with public funds and closely monitored by the public. At its unveiling in 1869, *The Dance* (**183**) by Jean-Baptiste Carpeaux, one of the decoratively conceived sculpture groups, caused a scandal. This work broke all contemporary rules for public art: Carpeaux's composition was neither symmetrical nor clear, nor was its outline consonant with any geometrical structure.

It was not, however, simply the fluid, moving bodies of the dancers that provoked someone to throw an inkwell against the loins of a Bacchante; it was their unbridled sensuousness. Still, whereas most journalists found the figures overtly sexual and therefore objectionable ("They stink of depravity and spew forth vapors of wine!"), Eugène Vermersch in *Le Figaro* celebrated Carpeaux's work: "Finally a living, passionate, trembling work; the flesh shows modern power, modern forms. Finally no more Greek women, copied by an artist in the Antique Museum and assembled from decayed, scattered fragments like an antediluvian animal. These are not women from the hands of Phidias, Kleomenes, or Praxiteles ... No! These are women of the nineteenth century, women as we know them, Parisian women of 1869!"

Like most of his colleagues, Carpeaux had traveled to Rome, and had learned to animate stone from Bernini. The realistic exuberance of the dancers, however, was essentially unprecedented. Only *The Marseillaise (Departure of the Volunteers in 1792)* (**184**) by his teacher François Rude had attempted similar dynamics and realism.

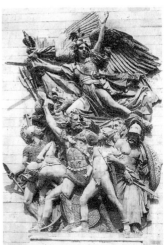

184 François Rude (1784–1855), *The Marseillaise (Departure of the Volunteers, 1792)*, 1833–1836. Stone, 42 1/2' (12.7 m) high. Arc de Triomphe, Paris.

1700 – 1850

1804–15 Napoleon Bonaparte becomes emperor of France

1814 George Stevenson builds the first steam locomotive

ca. 1821 Transition to industrial society

1848 Peoples' revolutions in France, Austria, and Germany

1867 Otto von Bismarck becomes German chancellor

1871 Victory of the Prussian army in the Franco-Prussian War and establishment of the Small German Empire

1876 The central organ of the German social democrats, Vorwärts, appears for the first time

185 Ernst von Bandel, design for the *Hermann Monument* at Detmold. Drawing by Carl Schlickum, 1840.

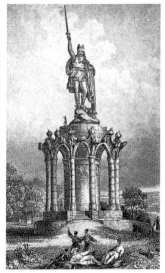

While the cities of Germany are adorned with Bismarck monuments or mounted Emperor Wilhelms, England's squares and circuses have their Trafalgars, and the United States has their George Washingtons and Ulysses S. Grants. As relics of the past, these monuments evoke nostalgia, which obscures their original function. Such statuary reflects the end of a developmental movement that began with the emancipatory demand for monuments of deserving citizens and ended in propaganda for the nation-state. Monuments became the primary assignment of the sculptors in the academies. In the year 1800, there were only about eighteen public statues in Germany; by 1883 the number had jumped to around 800. The reasons for this proliferation of what were often artistically uninteresting works have to do with the century-long process of national unification, though also with the belief left over from the Enlightenment that there was a social value in fostering a demand for art.

The national monument

At Detmold, the Hermann Monument towers more than 166 feet (50 meters) over Teutoburger Forest. From 1819 to 1875 the sculptor Ernst von Bandel worked without a commission on the design and realization of this monument (**185**) to commemorate the legendary Prince Hermann, who freed Germany at the time of the Roman Empire and after 1815 became a fashionable national symbol. After the wars of independence in 1813 and 1814, German self-confidence, weakened by Napoleon, needed such an injection of fervor. In 1835 the first concrete plans for the monument were started. Shortly thereafter, the Hermann Monument Society sent out a leaflet and

a lithograph, which triggered a public debate over the monument's substructure.

Prince Hermann, with his arm raised in warning, could well have prompted the Alsatian Frédéric-Auguste Colmar Bartholdi to create a statue that would surpass the Hermann Monument in symbolism. *Liberty Enlightening the World*—known throughout the world as the Statue of Liberty (**186**)—was created between 1871 and 1884 as a present from the French people to the people of the United States on the occasion of the 100th anniversary of the Declaration of Independence. The looming, 152-foot (46-meter) statue was constructed in 300 copper sections, stabilized by a walk-in scaffold constructed by Gustave Eiffel.

186 Frédéric-Auguste Bartholdi, *Liberty Enlightening the World* (the Statue of Liberty), 1871–84. Worked in copper, 152' (46 m) high, mounted on tubular steel scaffolding. Liberty Island, New York.

New York's Statue of Liberty bears no particular allusion to an historical or legendary individual. Rather, the woman's figure stands as an alle-

gory for an abstract concept of liberty, exemplified in the inscription, "Give me your tired, your poor, your huddled masses yearning to breathe free, indeed, the wretched refuse of your teeming shores. I lift my lamp beside the golden door." The later monument, *Bavaria*, in Munich (**187**) also embodies an abstract idea, in this case the land of Bavaria.

187 Ludwig von Schwanthaler, *Bavaria*, 1837–48. Bronze, 60' (18 m) high, pedestal 30' (8.92 m). Theresienwiese, Munich.

1800 – 1900

103

188 Rudolf Siemering, *George Washington Monument*, unveiled 1897. Bronze. Since 1929, Benjamin Franklin Parkway, Philadelphia.

189 Christian Daniel Rauch, monument for King Frederick II of Prussia, 1839–51. Bronze, 19' (566 cm) high; base of red-brown granite, 26' (784 cm) high. Unter den Linden, Berlin.

Monuments cross the Atlantic

The fully developed monument industry of the late 19th century needed to find new markets, once the many cities of Europe had been populated with various memorials. At the 1876 World's Fair held in Philadelphia, the deficiencies of the German contribution became clear. The *Nationalzeitung* reported that "Germany knows how to express no other motifs than the tendentiously patriotic." "A feeling of shame" stalked the reporters forced to contemplate the "frankly marching batallions of Germanias, ... Kaisers, and crowned princes."

Nonetheless, Rudolf Siemering of Berlin won the 1878 competition for the George Washington Monument (**188**) in Philadelphia. It took ten years of correspondence between the monument builder and the officials who commissioned the statue for an "American-enough" design to emerge for the equestrian statue, and the rather conventional monument was finally unveiled in 1897.

Comparison with the then definitive equestrian statue of Frederick the Second (**189**) by C.D. Rauch points up the purely iconographic differences: while Rauch followed the classic monument structure—pedestal/portrayal of the story/ portrayal of the state and people,

crowning figure/sovereign, statesman—for the pedestal of his *George Washington*, Siemering had studied buffalo and antelope in the Berlin Zoo. Where convention had once demanded a foundation of river gods, Siemering designed figures of American Indians.

"Heroes of the intellect" and costume wars

In Berlin, the monuments to Schiller and Goethe on the occasion of Goethe's 100th birthday captured the imagination of the entire nation. After the failure of the 1848 Revolution and the victory of the reactionary powers, the country attempted to make a show of unity and nationalism with the help of important representatives of German intellectualism. In 1849, Rauch, who had replaced Schadow as the leading German sculptor, manufactured a clay model that showed the great German poets still wearing antique garments. In 1857, Rauch's pupil Ernst Rietschel unveiled the first work ever seen in Weimar modeled in contemporary clothing (**191**). Previously, as in the *Lessing* monument in Brunswick (**190**), when it came to clothing his figures, Rietschel had decided against classic timelessness and opted for realism instead. Even Hegel in his *Aesthetics* felt it necessary to comment upon an issue that may appear trivial today—that is, whether a bust should be sculpted with or without a visible collar (Hegel's position was that only a judicious hint of the clothing was necessary).

The "costume war," which had

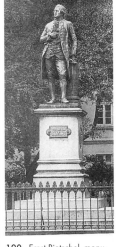

190 Ernst Rietschel, monument for (German dramatist) *Gotthold Ephraim Lessing*, 1848–49. Bronze, 8 3/4' (265 cm) high; pedestal 10 1/2' (315 cm). Lessing Place, Brunswick.

191 Ernst Rietschel, second casting of the Weimar *Goethe-Schiller Monument* of 1859, commissioned in 1907 for the inaugural ceremony of Washington Park in Milwaukee.

1800 – 1900

192 Johann Gottfried Schadow, model for the monument of *General Hans-Joachim von Zieten*, 1790–91. Bronze, 31″ (77 cm) high. National Gallery, State Museum of Berlin. *Below*: engraving by Peter Haas, after a drawing of Louis Serrurier.

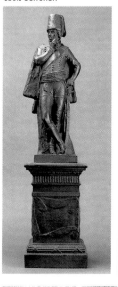

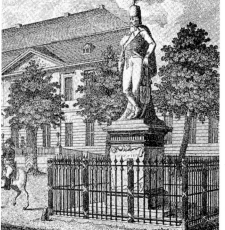

grown virulent since the middle of the 18th century, was launched by the strong stance of the classicists who preferred to present their subjects in god-like nudity or ancient draping garments. The shift from classicism to realism, from the toga to the uniform, is demonstrated in a clear, linear manner for the first time with the six statues of Prussian officers from the Seven Years' War planned for the Wilhelm Plaza in Berlin. The first two statues, by Kurt Christoph von Schwerin (1769) and Hans Karl von Winterfeldt (1777), wore antique Roman uniforms. The subsequent statues, by James von Keith (1786), created by palace architect Tassaert, and Friedrich Wilhelm von Seydlitz (1789), wore contemporary uniforms, which were clearly recognizable as representative of a certain era. With the completion of the last two monuments, *Hans-Joachim von Zieten* (1794) (**192**) and *Prince Leopold of Anhalt-Dessau* (1800), Johann Gottfried Schadow emphasized the physiognomic character, as well as the subjects' clothes. In the Propyläen, Goethe complained that the "universal human" would be displaced by the "Fatherlandish." Schadow and Goethe engaged in the same polemics, each at an opposite side of the debate, on the occasion of the public hearings about the Blücher monument in the city of Rostock.

The cult of the monument

With early classicism sculpture had become the vessel of ethical postulates; worship of the holy transformed into the cult of the genius. The new belief in the educability of the individual con-

verted the monument into an instrument of virtue. In parks and gardens, perfect nature fused with perfect intellects, their busts or statues reminding observers of their work (**193**). The above-mentioned officers of the Seven Years' War were the first monuments erected in a public place in Germany that did not represent monarchs. The designers who built these monuments, however, consistently understood their subjects—in this case, the six soldiers—as virtuous heroes in the sense made popular during the Enlightenment.

With the new age of Romanticism, patriotism gained ground. Schinkel's iron *Kreuzberg Monument* (built in 1821 though the figures were added in 1826) (**194**), with its statues in a Gothic style symbolizing the twelve most important victories of the wars of independence, was designed to appeal to the nationalistic sentiments of the popular masses. The monuments of Scharnhorst and Bülow embody a particular strain of German idealism—that is, the aspiration for a harmonious balance between the real and the ideal—which became evident in 1822 with the old guard (see p. 168). During the Biedermeier period, a new kind of monument came into existence; no longer the monarch or the great intellectual, the civic monument portrayed a third stratum: scholars, inventors, doctors, and entrepreneurs appeared in their best coats, frozen in motion holding in their hand some object that is an attribute of their learning or enterprise. The image of the natural man, statuarily and programmatically simple, was quickly exhausted.

193 *Round Temple with a Bust of Leibnitz* in the palace garden of the Hanover Mansion. Anonymous copper engraving of 1760.

194 *The Genius of Paris*, designed by Christian Daniel Rauch. One of twelve statues of the *Kreuzberg Monument* by Karl Friedrich Schinkel, 1821–26.

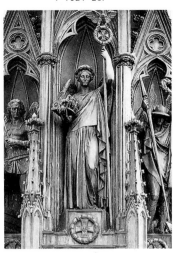

1800 – 1900

Bismarck and Kaiser Wilhelm

Reinhold Begas, the youngest pupil of C.D. Rauch, introduced the emotionalism appropriate to the empire. After classicist beginnings, he gave new life to Baroque animation, combining it with a sense of natural realism. It is difficult to believe that the marble group *Cupid and Psyche* (195), which Begas created during his first Roman sojourn in 1856–57, and the *Venus and Cupid* (196) from ten years later come from the same hand. In the latter sculpture, Venus comforts Cupid, who has been stung by a bee, just as any mother would comfort her weeping child. The *Cupid and Psyche*, however, which is an example of the sculpture of the "fruitful moment," already reveals the sculptor's attempts to incorporate realistic components in the view of the mythological history; the figures nonetheless remain classically beautiful and unapproachable. The power of Begas's National Monument for *Kaiser Wilhelm I* (197), which was erected in 1892–97 and has been destroyed, shows the king, not unlike Schlüter's *Great Elector* (170), as the conquering hero mounted on a mighty steed. Begas's last large work, the *Bismarck Monument* (198), which once stood before the Reichstag in Berlin, finally elevated the "Iron Chancellor" to

195 Reinhold Begas (1831–1911), *Cupid and Psyche*, 1857. Marble, 39 x 49 ½'' (97 x 124 cm). Sculpture Collection, Berlin.

196 Reinhold Begas, *Venus and Cupid*, 1864. Bronze, 22 ¼'' (55.8 cm) high. Bavarian State Art Collection, Neue Pinakothek, Munich.

1800 – 1900

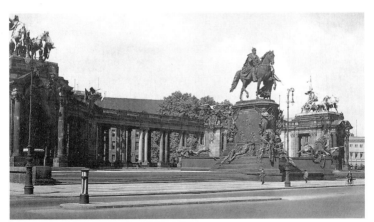

the stature of *übermensch*, though this enoblement had little to do with Bismarck's personal accomplishments. The larger-than-life figure, ringed with allegorical figures, rather, illustrates his titanic power. Similar statues of Wilhelm and/or Bismarck emerged in cities throughout Germany—financed by any number of different commissions—reflecting the self-confidence of the upper middle-class.

Wilhelm II was the first German ruler who consciously commissioned monuments to promote nationalist propaganda. In 1895, on the occasion of his thirty-sixth birthday he ordered the erection of the *Sieges-allee* ("Victory Parkway"); this promenade consists of a daunting row of thirty-two monument groups depicting the sovereigns of Brandenburg and Prussia. In 1902 Wilhelm presented the city of Rome with a Goethe Monument to demonstrate the dominance of German culture even in foreign lands.

197 Reinhold Begas, National Monument for *Kaiser Wilhelm I*, 1892–97. Bronze. Formerly in Berlin, now destroyed.

198 Reinhold Begas, *Bismarck Monument*, 1897–1901. Bronze. Formerly before the Reichstag, today on Grosser Stern, Berlin.

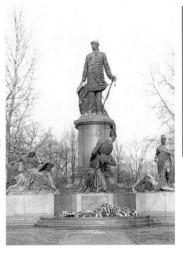

The demise of the traditional monument
The bust of Kaiser Wilhelm II was distributed in many forms in the mass market

1800 – 1900

199 "Sculpture Reducing Machine," thought to be from the Noack bronze foundry, Berlin, 1912. An *Amazon* of Albert H. Hussmann is being reproduced precisely in a smaller size.

200 Advertisement for the firm of the Brothers Micheli, Berlin (1889) for busts of Kaiser Wilhelm II.

201 Adolf von Hildebrand, draft for a *Monument of Emperor Wilhelm I* in Berlin, 1889.

at the end of the 19th century; in the process, what was meant to prop up the image of the ruler served to degrade the stature of the monument as an art form to the level of a knick-knack. Furthermore, the neo-Baroque leader monument, which Begas had once more managed to elevate to monumental proportions, was pounced upon by critics. After the 1889 competition for the National Monument of Wilhelm I, Adolf von Hildebrand, who is now better known for his writings than for his sculptures, questioned whether the equestrian statue was still the appropriate form for such a monument. His commentary culminated in the question of whether art must be left free to find its own means to meet its tasks. Hildebrand personally designed an architectural monument (**201**) that corresponded to his criteria of clarity, line, and architectural logic.

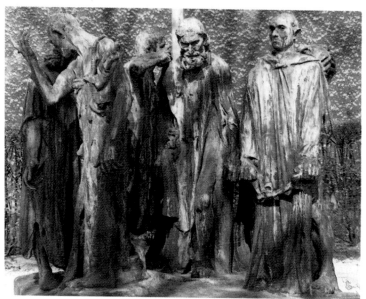

202 Auguste Rodin, *The Burghers of Calais*, 1884–85. Bronze, 6'10 1/2'' x 7'11'' x 6'6'' (2.07 x 2.41 x 1.98 m). Rodin Museum, Paris (additional casts in Calais, London, Basel, Tokyo, and Washington, D.C.).

It was in France, however, that the monument became a truly democratic art form. In 1884–85, Auguste Rodin created *The Burghers of Calais* (**202**), and in so doing, unleashed a scandal (for which France's various art worlds were ever on guard). The city of Calais had commissioned a monument to honor Eustache de Saint-Pierre, a regional hero, whose fame goes back to 1347, when King Eduard III after a one-year siege demanded the life of six patricians in exchange for sparing the city. Eustache, as the oldest, led the group, which was then pardoned by the pregnant queen. Rodin, however, was not satisfied with depicting a single individual; instead, he created a group that would express the despair of the whole city, whose heart-rending condition inspired a contemporary observer to describe the Burghers with great empathy: "Bare-headed and barefooted, the hangman's noose around their throats and the keys to the city and fort in their hands." Rodin dispensed with the single judgmental viewpoint,

203 Auguste Rodin, *Honoré de Balzac*, 1897. Plaster. Rodin Museum, Paris

which was fortunately made possible by the sculpture's position and the observer's vantage point. He also dispensed with the traditional pedestal and with it, heaved out the hierarchy between viewers and monument. The city attempted to moderate these violations against convention when the statue was unveiled in 1895 by placing the group on a high base, but it also banished the work from the Place de Richelieu. The monument was finally transferred to its intended place in 1924, without the apologistic base.

Rodin's break with sculptural convention made it clear that he would use any further commissions he received not to serve ruling political interests or bureaucracies, but to express the self-image of a social group. In 1891, the "Société des gens de lettre" commissioned Rodin to sculpt a commemorative statue of Honoré de Balzac, their first president, who died in 1850. Rodin saturated himself with Balzac's literary oeuvre, produced more than twenty head studies, and even asked Balzac's tailor for details about his bulky client. The costly studies led first of all to a figure of the author in contemporary costume, rendered in an attempt at realism. In the next carving, Rodin dispensed with the clothes, which had conveyed an image of old age. Instead, he created a muscular nude with crossed arms and stolid shoulders (**203**). His clients were shocked. The final sculpture shows Balzac wrapped in a cloak which he supposedly carried to his work. In the words of Eduard Trier, Rodin transformed the figure of the writer into a "heavy, towering rock." Seven years after he received the commission, when Rodin submitted his design to the Société—a design which he considered his greatest work—he

was met with harsh criticism. In fact, the powerful, nine-foot-high statue (**204**) was not unveiled until 1939—so vociferous were the critical objections.

Rodin had searched for an objective correlative (to use T.S. Eliot's term) to the genius lost in ecstacy, "who reconstructs the whole society piece by piece, to bring it before his contemporary and the following generations in a tumultuous life." In 1831 Balzac himself had prophetically sworn the "art for art's sake" doctrine—a doctrine according to which the artist's self-expression is considered the highest aspiration of the creative agent. In the novel, *The Unknown Masterpiece*, the old painter Frenhofer works for ten years on a portrait of Cathérine Lescaut (called "La belle Noiseuse"). When he finally reveals his work to friends, they are confronted with a tangle of lines and piles of color from which only a foot stands out. This story strongly influenced the subsequent heroes of the modern, including Pablo Picasso, who illustrated it in 1927 for the art dealer Vollard. Picasso transferred two scenes into the studio of a sculptor. The artist's novel was also understood as a universal step into the world of modern art: that which is specifically sculptural blends into the background.

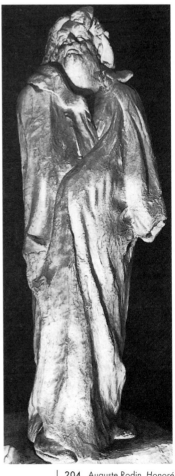

204 Auguste Rodin, *Honoré de Balzac*, 1897. Bronze, 10' (300 cm) high. Rodin Museum, Paris.

1800 – 1900

Glossary
Costume wars: Dispute between the classicists and the realists over the style of clothing to be used on people honored in monuments
Neo-Baroque: Return to Baroque formal language, after classicism, did not always correspond to the needs of representation; part of the historicism that marked the late 19th century, with a variety of styles used together in the design of building façades and furniture

1884 Beginning of German colonial politics

1907 Picasso paints his first Cubist picture, *Les Demoiselles d'Avignon*

1914–18 World War I

1919–33 Weimar Republic

1925 Werner Heisenberg and Max Born develop Quantum Mechanics of atomic particles

1928 The Kellogg, or War Banishment Pact is signed by fifteen nations

1929 The Museum of Modern Art is founded in New York City

The ugly is beautiful

Auguste Rodin, uncontestably the most important sculptor of the 19th century, thrice failed the entrance exam of the Ecole des Beaux-Arts—there could be no surer sign that the academies had lost touch with the stream of artistic movements. In 1875, the stonemason and caster traveled to Italy where he discovered the work of Michelangelo; his experience of its individuality freed Rodin fully from the constraints of academic art.

Rodin's figures are expressive of the contradictions of the late 19th century. His realism springs from the observation of nature, which for him is always beautiful: "The ugly is also beautiful!" He had his models walk nude through the studio, sketched a design, and then, if it pleased him, he worked at lightning speed in clay. In *The Gates of Hell* (**205**, **206**), inspired by Dante's *Inferno*, countless bodies lurch "against the entrance to eternal sorrow." Rodin had received a commission in 1880 for a formal door for the Musée des Arts Décoratifs, but he never completed it. The central figure of *The Thinker*, hunched above the door, was initially conceived as the

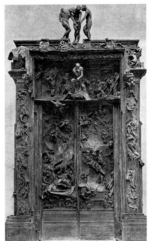

poet contemplating his work, but eventually came to be seen as a figure representative of doubt in the abstract.

During the 1880s, Rodin occupied himself with studies of the different ages. His figure of an old woman, later called *La vieille Heaulmière*

205 Auguste Rodin (1840–1917), *The Gates of Hell*, from 1880, unfinished. Rodin Museum, Paris.

1880 – 1930

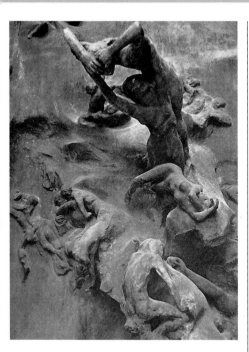

206 Auguste Rodin, *The Gates of Hell* (section). Rodin Museum, Paris.

207 Auguste Rodin, *La vieille Heaulmière*, 1885. Bronze, 20 1/2 x 10 x 12'' (51 x 25 x 30 cm). Rodin Museum, Paris.

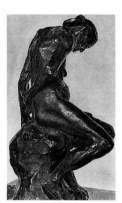

(**207**) after a poem by François Villon, not only presents the emaciated body of the old woman, which might be considered "ugly," but in Rodin's

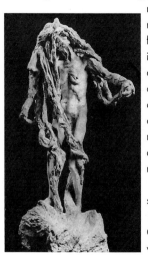

mind as a figure in nature is beautiful—one may also interpret it in more abstract terms, as a symbol of decay, the passage of youth, through maturity to old age in a single natural form.

The only major sculptress of the 19th century was Camille Claudel, who entered Rod-

208 Camille Claudel, *Clotho*, 1893. Plaster, 36 x 14 x 14'' (90 x 35 x 35 cm). Rodin Museum, Paris.

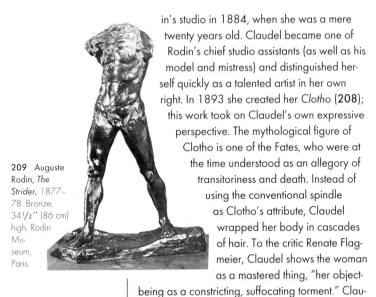

209 Auguste Rodin, *The Strider*, 1877–78. Bronze, 34¹/₂" (86 cm) high. Rodin Museum, Paris.

210 Auguste Rodin, *Danaïde*, 1885. Marble, 14 x 28 ³/₄ x 22 ³/₄" (35 x 72 x 57 cm). Rodin Museum, Paris. Camille Claudel is supposed to have been the model for this sculpture.

in's studio in 1884, when she was a mere twenty years old. Claudel became one of Rodin's chief studio assistants (as well as his model and mistress) and distinguished herself quickly as a talented artist in her own right. In 1893 she created her *Clotho* (**208**); this work took on Claudel's own expressive perspective. The mythological figure of Clotho is one of the Fates, who were at the time understood as an allegory of transitoriness and death. Instead of using the conventional spindle as Clotho's attribute, Claudel wrapped her body in cascades of hair. To the critic Renate Flagmeier, Claudel shows the woman as a mastered thing, "her object-being as a constricting, suffocating torment." Claudel herself suffered from lack of recognition or acceptance and her difficult relationship with Rodin, and was ultimately committed to an insane asylum where she lived out the last thirty years of her life.

In his long career, Rodin imported impressionism into sculpture, rejected superficial academic approaches, borrowed themes from literature (Dante, Villon, Balzac, etc.), and paid homage to the past. His *Strider* (**209**) introduced the autonomous torso. When he was asked why the sculpture had no head, Rodin answered: "Does one need a head for walking?" Mi-

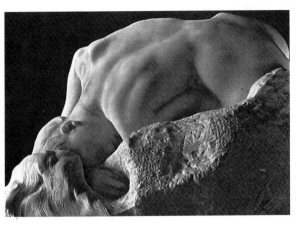

chelangelo's unfinished works may have asserted an influence on Rodin, or he may have intended an allusion to the *Belvedere Torso*, a fragment of a Greek sculpture that served many artists through the centuries as a model of an athletic male body.

Rodin straddles the transition from the 19th century to the 20th, in an artistic developmental sense. On the one hand, his work is clearly rooted in certain traditions and conventions, though it undeniably, on the other hand, transcends both to break completely new ground. One of his most important innovations is the fragmentation of the body. By creating sculptures consisting of only parts of the human form, Rodin firmly asserted the autonomy of the body in artistic representation. It is premature, however, to claim, as art historian Eduard Trier does, that Rodin brought about a new definition of the aesthetic nature of sculpture, as it would be seen by the Cubists. For Rodin, moreover, Trier explains, the torso had a fundamentally different meaning than it had for Michelangelo. While Michelangelo's unfinished slaves are testimonies to his struggle to give visible form to abstract ideas, Rodin used fragmentation in a conscious act of construction, as an aesthetic in itself.

In considering the work of Rodin or the modeled figures of the French impressionistic Edgar Degas, who is better known for his paintings and drawings, it is easy to infer that traditional sculpture since the Renaissance had been limited to no more than a half dozen classic poses. Rodin's *Crouching Woman* (**211**), on the other hand, may have been the result of an accidental observation. The sculptor elevated the ex-

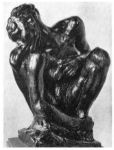

211 Auguste Rodin, *Crouching Woman*, 1880–82. Bronze, 38″ (95 cm) high. B.C. Cantor Art Foundation, California, on loan to the Art Institute of Chicago.

212 Edgar Degas, *Dancer, Looking under her Foot*, 1896–1911. Bronze, 19 ¾″ (49.5 cm) high. Private collection.

213 Edgar Degas, *Petite danseuse de quatorze ans*, ca. 1880. Bronze, 39 ½″ (99 cm) high. Tate Gallery, London.

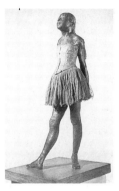

1880 – 1930

214 Umberto Boccioni (1882–1916), *Development of a Bottle in Space*, 1912. Bronze, 15 ¹/₂ x 24 x 12'' (39 x 60 x 30 cm). Kunsthaus, Zurich.

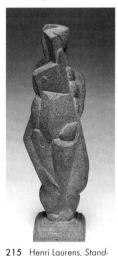

215 Henri Laurens, *Standing Nude Woman*, 1921. Stone, 16 ¹/₂ x 5 ¹/₂ x 4 ¹/₄'' (41.5 x 13.5 x 10.5 cm). Parish Museum, Hanover, Germany.

217 Aristide Maillol (1861–1944), *La Méditerranée*, 1905. Limestone, 46 ¹/₂'' (116 cm) high. Collection of Oskar Reinhart, Winterthur.

pressiveness of the body through the position of the head and the strained hands such that the overall expression is of pure and utter despair. Degas, for his part, studied the casual movements of dancers backstage. His drawings and paintings of ballet dancers in various stages and moods of preparation for the dance are world-famous. One of his most important themes was balance (**212**). As a sculptor, however, he is known only for his bronze *Petite danseuse de quatorze ans* (**213**); this bronze young girl (in all the casts made of her) wears an actual tutu and hair ribbon, making Degas' piece one of the first mixed-media sculptures.

Degas' sculpture became known only after his death in 1917. By the time the Italian Futurist Umberto Boccioni displayed his *Development of a Bottle in Space* (**214**), with its unique combination of space and motif, in Paris in 1913, Jacques Lipchitz, Alexander Archipenko (**242**), and somewhat later Henri Laurens (**215**) had already deconstructed the human figure in a crystalline Cubist manner, and Marcel Duchamp had exhibited his "sculpture," *Fountain* (**216**); this urinal was the first ready-made work of art. The early 20th century, thus, gave witness to these formal experiments, while the less experimental, heavy, structured, and self-supporting female figures of Aristide Maillol were also well received in artistic circles. *La Méditerranée* (**217**) was one of the

216 Marcel Duchamp, *Fountain*, 1917. Readymade. Porcelain urinal, 25'' (62.5 cm) high. New York.

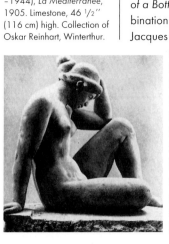

1880 – 1930

main attractions of the fall salons in 1906 and catapulted Maillol into the cultural limelight.

Clearly, as Degas's rather modest combination of nonconventional material and conventional material, or the more extreme development of the ready-made, or *object-trouvé* (found art), introduced by Marcel Duchamp demonstrates, the early 20th century was a time when both the structural norms and the range of "permissible" materials for sculpture were enormously expanded. This broadening of the range of sculpture was perhaps necessarily attended by a consideration of the relationship between form and material, or between manner of expression, content of expression, and means of expression. In *The Problem of Form*, published in 1893, Adolf von Hildebrand had demanded "justice of the material" in sculpture. The modeled form should somehow correspond to the "essence" of the material, although Hildebrand was at the time concerned only with the traditional raw materials of stone and bronze. While the idea of the "justice of the material" attracted some artists and theorists around the turn of the century, and continues to be of some interest today, many artists took offense at this credo, which demanded the subordination of the artist to the material.

Painter/sculptor

Unfettered by academic rules and stimulated by African, pre-Columbian, and Oceanic art, painters and sculptors now eschewed conventional processes and carved figures from wood. The direct chiseling, or cuts (*taille directe*), enforced a break with the old standard of perfection, which the classicists had served. In primitive tribal cultures, the ritual process of hewing corresponds to endowing the figure with a holy or magic spirit.

The exhibition "Primitivism in the Art of the 20th Century" held in 1988 at the Museum of Modern Art in New York undertook the task of covering

218 Paul Gauguin, *Self-Portrait*, 1889. Goblet. Earthenware with transparent glaze, 7 3/4 x 7 1/4" (19.3 x 18 cm). Museum of Decorative Art, Copenhagen.

219 Mixing Goblet, Moche, Peru. 12 3/4" (32 cm) high. The Metropolitan Museum of Art, New York.

1880 – 1930

The Classic Modern

Paul Gauguin

220 Paul Gauguin, *Soyez amoureuses, vous serez heureuses*, 1889. Linden wood, paint, 38 3/4 x 30″ (97 x 75 cm). Museum of Fine Art, Boston.

221 Paul Gauguin, *Lust*, 1890–91 (below right). Painted oak, 27″ (70 cm) high. J. F. Willumsen Museum, Frederikssund, Denmark.

222 Ernst Ludwig Kirchner, *The Dancer*, 1911. Wooden, yellow and black paint, 34 3/4″ (87 cm) high. Stedelijk Museum, Amsterdam.

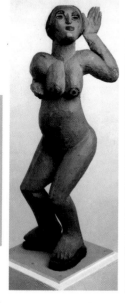

the immense influence of ethnic art on the modern, using comparative examples. In 1889, for example, Paul Gauguin, who grew up in Peru, produced a ceramic goblet that is simultaneously a *Self-Portrait* (**218**) and a vessel characteristic of the Moche culture (**219**). Gauguin worked at one time with the Nabis—a group of Symbolist artists in Pont-Aven, Brittany—and with Vincent van Gogh in the south of France; he left France, however, and traveled widely. In 1887 he moved to Martinique, and then to the South Pacific, specifically to Tahiti, where he died in 1903. The 1889 relief *Soyez amoureuses, vous serez heureuses* (**220**) is an early example of his openness toward Indian and Oceanic tribal art; the piece was completed before he left France. About the symbolism of the relief, Gauguin wrote to the painter Emile Bernard that he himself is presented above on the right like a monster and the fox in the lower right corner symbolizes lust in India. In Tahiti from 1891 to 1893 Gauguin produced several statuettes (**221**). His sculptural works were among the great attractions of the Autumn salons of 1906 and influenced the sculpture of the following generation.

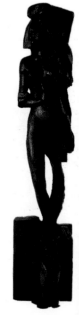

1880 – 1930

120

The Expressionists

The crude painted wood sculptures of "Die Brücke" (The Bridge) document the interest of this group of Dresden-based German artists in ethnographic art. Founded in 1905 by Ernst Ludwig Kirchner (222), Karl Schmidt-Rottluff, Erich Heckel (223), and Fritz Bleyl, Die Brücke first produced exotically painted furniture and household goods made from wood. About wood carving, the painter Kirchner commented: "It is a good thing for painters and draftsmen to make figures, it gives the figures compactness, and it is a sensual enjoyment when blow by blow the figure arises from the timber. Inside each piece of wood a figure is caught, one needs only to peel it out."

The elongated figures of Wilhelm Lehmbruck also fall under the heading of "Expressionism." His larger-than-life *Kneeling* (225) became famous when it was exhibited in the New York

223 Erich Heckel, *Bather with Towel*, 1913. Maple, black and red paint, 16 3/4 x 5 1/2 x 4" (42 x 14 x 10 cm). Private collection.

226 Georges Minne, *Fountain with Five Kneeling Boys*, 1898–1905. Marble, 68" (170 cm) high. Urban Karl Ernst Osthaus Museum, Hagen, Germany.

224 Ernst Ludwig Kirchner, *Sketch for Sculpture*, 1912. Pencil and chalk on paper, 19 1/2 x15 1/4" (48.5 x 38 cm). Bündner Art Museum, Chur.

225 Wilhelm Lehmbruck, *Kneeling*, 1911, cast ca. 1925. Bronze, 70" (175 cm) high. Wilhelm Lehmbruck Museum, Duisburg, Germany.

1880 – 1930

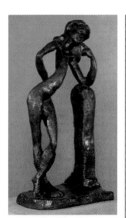

227 Henri Matisse, *La Serpentine*, 1909. Bronze, 22 ½" (56.5 cm) high. Musée Matisse, Nice.

228 Ernst Barlach, *Güstrower War Memorial*, 1927. Bronze, 86 ½" (217 cm) long. Güstrow Cathedral, Germany.

229 Pablo Picasso (1881–1973), *Head of Fernande*, 1909. Bronze, 16 ½" (41.3 cm) high. Private collection, Switzerland.

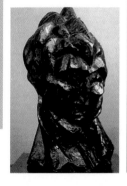

Armory Show of 1913 (one of the few German Expressionist works to make it into the foreign section of this monumental exhibition). Trier compares the motif and the formal language of Lehmbruck's sculpture with George Minne's *Fountain with Five Kneeling Boys* (**226**) and with *La Serpentine* (**227**) by Henri Matisse, whose title may well allude to the *figura serpentinata* of Italian Mannerism. Matisse, also primarily a painter, was deeply interested in African and Oceania sculptures, largely because of their often characteristic lengthening and shortening of the legs and arms.

Apparently untouched by such non-Western influences, the German sculptor Ernst Barlach went on to develop his own compact, block-like figures. His best known work is the *Güstrower War Memorial* (**228**), which was conceived as a memorial for the fallen of the First World War. From 1927, the Nazis began to melt down Barlach's sculptures, including the figure in

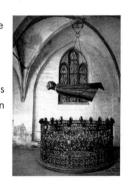

the *Güstrower* that is suspended horizontally, with features like those of the German artist Käthe Kollwitz. Thanks to a preserved casting model, it was possible to cast a second version for the memorial in Güstrow, and a third for the Church of St. Anthony in Cologne. For the historian Trier, "It is her spirit that allows her to defy gravity, though not to a dynamic flight, as presented in Baroque art, but to a static 'soaring-being' analogous to the 'hovering' figures of Gothic sculpture."

Pablo Picasso

Until late in his life, Pablo Picasso kept the seven hundred works of his extensive sculptural output a

closely guarded secret from the pub-
lic. Nonetheless, his sculpture, like his
paintings and other two-dimensional
works, repeatedly kindled sparks of
modernism for other artists, if not
directly, then in their function as de-
partures for his own work.

Two years after Picasso met
Fernande Olivier in 1904 in the
"Bateau-Lavoir," he sculpted a head
of her (**229**); this head is considered
the first Cubist sculpture, although the
fissured surface in its impressionistic
manner is reminiscent of Rodin.
Around 1912 Picasso began to ex-
periment with different materials, including paper,
cardboard, metal, threads, and wires. For the
Guitar, a relief construction, he used sheet metal
and wire.

230 Picasso collected and
preserved ethnographic art
and kept it near him; here he
is seen in a room in his villa
La Californie, Cannes.

The Russian artist Wladimir Tatlin, who visited
Picasso in his studio in 1913, incorporated the
latter's idea of the material collage into his own
Corner Counter-Relief (**232**), which is an early in-
cunabula of Russian Constructivism, a movement

of which
Tatlin would
be a major
exponent.
Picasso's
experiments

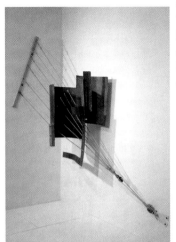

231 Pablo Picasso, *Absinthe
Glass*, 1914. Colored bronze,
8 ½" (21.6 cm) high. Geor-
ges Pompidou Center, Paris.

232
Wladimir
Tatlin, *Corner
Counter-Relief*,
1915 (right).
Display
"0.10," Petro-
grad, 1915.
Left: *Corner
Counter-Relief*,
1915- 1925.
Reconstruction

1880 – 1930

233, 234 Pablo Picasso, *Carnet Dinard 9* (*left*), and *Carnet Dinard 20* (*right*), 1928. India ink and pencil, 14 ¾ x 12 ½" (38 x 31 cm). Gallery Jan Krugier, Geneva.

235 Pablo Picasso, design for the *Monument for Apollinaire*. Iron wire, 24 ¼ x 6 x 13 ½" (60.5 x 15 x 34 cm). Picasso Museum, Paris.

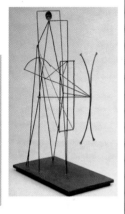

with the inclusion of actual objects in his constructions led to the *Absinthe Glass* (**231**), of which there are six differently painted bronze castings. Picasso modeled the belly of the glass and completed the sculpture—for the first time since Degas' use of the tutu—with an objet trouvé, a spoon.

His ideas for the *Monument for Apollinaire* (1928), which Picasso sketched in two sequences, proved particularly consequential. He immediately applied himself to two creative principles, which would become significant for the sculpture of the 1950s and 1960s: one is the "biomorph sculpture" consisting of organic, bulging forms (**233**), and the other is the wire sculpture, which has also become known as "drawing in space" (**234**, **235**). Picasso personally realized the models for the *Monument for Apollinaire* (**235**) with the help of his friend, the metal sculptor Julio González, although by the time they finished it, the drawings Picasso had submitted had been rejected by the monument committee.

It was considerably later, around 1927, that González decided to dedicate himself to his own sculptures. His late start notwithstanding, he became the founder of metal sculpture, which

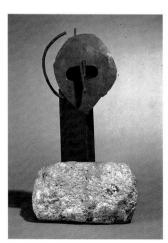

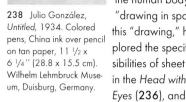

238 Julio González, *Untitled*, 1934. Colored pens, China ink over pencil on tan paper, 11 ½ x 6 ¼″ (28.8 x 15.5 cm). Wilhelm Lehmbruck Museum, Duisburg, Germany.

grew increasingly common in the second half of the 20th century, with artists such as David Smith, Anthony Caro, Hans Uhlmann, Norbert Kricke, and Eduardo Chillida. Around 1918, González, originally an artsmith had entered an apprenticeship as a metalworker and learned the technique of acetylene-oxygen welding. He described his own abstract figures—using the staple of sculpture, the human body—as "drawing in space." For this "drawing," he explored the specific possibilities of sheet iron, as in the *Head with Large Eyes* (**236**), and arbitrarily welded metal parts, as in the *Dancer with Daisy* (**237**). González's symbolic language of forms consists in part of identifiable short forms—the ray-like or parallel-running bundles of iron bars, for instance, representing hair—though his forms can also be interpreted in terms of surrealistic alienation, such as the fingers of a hand, which can also be seen as a flower.

236 Julio González, *Head with Large Eyes*, ca. 1930. Iron, shell limestone base, 17 ½″ (44 cm) high. Wilhelm Lehmbruck Museum, Duisburg.

237 Julio González, *Dancer with Daisy*, ca. 1937. Iron, 19 ¼″ (48.3 cm) high. Centre Julio González, Valencia.

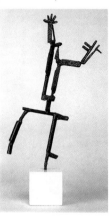

1. Space and time are the sole elements of real life; therefore, if art is to correspond to real life, it must refer to both these fundamental elements.
2. Volume is not the only spatial method of expression.
3. Static rhythms are not the only means of expression for time. Kinetic and dynamic elements are the only methods that make it possible to express real time.
Naum Gabo, *Realistic Manifesto*, printed in 1920 in Moscow in an edition of 3,000 in lieu of official ordinances

1880 – 1930

> "Since the beginning of the Constructivist movement it was clear to me, that one constructed sculpture alone through art and technology of its manufacture, which makes it kin to architecture ... My works created since 1924 seek to combine all the sculptural and architectural elements with each other."
>
> Naum Gabo

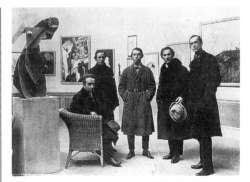

239 The van Diemen Gallery, Berlin 1922. "First Russian Art Exhibition." On the left is Naum Gabo's *Torso*. Left to right: D. Schterenberg (exhibition commissioner), D. Marianow (propaganda commissioner), Nathan Altman, Naum Gabo, and Ludwig Lutz (gallery director).

The unification of art and life

While the work of Julio González marks the birth of metal sculpture, Naum Gabo is one of the first in a string of artists who used metal because of its techno-like features. The constructive sculpture Gabo cofounded (with his brother, Anton Pevsner) was derived from Russian Constructivism.

In 1922, the "First Russian Art Exhibition" was held in the Gallery van Diemen in Berlin. Paul Westheim, the publisher of the *Kunstblatt*, called it an "Exhibition of Artistic Problems." In Kasimir Malewitsch's work *White in White*, he correctly saw no picture, but an intellectual position. The sculptures of Naum Gabo, who traveled to Berlin as the exhibition's commissioner and was supposed to stay in Berlin for the next ten years, made reference to a theoretical consideration. In their *Realistic Manifesto*, Gabo and Pevsner asserted that the only meaning of new art is the demonstration of space and time. Only a few weeks before, Gabo had created

240 Naum Gabo, *Kinetic Construction*, 1919–20; reconstructed in 1985. Metal rod with electric motor, 24 ½" (61.5 cm) high. Tate Gallery, London.

241 Naum Gabo, *Constructive Torso*, 1917 (lost). Reconstructed from cardboard, 1985. 46 ¾" (117 cm) high. Berlin Gallery.

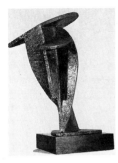

his *Kinetic Construction* (**240**), consisting of an upright standing wire, set in motion with a motor, which the eye experiences as an oscillation of the spindle-shaped figure. Gabo also exhibited his 1916 *Torso* (**241**), a figure soldered out of honeycombed sheet iron. This Cubistic statue in light and shadow has been lost, although a cardboard model discovered after Gabo's death is today one of the gems of the Berlin Gallery.

Alexander Archipenko, a Russian who had been living in Paris since 1908, broke open the concept of mass. His 1913 *Head Construction* (**242**) remained a turning point in his work: From his concave-convex alternating planes of built up torsoes in the Futuristic "Medrano Construction" and the "Sculpto-Painting," in which he attempted to unite both painting and sculpture, he arrived at the essentially archaic.

Gabo, unlike Archipenko, consistently expanded the scope of his sculpture in a manner detached from the individual hand work. His *Space*

242 Alexander Archipenko (1887–1964), *Head Construction*, 1913. Bronze, 15 1/4" (38 cm) high. Private collection, Berlin.

243 Naum Gabo, *Space Construction: Vertical*, 1923–25. Reconstructed 1985. Glass, painted brass, and plastic on a black painted wood base, approx. 48" (120 cm) high. Berlin Gallery.

244 Katarzyna Kobro (1898–1951), *Space Composition 6*, 1931. Painted steel, 25 1/2 x 10 x 6" (64 x 25 x 15 cm). Muzeum Sztuki, Lódz, Poland.

Construction: Vertical (**243**) is stabilized only at a few points through screws and fixtures. The glass parts in the fixtures form an architectural sculpture in space. Like Gabo, in the 1930s Katarzyna Kobro developed architecturally conceived con-

structions (**244**). Kobro had left Soviet Russia at the beginning of the 1920s; together with the painter Wladislaw Strzeminski, she went to Poland. There, in 1932, they jointly formed the easternmost outpost of the international artists' group "Abstraction-Création." Unlike Tatlin, who sought in his *Monument for the Third Internationale* (**245**) not only to build a new future in a symbolic sense, but also to erect a monument, Kobro plays with sculptures with multiple points of view, constructed from planes with countless variants of the new sense of space and time.

245 Wladimir Tatlin, *Monument for the Third Internationale*, November 1920. Reconstruction of 1992–93.

László Moholy-Nagy was another exponent of Russian Constructivism. In 1923, this native Hungarian received a place at the Bauhaus in Weimar, where he added his view of a "Dynamic Constructivism" to the course of instruction.

Stage sets as sculpture

The experiences of the Constructivist organization of space would end up not only being transferred to architecture, design, and the new media (still and moving photography), but also simultaneously revolutionizing theater and stage production. Moholy-Nagy designed a mechanical stage that would be a synthesis of the dynamically contrasting phenomena of space, form, movement, sound,

246 Oskar Schlemmer (1888–1943), figurine "The Abstract" from the *Triadic Ballet*. State Gallery, Stuttgart.

1880 – 1930

247 László Moholy-Nagy,
Light-Space-Modulator,
1922–30. Reconstruction of
1970. Metal, glass, wood,
60 ½ x 28 x 28''
(151 x 70 x 70 cm).
Stedelijk Van Abbe Museum,
Eindhoven, The Netherlands.

and light. Moholy-Nagy's idea of Total Theater
would become manifest in his *Light-Space-Modulator* (**247**). In contrast, the better-known *Triadic
Ballet* (**246**) of Bauhaus member Oskar Schlemmer derived from the effort to fill the stasis of fine
art with living movement and to create, on the
basis of constructed space in synthesis with the
mechanical body movements of the figurines, a
new form of stage art.

Constantin Brancusi
The fascination with technology and the enthusiasm for new materials were well suited to the new
era, which through electrification and mechanization accelerated daily routine. In opposition,
Constantin Brancusi, arguably the last great sculptor of the 20th century, originated in the deepest
provinces of Rumania. The 28-year-old had
already been educated as a cabinet maker at the
Arts and Crafts School of Craiova, as well as
spending four years at the Bucharest Art Academy, by the time he came to Paris in 1904 to be
near Auguste Rodin. Brancusi refused Rodin's
offer to work in his studio, however: in the shadow
of large trees small plants do not flourish. He did
remain in the art world, however, and formed
friendships with the Italian painter Amedeo Modigliani, and the French painters André Derain and
Marcel Duchamp.

1880 – 1930

248 Constantin Brancusi, *The Kiss*, 1907–08. Stone, 11 1/4'' (28 cm) high. Museul der Artā, Craiova, Rumania.

249 Auguste Rodin, *The Kiss*, 1886. Marble, 73 1/4'' (183 cm) high. Rodin Museum, Paris.

250 Henri Gaudier-Brzeska, *Red Stone Dancer*, 1913. Red Mansfield stone, 17 1/4'' (43.2 cm) high. Tate Gallery, London.

251 Constantin Brancusi, *Danaide*, 1910–13. Bronze, top gilded, 11'' (27.5 cm) high. National Museum of Modern Art, Georges Pompidou Center, Paris.

For the painters, who had begun to work directly on blocks of wood, the *taille directe* process remained mostly an excursion, or an episode. Brancusi, however, found new forms and themes in dialogue with the sculptural material. Like the sculptors Jacob Epstein and Henri Gaudier-Brzeska in London, Brancusi referred to African sculpture, only without exploiting the expression of ethnographic art. The first version of *The Kiss* (**248**), the second of his sculptures completely hewn from stone, borrowed its theme from Rodin (**249**) and borrowed its formal reductionism from folk art. Where Rodin's interpretation displays eroticism, Brancusi has created a symbol for the passionate fusion of man and woman.

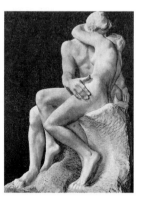

The *Danaide* (**251**), which again refers to a work of Rodin (**210**), demonstrates one of Brancusi's important innovations. In this sculpture, the polished bronze head is reduced to an oval and partially gilded, and set on a roughly hewn wooden pedestal. With his sculptures, Brancusi established his own frame of reference, which functioned also in purist theatrical presentation.

For the artist, the studio was the ideal space for his sculptures. His

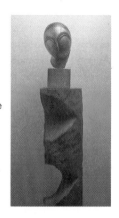

1880 – 1930

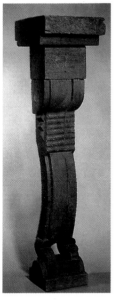

wooden steles, inspired directly by African sculpture, emphasize the equal treatment of bases and figures (**252**). For Brancusi, who had abandoned modeling in clay, more than for other artists, the appropriateness of the material to the form was unwritten law. Accordingly, he reduced his marble sculptures to their essential oval form. His *Sleeping Muse* (**253**), the first version of which he sculpted in 1909–10, demonstrates the uncompromising reduction of the head to the shape of an egg. This abstraction picks up the similarity to nature, without denying its reference.

Like Piet Mondrian's geometric color compositions in the process of forced abstraction of the structure of an apple tree, Brancusi first moved outward from the object. For him, the egg form symbolized fertility, the source of life. He called a bronze version of 1924 the *Beginning of the World* (**254**); its reflecting surface optically emphasizes its materiality. The same phenomenon is exploited in the bronze versions of his twenty-seven-plus bird sculptures: while the mythical bird *Maiastra* (**255**) is still recognizable as a bird, by the time Brancusi created the *Bird in Space* (**256**), all literal references to the animal disappeared. In 1927, the photographer Edward Steichen wanted to introduce one of Brancusi's bronze birds to America. The customs officials, however, were

252 Constantin Brancusi, *Caryatid*, 1914–16. Wooden, 66 ¾″ (167 cm high). Fogg Art Museum, Harvard University, Cambridge, Massachusetts.

253 Constantin Brancusi, *Sleeping Muse*, 1927. White marble, 11 ¾″ (29.3 cm) long. Collection of Mary A. H. Rumsey.

254 C. Brancusi, *The Beginning of the World*, 1924. Bronze, 10 ¾″ (27 cm) long. National Museum of Modern Art, Georges Pompidou Center, Paris.

1880 – 1930

baffled by the smooth bronze body, which in no way conformed to customs criteria, according to which works of art had to be conspicuously hand-modeled. To them, the sculpture appeared to be no more than a clump of material, and they therefore demanded the 40 percent import duty. Brancusi won a lawsuit in the following year and was awarded compensation.

A look inside Brancusi's studio (**257**) betrays how obvious the dialogue between bases and figure was to the sculptor. This studio photo taken in 1918 shows one wooden column built up from rhomboid forms. The *Endless Column* might, so art historians conjecture, first of all have been conceived as a

255 C. Brancusi, *Maiastra*, 1912. Bronze, 24 ½" (61 cm) high. Private collection.

256 Constantin Brancusi, *Bird in Space*, ca. 1940. Bronze, 76 ½" (191.5 cm) high. National Museum of Modern Art, Georges Pompidou Center, Paris.

258 Constantin Brancusi, *Endlesss Column*, 1937–38. Iron casting, 978'4" (293.5 m). Tîrgu Jiu, Rumania.

257 Constantin Brancusi, *Endless Column*, in the studio, photo taken in 1918.

pedestal for a form. This may be true, or it may not be: many columns executed in multiple versions number among the body of Brancusi's continuing work. With repetition of the module he effaced his personal signature, construction became reproductive. In 1937–38 Brancusi created the endless column in monumental proportions. The Rumanian government had authorized him to create a monument for the sacrifices of the First World War in the park of Tîrgu Jiu, and gave the internationally renowned artist a completely free hand. Brancusi built the nearly 978-foot

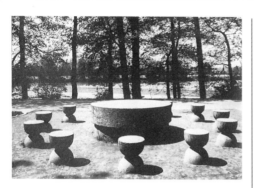

(293-meter) high column (**258**) in a line with the *Table of the Still* (**259**) and the *Kiss Door* (**260**), both of which refer to themes from his previous work: the base of the table refers to his *Leda* (**261**), while the door is a monumental version of *The Kiss* (**248**).

Remarkably, this installation corresponds to the axis in Paris running from the Obelisks of Luxor and the Place de la Concorde, over the Arc de Triomphe to the Parc du Caroussel. Thus, Brancusi used a structure familiar as a celebration of French imperialism for a war memorial. It is doubtful that the sculptor himself was conscious of the analogy and its implications.

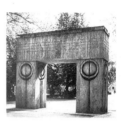

260 Constantin Brancusi, *Kiss Door*, 1937. Stone, 16'9" (5.27 m) high. Tirgu Jiu, Rumania.

Surrealism

Surrealism exerted a significant influence on the development of sculpture. Since the surrealist artists were not wedded to any particular material, they tended to produce strange objects along the lines of Marcel Duchamp's ready-made.

The American artist Man Ray, known as a photographer though he actually worked in a range of media, created haunting, unsettling objects such as the *Cadeau* (**262**), in which he mounted a row of upholstery nails along the flat surface of an iron. Among the circle of surrealists who came to Paris from Basel was Meret Oppenheim, whom Man Ray liked to use as a model

261 Constantin Brancusi, *Leda*, 1923. Marble with stone pedestal, 21 1/2" (53.4 cm) high. Art Institute of Chicago.

1880 – 1930

133

262 Man Ray (1890–1976), *Cadeau*, 1921. Iron with 14 nails, 6 ½ x 4″ (16 x 10 cm). Original lost, reproduced 1963. Private collection.

because of her boy-like beauty. In her own work, Oppenheim, like Ray, explored the function of an object stripped of its inherent power; for example, she covered a cup, saucer, and spoons with fur and called it *Breakfast in Fur*. The concept might well be an allusion to the "Déjeuner en Fourrure"—breakfast with oysters and champagne—which French ladies are supposed to have attended dressed in fur.

Surrealistic sculpture, however, must be approached from a more narrow perspective: the surrealist sculptor projects his or her own image via such dramatic themes as love and power, sexuality and blood lust (e.g., Alberto Giacometti), or strives to redefine certain essential underpinnings of life via the metamorphosis of material (e.g., Hans Arp, Max Ernst).

In 1930, after ten years of modest success, Alberto Giacometti's surrealistic early work captured the attention of the Parisian art world. At the New Year's Exhibit of gallery owner Pierre Loeb, Giacometti showed his *Hovering Ball* (**263**), which had been executed by a cabinet maker in wood after a plaster model. The ball with an indent along a section of its surface and the underlying sickle glide into each other. The piece was considered sexually provocative. André Breton bought the sculpture in a gesture to win Giacometti over to surrealism. In addition to the sexual symbolism, the piece suggests the moment of wounding, reminiscent of the cutting through the eye in Luis Buñuel's surrealistic film *The Andalusian Dog* (1928).

263 Alberto Giacometti, (1901–66), *Hovering Ball*, 1930, Iron and wood, 24 x 14 ½ x 13 ¼″ (60.3 x 36 x 33.1 cm). Private collection.

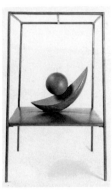

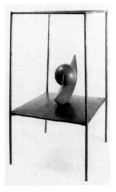

The reservoir of the modern

The most important artistic/aesthetic innovations of the beginning of the 20th century—the ready-made, abstraction, Cubism, Constructivism, Surrealism—brought with them a major expansion of sculptural ideas. The time of change we know today as the classic modern to this day remains a reservoir from which new artistic positions continually draw inspiration. For example, from Brancusi, the minimalists take the concept of the module in which the individual signature of the artist is eliminated. This was how the Rumanian sculptor was able, unlike others, to create out of an intense struggle with his material. His principle, to create universally understandable "ur-forms" such as the oval, refers to an interest in archetypal symbols, which was considerably broadened by the surrealists.

Marcel Duchamp—though never a sculptor in any traditional sense—has a particular meaning for nearly all three-dimensional art works standing in space by the later decades of the 20th century. Duchamp's ready-mades, in a rational, technically spirited time, threw the viewer's interpretation right back at him or her. In a very real sense, Duchamp marks the beginning of conceptual art, which reached an apogee in the 1960s. In 1956 Duchamp formulated it thus: "a work is made completely by the one who views it or reads it and they, through their applause or even through their rejection, allow it to survive."

264 Marcel Duchamp (1887–1968), *Bottle Dryer*, 1914. Reproduced in 1964. Ready-made, first displayed in 1921; galvanized iron, 25 ½'' (64.2 cm) high. National Museum of Modern Art, Georges Pompidou Center, Paris. Duchamp was himself conscious of the aesthetic view of bottle dryers in the 1960s: "This damned Hérisson has become a large temptation. It begins to look good."

Avant garde: French = vanguard; an artistic position that sees itself in relation to society, such as the "Russian avant garde," which had a new society in mind, or the Dadaists, who reacted to the absurdity of life in the face of the First World War
Classical modern: Among other things, the formal innovative tendencies of the first half of the 20th century
Ready-made: Designation for industrially produced commodities: "prefabricated objects that have attained the dignity of a work of art through the choice of the artist" (André Breton); of course, in the ready-mades of Marcel Duchamp, bringing out the dignity of an object may not be the artist's point—it might more likely be to debase the dignity of art.

1880 – 1930

135

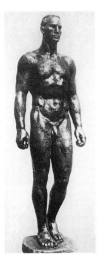

265 Georg Kolbe, *Decathlete*, before 1941. Bronze.

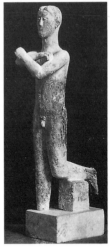

266 Hermann Blumenthal, *The Man in the Water (Bather)*, 1932. Brown-toned plaster, 1936–37, stolen from the studio in the Klosterstrasse Studio Organization.

The production of German art during the twelve years under Nazi domination is often eagerly passed over in overviews of art history. Even the *Propyläen Art History*, a standard German art history text, doesn't touch it, not even to differentiate between a decathlete by the Nazi sculptor Arno Breker and the same motif by Georg Kolbe (265). In 1982 Klaus Wolbert published *The Naked and the Dead of the "Third Reich,"* in which he distilled the fine differences and considered the art of the Third Reich within the context of the continuum of traditional sculpture. The most important results: A change had certainly occurred in 1933, yet nothing new prevailed, though some developments passed into obsolescence. The question of the quality and value of the Nazi-era figures, however, remained unanswered.

The longing for one universal image of humanity, with reference to the ancient Greeks, was sanctioned through the excessive elevation by German culture of Goethe as the "übervater" after the Germans were defeated in the First World War. Representation of the nude had survived the experiments of the modern. Artists following Adolf von Hildebrand, including the sculptors Edwin Scharff, Georg Kolbe, and Richard Scheibe, were less inclined to venture into the abstract expressionist realm, and produced much more figurative work.

While abstract and expressionist sculptures such as Otto Freundlich's the *New Man* (269) were slandered in an exhibit of "Degenerate Art,"

267 Hermann Blumenthal was killed in 1942 during Hitler's campaign against Russia. This 1933 sketch reveals his interest in the tectonic construction of the figure.

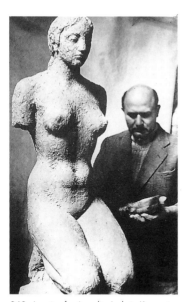

268 Longing for Arcadia: Ludwig Kasper in his studio in the Berlin Klosterstrasse.

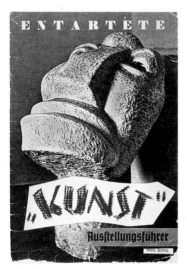

269 Otto Freundlich's *New Man*, slandered on the cover sheet of the catalog for a 1937 Nazi-sponsored exhibition called "Degenerate Art."

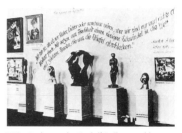

270 Sculptures by Rudolf Belling and by German Expressionists were exhibited in "Degenerate Art" in 1937.

Hermann Blumenthal and Ludwig Kasper were granted a niche.

Goethe had once declared that the mandate of sculpture is to present the dignity of the person within the form of the human body. This dictum was specifically invoked by Hitler, though otherwise, the official policy of the Third Reich toward sculpture offered no concrete ideas initially. Later ostracized and banned from exhibiting in their homeland, artists including Lehmbruck, Kollwitz, and Barlach had once been touted as "Pioneers of the strong German form." But with the Third Reich under full sway, the art that was allowed to be displayed consisted mainly of animal representations, portrait heads, and harmless scenic genres,

271 Karl Albiker, *Relay Runners*, 1936. Berlin Olympic Stadium.

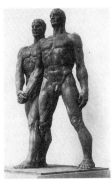

272 Josef Thorak, *Comradeship*, 1936–37. Group for the German Pavilion at the 1937 World's Fair in Paris.

with an occasional nude.

When the 1936 Olympic Games were held in Berlin, the Nazis seized on the promotion of the athlete as the representative of the perfect human form; thus, the popularity of the games was exploited as a pretense for the display of supposedly perfect bodies, of the racial ideal, the perfect Aryan, envisioned by Hitler and his chief ideologues.

In such a milieu, Karl Albiker carved his larger-than-life *Relay*

273 Josef Thorak, *Self-Denial*, 1940.

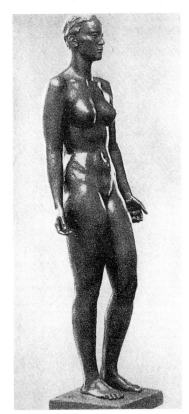

274 Georg Kolbe, *Amazon*, 1942.

Runners (271) and *Discus Thrower* for the Berlin Olympic Stadium out of travertine marble. The work of Josef Thorak and Arno Breker, however, was more influential in setting the aesthetic and ideological standard for the propagandistic National Socialist body design. *Preparedness* (275), which Breker created in 1939, bears reference, obviously, to Michelangelo's *David*, but his unnatural accumulation of tight, sinewy muscularity produces a rather

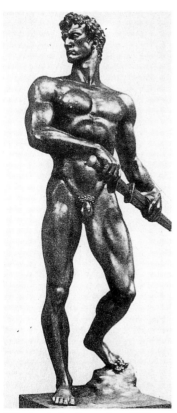

275 Arno Breker, *Preparedness*, 1939.

armor-like anatomy. This is, of course, perfectly consistent with the expression of mastery over the human body which expunges any memory of the apparently freely evolved corporeality that had characterized sculpture even in Germany at the beginning of the century.

The Nazi-era representation of women in German sculpture is clearly dominated by prostituting moments. Josef Thorak's *Self-Denial* (**273**) reinforces the accepted role

of women even in its title. Women were seen only as organs of elementary biocentric powers, as the "vessel of manly semen," as National Socialist goddesses of fruitfulness, their individual eroticism entirely erased.

"People die, deeds endure." Such would seem to be the underlying ideology of National Socialist sculpture: mankind made of steel symbolizing the blind devotion demanded by the führer of the mortal soldiers and the mothers responsible for the new generation. Hitler's desire was for a "powerfully active, ferocious youth" who "learns to conquer the fear of death."

The rearmament of the human body as machine-like figures came about gradually. Even if the ideal substance of the classic body had already been corrupted in the 19th century, the National Socialists' exploitation of this decaying vision reached an intolerable level. After 1945, awareness of the human figure and its representation in the arts seemed initially to offer mere continuity. Thus, Richard Scheibe, as well as Gerhard Marcks, were given professorships in the postwar era; moreover, nobody was particularly fazed in 1942 when Arno Breker, enjoying continued success after the end of the war, bought back the Nazi-approved work he had exhibited in Paris and set it up around his garden where no one would see it.

1945 Unconditional surrender of the Germans and end of World War II; the first atomic bomb dropped by the United States on Hiroshima leaves 100,000 Japanese dead

1950 Red Chinese troops penetrate into Tibet

1958 Preliminary ban on nuclear tests in the United States

1961 First orbital space flight: Soviet Major Yuri Gagarin

1964–75 The Vietnam War

1967 Six Day War of Israel against the Arab nations ends with a crushing defeat for the Arabs

1969 Apollo 9, Neil Armstrong and Edwin Aldrin walk on the moon

1974 Richard Nixon resigns from the U.S. presidency

1976 Death of Mao Tse Tung (b. 1893), founder of the People's Republic of China

1989 The fall of the Berlin wall leads to the reunification of Germany

1945 – today

Paris, which had been the center of the modern art world since the 19th century, managed to sustain its radiance for a short time after 1945, though even the city of light was not spared by the devastation of the Second World War, of the Nazis, and of the Vichy government. After the June 1940 invasion by German troops, Hitler led his sculptor Arno Breker on a tour through Paris. Breker's exhibition in the Orangerie became a symbol of the occupation. Many modern artists fled to the countryside, others went to New York.

New life for the human figure

Unlike the many artists who chose to flee Nazi-occupied France, the Paris-born sculptor Henri Laurens remained at home in his Villa Brune at the Porte der Châtillon. Since the 1920s, Laurens' style had changed under the influence of Maillol, from a Cubist-analytic formal language to a language that was more dynamic, more voluminous. In reaction to the exodus of his colleagues, he created his 1940–41 *Adieu* and *The Little Adieu* (**276**). These sculptures show a reduction in the inherent motion of the figures in favor

276 Henri Laurens (1885–1955), *The Little Adieu*, 1940–41. Bronze, 9 ½ x 10 ¾ x 10″ (24 x 27 x 25 cm). Parish Museum, Hanover.

of a sense of monumentality. This heavy, sunken-in figure represents Laurens' first overt statement on the contemporary situation, in art as well as in life. In the face of current avant-garde experiments with materials, Laurens followed the logic of the material and the rules of sculpture, which attained a new legitimacy after the debacle of World War II. His postwar book illustrations for the publisher Tériade

277 Henri Laurens, *Sleeping*, 1951. Pencil, chalk on paper, 8 x 13" (20 x 32.5 cm. Parish Museum, Hanover.

are autonomous drawings (**277**) that clearly bear the signature marks of the sculptor: over the contour lines, Laurens spread a colored surface, granting the figure emphasis and dimensionality.

> "When he models in clay, Laurens works at the same time on the emptiness that surrounds this matter; the space itself becomes form. Laurens simultaneously creates a volume of space and volume of clay. The volumes alternate, equalize themselves, and close themselves together around the sculpture."
> *Alberto Giacometti*

Existentialism

Alberto Giacometti, the much younger Swiss sculptor, was an admirer of Laurens. When he left Paris in June 1940 after the invasion, in panic and on a bicycle, he managed to hide his *Pin Figures* (**278**), which had been created in 1935 after Giacometti's break with surrealism, in a couple of match-boxes in a corner of the studio.

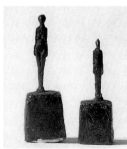

278 Alberto Giacometti (1901–66), *Pin Figures*, 1940–41. Bronze, approx. 1 ¹/₂" (4.1 and 3.5 cm) high. Legacy of C. and Y. Zervos, Commune der Vézelay.

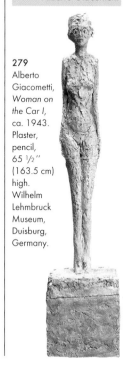

279 Alberto Giacometti, *Woman on the Car I*, ca. 1943. Plaster, pencil, 65 ¹/₂" (163.5 cm) high. Wilhelm Lehmbruck Museum, Duisburg, Germany.

Giacometti's chief work, the emaciated "Stick Figures," are generally interpreted as expressions of the existentialist mood, crystalized between 1942 and 1945, and became even stronger in the 1950s. In the painting studio his father left him in Maloja, Switzerland, Giacometti produced the first almost life-sized, head-on *Woman Figure* (**279**) of this type. Since 1938, his creative process began to focus

1945 – today

280 Alberto Giacometti's studio in the Rue Hippolyte-Maindron.

281 Alberto Giacometti, *The Plaza*, 1948–49. Bronze, 4 3/4″– 6″ (12–15 cm) high. Collection of Peggy Guggenheim, Venice.

282 Alberto Giacometti, *Annette*, Oil on canvas, 32 1/2 x 26″ (81 x 65 cm). Alberto Giacometti Foundation, Zurich.

on memory images, exploring an imaginary space that displaced actual space. This shift away from observation and toward images from memory impressed itself on the sculptor in 1937, when Giacometti saw his lover Isabel disappear around midnight on the boulevard St Michel.

For the rest of his life, Giacometti wrestled with this ephemeral image of humanity—during long hours of model-sittings in his spartan studio in the Rue Hippolyte-Maindron 46 (280). The sculptor's brother Diego carefully cast Alberto's proportionate though anatomically indistinct modeled female figures. To this group of works Giacometti added the *Striding Man* after 1948–49; he assembled them all together on a plinthe. The result was *The Plaza* (281), a "Monument to Human Existence." Though no figure exceeded 6 inches in height,

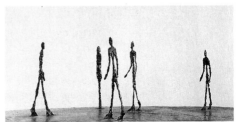

Giacometti considered *The Plaza* no insubstantial construction, but a clear, direct expression of life at street level.

Giacometti's work was well known and widely studied. Jean-Paul Sartre wrote approvingly about his sculpture, as did the controversial French dramatist Jean Genet. Giacometti dominates the sculpture of the early postwar years. He was, however, not sculpting in a vacuum. A relatively obscure artist was Germaine Richier. With her *Great Prayer*

to God (**283**) Richier created a monstrous hybrid entity that was also interpreted, like the work of Giacometti, as a metaphor of existentialism.

Organic volume

Besides the new interest in the human image, sculptors in the 1950s set themselves the monumental task of rendering organic forms. The credo "Abstraction as a Worldwide Language" bestowed on these nonfigurative works the breadth of internationalism, whether they dealt with "abstract" or with "concrete" forms.

From around 1931, Hans Arp, who had already made his mark in the 1920s as a Dadaist and surrealist, created the first full sculptures made of plaster. He called these works "Human Concretions," referring to Theo van Doesburg's definition of a work, which no longer need refer directly to a model (unlike abstraction, in which the model may be indiscernible, but did serve as a jumping off point and may provide an integrated organizing principle). Arp was a member of a group of international artists founded in 1931 in Paris who called themselves "Abstraction Creationists." This group included Naum Gabo, Anton Pevsner, and Max Bill. Arp's dissolving torsos and perforated sculptures (**284**) appear to be alive through their changing positions.

The English sculptor Henry Moore, in contrast, drew his inspiration from "driftwood, pebbles, or bones" and

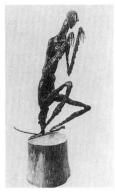

283 Germaine Richier (1902–59), *Great Prayer to God*, 1946. Bronze, 48″ (120 cm) high. Hall of Art, Mannheim, Germany.

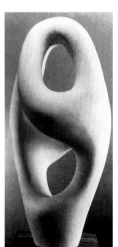

284 Hans Arp (1887–1966), *Ptolemäus*, 1953. Limestone, 41 ¼″ (103 cm). Burden Collection, New York.

"Concretion is the natural process of condensation, hardening, congealing, bulging, growing together ... Concretion means petrification, stone, plants, animal, person. Concretion is something growing."
 Hans Arp

1945 – today

143

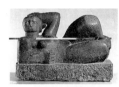

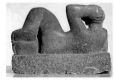

285 Henry Moore (1898–1986), *Reclining Figure*, 1929. Stone, 22 ¾ x 33 ½ x 15 ¼" (57.2 x 83.7 x 38 cm). City Art Gallery, Leeds, U.K.

286 Henry Moore, *Reclining*, 1969–70. Bronze, 68 ¾ x 174 ½ x 98 ¾" (172 x 436 x 247 cm). Hakone Open Air Museum, Japan.

applied these forms to his interpretations of the human body. Moore varied a few motifs (mother and child, family group, the wounded warrior) over and over since the end of the 1920s. The *Reclining Figure* (**285**), which he recreated over a hundred times, refers back to pre-Columbian art. At the end of the 1950s, Moore divided his sculptures into two sections (**286**) and placed them into the landscape.

Likewise, Max Bill, the leader of the Academy of Design in Ulm, was entrusted with monumental commissions. His nonobjective sculptures formed of circles and ribbons are based on mathematical principles (**287**), expressing a harmonious sense of balance. Bill may be considered the first consistently "concretist" sculptor. This he himself defines: "Concrete art is in its final consequence the pure expression of harmonious measure and principle."

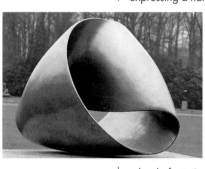

287 Max Bill (1908–94), *Endless Loop*, 1935/56. Bronze, 50 x 50 x 32" (125 x 125 x 80 cm). Open Air Museum voor Beeldhouwkunst Middelheim, Antwerp, The Netherlands.

Iron work

A mechanic's workshop was seldom a standard facility of the school of art. American sculptor David Smith, whose work forms a bridge between the artsmith González and the metal artists of the 1970s, came to his work with iron and steel through an early job as an auto welder. He was the first artist known for working with industrial scrap metal, and thereby launched an American practice that was a clear counterpoint to European tradition.

Smith's sources of inspiration ran a course through the circuitous tradition of the modern era.

When a friend entrusted him with a head by Gon-
zález, Smith set out on a trip to Europe in 1935–
36. This voyage brought him to Paris, Greece,
London, and Moscow. When he returned to New
York—by now the new center for abstract expres-
sionism, and the growing rival of Paris as the cen-
ter of the art world—he met the expressionist paint-
ers Willem de Kooning and Jackson
Pollock.

It was, then, in this milieu that Smith
created forged and welded iron sculp-
tures, such as *Blackburn—A Song of an
Irish Blacksmith* (**288**). This "drawing
in space," which Smith intended to be
placed outdoors, is a homage to one
of the proprietors of the "Terminal Iron
Works" in Brooklyn, where the artist
had worked since 1940. Smith's work
evolved from these sculptures worked
in silhouette to his series *Agricola*,
which welded parts of agricultural
machinery into an assemblage. From 1953 to
1955 he created his *Tanktotems* out of tank cov-
ers; when in 1963 he assembled a pile of square
forms to create *Cubi* (**289**),
he approached a new
formal language. Accord-
ing to art historian Frede-
rick Hartt, what remains
fascinating, and ground-
breaking, about Smith's
sculptures is that, while he
worked in three dimen-
sions, and created a rich
array of lines and planes,
he did not create volume,
as previous constructed
sculpture had done.

The work of David Smith
marks a decided turning

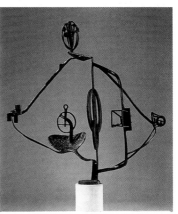

288 David Smith (1906–
63), *Blackburn—A Song of an
Irish Blacksmith*, 1949–50.
Iron, bronze, marble, 46 ³/₄
x 41 ¹/₄ x 23 ¹/₄" (117 x
103.5 x 58 cm). Wilhelm
Lehmbruck Museum,
Duisburg, Germany.

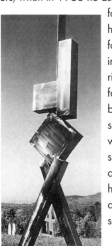

289 David Smith, *Cubi VI*,
1963. Stainless steel, 12'
(36 m). Estate of the artist.

point in sculpture, which would continue to break many hard and fast rules from the past millenia in rapid succession in the final decades of the 20th century. The proliferation of metal junk art by artists such as John Chamberlain and Richard Stankiewicz was a sign of change not just in material but in method; sculpture became very much an art of assembling and constructing, rather than carving or modeling, and this would forever alter the nature of the form.

Perhaps the most expressive of the assemblage artists was the American Louise Nevelson (1900–1988). Nevelson grew up with the abstract expressionists but did not make her own mark in an appreciable sense until the 1960s. Her sculptures, wall-like structures harking back to the tradition of the relief, attain classical proportions—though they are fully assembled out of found objects—boxes, scraps of wood, pieces of furniture, architectural and ornamental fragments. Her 1960–65 work, *An American Tribute to the British People* (now in the Tate Gallery in London) may be thought of as a successor to Lorenzo Ghiberti's *Gates of Paradise* and to Auguste Rodin's *Gates of Hell.* Thus, Nevelson brought traditional compositional and stylistic elements to a thoroughly new technique.

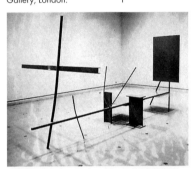

290 Anthony Caro (b. 1924), *Early One Morning,* 1962. Painted aluminum, 144 x 244 x 131' (43.2 x 74.2 x 39.3 m). The Tate Gallery, London.

291 Anthony Caro, *Shadows,* 1968. Lacquered steel. Westphalian State Museum, Münster.

"Sculpture became bogged down because it stuck to monuments and monoliths, because it took itself too seriously. I have freed sculpture from these totems, I have tried to cut away something of their decorative language and bring it in more direct relationship to the viewer, and that has helped some."

Anthony Caro

The assemblage technique developed by Smith and others was adopted by the English sculptor Anthony Caro. Caro started out working in clay as an assistant to Henry Moore. In 1959 he came on a stipend to the United States. It was here that he was exposed to the work of David Smith. When he returned to England, Caro equipped himself with welding tools and scrap metal. One of his earliest works, *Early One Morning* (**290**) was precocious in its embodiment of a formal vocabulary that would not fully evolve until much later: without a base, the sculpture stretches out

292 Alexander Calder (1898–1976), *Untitled*, ca. 1940. Steel, iron, black and orange paint, 93 1/2″ (234 cm) high. Wilhelm Lehmbruck Museum, Duisburg, Germany.

293 Jean Tinguely (1925–91), *Fairy Tale Relief*, 1978. Wood, iron, rubber, children's toys, garden gnome, electric motors, 112 x 248 x 60″ (280 x 620 x 150 cm). Wilhelm Lehmbruck Museum, Duisburg, Germany.

horizontally in space, through which the silhouette produces an image. The *Table-Pieces*, which Caro created in 1966, return to the simple use of primary colors. *Shadows* (**291**) encloses no space, follows no established principles, but presents the form of the materials as a means of expression.

Iron by now was an established medium, and many sculptors were using it in different ways. The American Alexander Calder (**292**) in the latter half of the 20th century bent figures out of wire and built mobiles in contrasting primary color combinations; he calls his nonmoving sculptures, in contrast to his mobiles, "stabiles."

The Swiss artist Jean Tinguely used scrap metal to construct playful, absurd machines (**293**), while George Rickey created kinetic sculptures in which

294 Hans Uhlmann (1900–75), *Accord*, 1948. Black-toned iron, 31 ¾" (79.5 cm) high. On temporary loan to the Wilhelm Lehmbruck Museum, Duisburg, Germany.

small steel needles were positioned in moveable airplane hinges, allowing the sculpture to assume a multitude of positions and appearances.

Moving in space

The evolution of artistic ideas had always depended on an establishment of boundaries—a process of definition and redefinition of the limits of a given form or medium. By the latter half of the 20th century, these boundaries had both expanded almost infinitely, and contracted as well, down to the microlevel of pure concept. And so, today, we might consider earth art, performance art, and minimalist combinations the last offshoots of the history of sculpture (at least for the time being).

Norbert Kricke taught beside the revolutionary Josef Beuys at the Düsseldorf Academy. While Kricke was the purist who for thirty years held fast to his material and his linear language, Beuys explored the boundaries of abstraction, which he found first in the analogy of "thought as sculpture" and from life in society as "social sculpture."

Knowledge of structure was well exploited in the wire sculpture of Hans Uhlmann, who had assumed an important role in the art world of postwar Berlin. Before the Second World War, Uhlmann had studied mechanical engineering and taught at the technical university in Berlin-Charlottenburg. He began by soldering constructivist wire and sheet metal sculptures with primitivist influences; of course, back in 1935, there was little opportunity for Uhlmann to show these works publicly under the Nazi regime, so he kept them hidden at home on his kitchen table. After 1945 Uhlmann began to search in his sculpture for a sculptural analogy to music, and he began to bend wire in what he considered linear progressions for rhythm and movement (**294**).

295 Norbert Kricke (1922–84), Space sculpture *Mannesmann*, 1958–59. High-grade steel, 280" (700 cm) high. Mannesmann high-rise, Düsseldorf.

The much younger Kricke had quickly extricated himself from figurative echos; he saw in the pure line a manifestation of movement. Kricke shaped gleaming steel rods into angled, bent, and coiled forms to create a sculpture captured in space. His *Mannesmann* (**295**) forms a powerful bundle of steel rods radiating out in all directions. Over the years, Kricke has untangled his balls of wire into simplified individual strands, stretched out on the floor and attempting to seduce the eye through changing angles into the experience of its rhythmic movement. With this, and like others of

296 The Kricke Room *Situation Art—Weitmar House*, Bochum: *Space Sculpture White* (1975) and a drawing from the 1980s.

his generation throughout the world, Kricke brought his sculpture down to the boundary of the immaterial. In *Situation Art—Weitmar House*, which Kricke dedicated to the art historian Max Imdahl in Bochum, beside the late work *Space Sculpture White*, are several drawings that produce a similar effect (**296**).

297 Joseph Beuys, *Torso*, 1949-51. Plaster, gauze, wood, lead, oil paint, 41 3/4" (104.5 cm) high. Wilhelm Lehmbruck Museum, Duisburg, Germany, on temporary loan from the collection of Eva Beuys.

Thought is sculpture

Joseph Beuys, though not a household name like Rodin, Brancusi , or Picasso, has influenced many of the sculptors who were to make their mark on sculpture throughout the world in the latter years of the 20th century. His experiments with a new realm of nontraditional materials—in an era when the nontraditional had become traditional—and his lessons as a teacher, filtered into the early training of the American Process Artists (including Robert Morris, Richard Serra, and Eva Hesse), as well as

298 Joseph Beuys, *Elk*, 1979. Color lithograph, 18 1/4 x 25" (45.7 x 62.3 cm). Copper Engraving Cabinet, Museum of Prussian Culture, Berlin.

1945 – today

299 Joseph Beuys, *Fat Chair*, 1964. Beuys Center in the Hessian Museum, Darmstadt. Photo: Eva Beuys, Düsseldorf.

into the works of a new generation of German painters and sculptors.

When Beuys entered the Düsseldorf Academy in 1947, he was fascinated by the archaic animal figures of Ewald Matarés. The *Torso* (**297**) is a relic from this time, a half-finished, female nude. The corroded working body was part of the Beuys Installation in the "Zeitgeist" exhibit of 1982–83 in the Berlin Gropiusbau. The animals that emerge in his sculptures, performances, installations, and drawings (**298**) play with their mystical symbolism, with Beuys suggesting a spiritual dimension through the superimposition of religious imagery.

With the *Fat Corners* and *Fat Chairs* (**299**), known from the 1960s, Beuys "initially wanted to kindle discussion." He first decided to use fat and felt—flexible, temperature-sensitive materials—in 1963, claiming that as substances unknown to conventional art processes, they "stand for an elementary basis of our life." One might say they were certainly the elementary basis of his own life: when, during the Second World War, Beuys was shot down in 1943 as a Nazi combat pilot, nomadic Tartars supposedly saved his life by rubbing him with fat and wrapping him in felt. The story may or may not be true, though many see in his use of such unusual media his desire to atone for his Nazi past.

In 1961 Beuys became a professor at

300 "I Like America and America Likes Me," Gallery of René Block, May 23–25, 1974. Photo: Gwen Phillips, New York.

301 Joseph Beuys, for "Action using Felt Objects," assembled for the retrospective in 1979–80 in the Solomon R. Guggenheim Museum, New York. Photo: Franziska Adriani.

the Düsseldorf Art Academy. There he came in touch with Nam June Paik, known for his video-sculptures and learned of the "Process" movement. His material palette expanded into the acoustic realm. He developed his characteristic performance form, using his signature material and motifs: fat, felt, and animals. In 1974 he locked himself and a coyote, which to him symbolized an unbroken America, in the New York gallery of René Block (**300**). In this "Happening" Beuys wrapped himself in a felt coat, leaving only the crook of his elbow showing. As the coyote became used to him, Beuys repeated the same basic rituals, and then took off the coat.

In contrast to Robert Morris's *Felt Pieces*, which fall from the wall in a form (**301**), Beuys's felt objects assume a symbolic and physical meaning: "Felt as an insulator, a protective cover against other influences, conversely a material, which allows the intrusion of outer influences."

In 1972, Beuys was dismissed from his teaching post by the state government; among other reasons, because he opposed the piecemeal restriction of the academy. In 1973 he founded the "Free International University." Since then, he has petitioned for "social sculpture," where sculpture works as a socially effective power. His petition was symbolic in the ecologically motivated action *7000 Oaks*, which he organized for Kassel's documenta in 1982 (**302**). In a merging of process,

302 Project *7000 Oaks* "documenta" 7, 1982.

1945 – today

conceptual, and earth art, Beuys arranged for people to acquire a tree and a basalt stone and to plant them in a place that was personally significant. The oaks grew in relation to the stones, which were heaped up in front of the Museum Fridericianum. "Thought is sculpture," said Beuys. "Thoughts work in the world possibly naturally more vehemently than a sculpture, which has derived itself and in certain ways materializes itself into an object."

Minimal art

The proponents of minimal art in the United States—Donald Judd, Robert Morris, Carl Andre, Dan Flavin, Sol LeWitt, and others—defined it first of all in purist terms as a new relationship between object and viewer. Often using industrially manufactured parts and allowing these scraps to stand on their own, they avoided the long preached "inner necessity of a form." They turned against the hierarchy of composition and the pressure to supply a special meaning in their works. A broad survey exhibition of minimalist art was held at the Jewish Museum in New York in 1966. It was, perhaps predictably, controversial, with many finding the works relentlessly boring, and others seeing in this reductiveness a rather moving expression of Puritan tradition.

Donald Judd reduced his offering to the viewer to a repetition of identical metal cubes, by which he produced a spatial journey that can hardly be captured in a photograph (**303**). His works simply exist in space. These apparently emotionless boxes may be seen as a reaction against the dominance of abstract expressionism. Moreover, the

303 Donald Judd (1928–94), *Untitled*, 1965. Aluminum sheets with glass wire elements, 34 ½ x 164″ (86.4 x 410.2 cm). The Saatchi Collection, London.

304 Marfa, Texas: View into one of the exhibit halls with works by John Chamberlain.

1945 – today

clarity of the minimalist purpose is evinced by Judd's installation in the light-drenched halls of his foundation in Marfa, Texas, where, in a remodeled old garrison, Judd suggests the suspension of the banality of the material in favor of the perceived spatial effect. The space also houses works by his colleagues, including the scrap sculptures of John Chamberlain (**304**).

Carl Andre always bristled at being labeled a minimalist. Andre was powerfully influenced by his visits to prehistoric sites, including Stonehenge. In 1960 he began the *Element Series*, sculptures from identical prefabricated lumber, which he built according to simple architectural laws. Andre used this system until the 1980s, when he began to adapt his constructions to the exhibition space available to him (**305**).

Since 1965, Andre has produced his *Floor Sculptures*, which quite clearly varied according to the exhibition space. For the opening exhibit of the renowned Düsseldorf Gallery owner Konrad Fischer in 1967, he laid out a floor in a narrow room with metal plates; visitors, walking into the room, immediately find themselves in a "sculptural situation." *Weathering Piece* (**306**) was supposed to be exposed to the weather, and was intended for the terrace of the Antwerp gallery "Wide White Space." The work is composed of 6 x 6 square metal plates of the same size. When one enters the room, the sculpture becomes the plinthe, the person the sculpture.

305 Carl Andre (b. 1935), *Breda*, 1986. The Hague Gemeentemuseum. Photo: Rob Kollard.

> "All I do is Brancusi's *Endless Column* lying on the floor instead of in the air."
>
> Carl Andre

The "unknown size"

"Formal principles are understandable and

306 Carl Andre, *Weathering Piece*, 1970. Aluminum, copper, lead, zinc, ½ x 120 x 120'' (1 x 300 x 300 cm). Rijksmuseum Kröller-Müller, Otterlo, Visser Collection. Taken in from the terrace of the Antwerp gallery "White Wide Space," 1970.

1945 – today

307 Eva Hesse (1936–70), 1967–68. Photo: Shunk-Kender.

308 Eva Hesse, *Untitled*, 1961. Gouache and ink on paper, 6 x 4 ½'' (15.2 x 11.2 cm). Estate of Eva Hesse.

understood. It is the unknown size, from which I start out and at which I will arrive." So declared Eva Hesse in the notes to her first sculpture exhibit in 1968. Hesse arrived at the material experiment with fully new works. Here, she suggests a new interest in the abysses of human experience, where minimal art at best relied on the viewer to supply any emotional or individual content.

Hesse was born in Hamburg in 1936, but her family fled the Nazis as refugees and emigrated to New York when she was only three. She began as a painter. In 1961 she produced a series of gouache paintings (**308**), which already look ahead to the sensible materiality of her later sculptures.

Her first reliefs with rope on plaster were produced in 1964 in Germany, when she and her husband, sculptor Tom Doyle, were guests of the Kettwig textile manufacturer, F.A. Scheidt. In the summer of 1965 the art association for the Rhineland and Westphalia in Düsseldorf showed "Drawings and Material Images," Hesse's first great success in the new medium.

In 1965, after separating from Doyle, she discovered such materials as latex, fiberglass, plastic, and rubber, all of which she would use in her installations. She transformed the repeated geometric boxes of minimal art into battered, transparent forms (*Saturday II*) or left sausage-shaped tubes with cord-wrapped expanded bodies (**309**). Hesse was a great admirer of the American

1945 – today

"pop" sculptor Claes Oldenburg (born in 1929), whose giant sculptures of ordinary foods (among other things) had captured the imagination and delight of Hesse's generation. In the five years before her death she created a work that owes a debt to Oldenburg, though it clearly bears the inventive stamp of Hesse's own "controlled eccentricity" (as Frederick Hartt describes her). Her last work, completed in 1970, is composed of seven mighty feet, which hang from the ceiling, the textures typical of her work in which the human body appears to be turned inside out. The *New York Times* hailed *Seven Poles* (310) as "fearless in its ugliness," while others compared the glassy L-form with the brain tumor from which Eva Hesse died that same year.

The stylistically irregular work of Bruce Nauman is informed by traces of disgust, anxiety, and uneasiness. His "body art" is likewise sculpture: he brings to his work not only historical narrative, but an innate bodily thought. Nauman wanted to trigger direct sensations, to explore how people in certain situa-

309 Eva Hesse, *Ingeminate*, 1965. Tube, papier maché, cord, paint. Private collection, Switzerland.

310 Eva Hesse, *Seven Poles*, 1970. Reinforced fiberglass over aluminum wire and polyethylene, 75 $1/4$"– 113" (188–282 cm) high. National Museum of Modern Art, Georges Pompidou Center, Paris.

311 Eva Hesse, *Sketch*, Lucy Lippard, New York.

1945 – today

155

312 Bruce Nauman (b. 1941), *Corridor Installation* (above) and *Study for Corridor Installation* (right), 1969. 23 ½ x 25" (58.4 x 62.5 cm). Hall for New Art, Schaffhausen, Switzerland.

313 Bruce Nauman, *Dream Passage*, 1983. Wood panels, two steel tables, two steel chairs, and fluorescent tubes, corridor: 40' (1,200 m) long, 42 ½" (106.5 cm) wide; at the broadest place 114 ½" (286.5 cm) long and 98 ½" (246 cm) wide; different heights. Hall for New Art, Schaffhausen, Switzerland.

tions, under certain conditions, react. In 1968–70 from his experimentation with video he issued his first *Corridor* (312). This installation uses closed-circuit cameras installed at the entrance to capture the rear view of the "observer" (cum participant) running through the corridor. The narrow, unexpectedly expanding entrance becomes an element of the installation with neon lights, aimed directly at manipulating perception (313). Nauman, like Hesse, hung many of his works in space. He cut up bodies, reduced them to cast wax heads, and formed mutants out of foam (315). Since the 1980s, he has incorporated increasingly concrete factors from political and social events, such as the violations of human rights in South America.

314 "The true artist helps the world, in that he reveals mythical truths." Bruce Nauman, *The Artist as a Fountain*, 1966–67. Black and white photograph, 8 x 9 ¾" (20.3 x 24.5 cm). Collection of the artist.

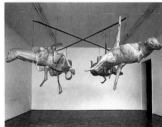

315 Bruce Nauman, *Sculpture 2 Wolfe, 2 Dear*, 1989. Foam material. Photo: Dorothee Fischer.

Back to sculpture?

In the name of the progress of art, sculpture and painting have been repeatedly pronounced dead. While there are exhibits of "sculpture," featuring artists known as "sculptors," the traditional vocabulary of sculpture has changed. Terms are now defined by the artist, rather than by any longstanding or established convention. And there is very little consensus. We have two particular phenomena to thank for this evolution/revolution in aesthetic understanding: Duchamp and minimal art. The experiments of Dada and Neo-Dada (a 1950s movement based in New York, dominated by the Duchamp-influenced Robert Rauschenberg and Jasper Johns) broke all boundaries of artistic thought, but in their wake, the uninhibited relation with sculptural forms, casting techniques, and "figure" again become possible.

The organically formed sculptures of Richard Deacon cite the typically 1950s interest in "ur-form" with earnest English irony. He uses complicated geometric calculations for the construction of his forms, which distinguish themselves from the influence of Donald Judd and refer to a personal experience.

In 1978 Deacon, inspired by Rilke's *Sonnets to Orpheus*, returned to the relationship of language, song, and listening. From this effort, he produced drawings with serpentine formations, muscle forms, mouths, ears, and genitals—all precursors to his later sculptures. Deacon's carefully handworked metal, plastic, or wood pieces do not deny their artificiality, in contrast to the soft forms of Hans Arp or Henry Moore. The structure of the glued woods of the floor sculpture *Border I* (**316**) is an integral part of the work. Deacon emphasizes the seams and with them the forms of the components, rather than the mostly harmonious totality.

316 Richard Deacon (b. 1949), *Border*, 1991. Wood and welded PVC, 19 1/4 x 134 x 68 1/2'' (48 x 335 x 171 cm). Lisson Gallery, London.

317 Richard Deacon, *Untitled*, 1991. Welded steel, 64 3/4 x 62 1/2 x 73 1/2'' (162 x 156 x 184 cm). Lange Display House, Krefeld, Germany.

1945 – today

318 Rachel Whiteread (b. 1963), *House*, 1993. London East End (destroyed).

319 Rachel Whiteread with one of her *Amber Mattresses*.

While the technoid-like organic forms of Deacon point toward common perception, Rachel Whiteread's works hone in on the strangeness of objects, to which end she uses a technique of casting lost forms. Whiteread made a name for herself in 1993 when she poured cement into the interior of a Victorian rowhouse slated for demolition in London's East End (**318**) until it overflowed. She shows the paradox of seeing an object from the outside, by revealing an object on the inside.

Whiteread first sketches her ideas in ink and correction fluid on graph paper, and then scours through junk shops for suitable objects. She may also find her forms on the street; this is where she "discovered" her *Amber Mattresses* (**319**). Like "the bodies of forsaken people" the artist finds discarded mattresses which nobody can use any longer and which no one examines any longer. Whiteread expresses the self-evident assumption, that we live constantly amid *things*. In the moment, in the virtual world of things of life degraded to triviality, art saves these things.

Despite public protests, Whiteread's *House* was demolished at the beginning of 1994. For her it was also "a pathetic monument for something that is lost," for the cheap apartments, that must yield to the ambitious concepts of community city planners.

Düsseldorf artist Thomas Schütte's 1984 "Human Images of the Present" are strongly informed by a drive toward social criticism. His *Strangers* (**320**), which were erected in 1992 on the occasion of the "documenta" on the roof of Leffers Department Store near the Museum Fridericianum in Kassel, Germany, anticipated the pub-

lic debates over immigra-
tion and deportation.
Schüttes figures, manufact-
ured with the help of a cer-
amic workshop, show little
concern for the traditional
forms of sculpture.

This becomes even more
clear with his Fimo dolls
(Fimo is a brand-name for a
synthetic sculpting material
that has become popular as a crafts medium in
the 1990s). These dolls are not portraits but are
nevertheless somehow suggestive of people one
knows. *United Enemies* (**321**), who have grown
together like Siamese twins, clearly step over the
border of repugnance. On the one hand, they are
traditional human figures—the oldest sculptural
form known to man—while on the other hand they
land us squarely in the realm of satire and subtle
social criticism, with no less force than Jonathan
Swift satirized his world with in *Gulliver's Travels*
in the 18th century.

Schütte turned these enduring harsh plasticine
dolls into the protagonists of scenes and situa-
tions. Before his Fimo phase, the artist had al-
ready built theatrical arrangements, such as his
Large Theater of 1980, in which figures out of
Star Trek comment from behind a linen-draped
stage; the stage is spanned by the slogan
"Peace, Progress, Unity." Schütte's models, his
colorful architecture, and suggestive scenarios
demonstrate his interest in "illusion," in delimiting
the purist light and
space problems of
the minimal artist,
and the conceptual
painting of his
teacher Gerhard
Richter.

320 Thomas Schütte (b.
1954), *The Strangers, 1992.*

321 Thomas Schütte, *United
Enemies*, 1994.

322 Thomas Schütte, *End*,
Sketch for the project *Large
Theater*, 1980.

1945 – today

323 Robert Smithson (1938–73), *Spiral Jetty*, 1970. Great Salt Lake, Utah. In addition to the construction of this dirt and rock path, Smithson's landscape project included text, film, and photographs. Smithson developed the ideas of the "Site" and the "Non-site": An artistic act itself has a limited duration and is not repeatable. There remain only texts and photos as "tracks of memory."

During the 1970s, in the United States, Great Britain, and the Netherlands, art moved outdoors. True enough, there had always been monuments and memorials, architectural façades, and sculptures installed in plazas and squares. But now advocates of Earth and Environmental Art looked far beyond the normal realm of the art museum, the city plaza, the accepted domain of the traditional art venue. Where sculpture had over the decades of the 20th century broken the rules about what constituted appropriate materials and models and methods for their creative undertakings, some artists now expanded from the conceptual even further, accepting seemingly no boundaries whatsoever. One of the most awe-inspiring undertakings of

324 Gordon Matta-Clark, *Splitting*, 1973. Eaglewood, New Jersey.

"Many of Matta-Clark's works treat the structure of place-specific apartments or duplexes. The incisions further the adjustment of the custom of living space divided in cells into the light, in that they uncover, how each individual family with their 'container' is dictated by social structures. What the structural form imposes as pressure the outside observer sees as 'sculpture.'"

Dan Graham

the Earth Art movement is the *Spiral Jetty* (**323**) by Robert Smithson. This sculpture is actually a 1,500-foot long spiral built into the Great Salt Lake in Utah. Smithson built the jetty in 1970 out of rocks, salt crystals, earth, and algae. The process of building the jetty was filmed, and the film is in itself a work of art documenting the earth-moving equipment carrying in the material for the construction. The *Spiral Jetty* was eventually submerged in the waters of the lake, while Smithson himself was killed in 1973, while flying over prospective sites for his projects.

Both Smithson and one of his contemporaries, Christo (born Christo Javachef in 1935 in Bulgaria) were aware of their true predecessors—the pre-Columbian mound builders of North America as well as similar mound-shaped tombs from other European, near Eastern, and Chinese cultures. While Smithson's work was swallowed up by the forces of nature, which was an accepted risk of the environmental artist, Christo often planned his works from the outset to be temporary—another great leap away from sculptural convention. Christo attempted to control the environment (conceptually, that is) by packaging it, treating it as if it were truly an object at man's disposal. Christo wrapped all sorts of ob-

325 Timed installation: René Sintenis, *Foals*, set up 1932, 1960 before the René-Sintenis-School in Berlin-Reinickendorf.

jects, from bicycles and machines to the coast of Australia and islands in Biscayne Bay, near Miami Beach, Florida, with various kinds of plastic or fabric. The monumental breadth of these undertakings necessitates the involvement of huge numbers of groups—civic authorities, planning boards, contractors—and the entire process is, for Christo, part of the "art" project. Thus, Christo questions

326 "Art in Construction": Erich F. Reuter, *Flying Cranes*, 1960. Fountain sculpture, bronze, 140" (3.5 m) high. Subdivision in Berlin-Tempelhof.

327 The German Opera in Berlin on the day of its closing (August 24, 1961) with the steel sculpture of Hans Uhlmann.

the differing authorities of the natural environment, the creative individual, and the civil world of regulations. But for most, the impact of Christo's work, like that of Smithson, comes not from first-hand experience of his undertakings but from video documentation, effectively making video yet another tool in the expanded artist's and sculptor's armamentarium.

In 1969, the German video pioneer Gerry Schum (1938–73) pro-

328 In close cooperation with the architect of the Berlin Philharmonic, Hans Scharoun, Hans Uhlmann created the *Auftragsarbeit No. 12*, 1963. Aluminum, 20′ (6 m) long.

duced the film *Land Art*, in which he showed the environmental artists at their projects in the landscape. This film was the pilot film for Schum's planned *Television Gallery*.

Gordon Matta-Clark, on the other hand, turned his vision toward the urban landscape. With *Splitting* (**324**), Matta-Clark transformed an ordinary house into a sculpture.

While this international group of avant-garde artists has long overtaken the contributions of the German program of communally supported "Art in Public Spaces," the importance of the latter may not be underestimated.

"Art in Construction"

Sculpture, far more than painting, has always been a public art. Its sturdier materials, its spatial dimension, the tradition of the monument all contribute to its specific place in the outdoors. But all these also contribute to the expense of creating sculpture, leaving sculptors with little alternative but to depend on commissions. This economic constraint has forced otherwise independent-thinking artists to produce pieces for museums or private collectors.

During the Weimar Republic in Germany, when the "cultivation of art" was written into the constitution, many artists voluntarily organized themselves into artist associations; this represented a change from the once-common struggles and claims toward autonomy among artists.

Sculptors and painters now more regularly became involved in designs for public buildings and the promotion of culture lay in the hands of provincial governments. The Prussian government considered the arts a part of their sociopolitical obligation and in 1928 published an official recommendation in that regard.

The Nazis, however, were quick to seize on such policy and to use it for their propagandistic objectives. After 1933, any artist in Germany seeking a government commission was required to become a member of the "Reichskulturkammer" (State Cultural Council), and this, of course, only accepted artists whose work conformed to their standards (the main criterion, as we have already seen, was figurative representation). Thus, in one fell swoop, the entire modern and avant-garde movements were essentially banned, in practice if not in policy, and artists were further subjected to the attempts at humiliation typified by the 1937 Berlin exhibition of "Degenerate Art." The inclusion in this exhibition was, of course, quickly followed by removal of any so-called degenerate works from the museums.

After the defeat of the Nazis, "Freedom of Art" was written into German constitutional law. While this offered some relief from the Nazi oppression, the provincial and city governments simply assumed the "Art in Construction" recommendation of the Weimar years, and antici-

329 Bogomir Ecker, *Gorge.* Installation for the outdoor project "Jenischpark," 1986.

pated spending up to 2 percent of their total building budgets for art. In response to this 2 percent promise, according to commentator Georg Jappe, "inexperienced architects and local cliques came emerged with frog fountains and glittering crane mosaics on school walls to gorge on the cities."

In the 1960s and 1970s, "Art in Construction" came in for some very vocal criticism. Still, the program did manage to produce some successes, such as the "Spear" in front of the German Opera in Berlin (**327**) or the Hans Uhlmann's sculpture, created in cooperation with the architect of the Berlin Philharmonic (**328**). As a rule, however, most of the reliefs and stone animals installed in the country's parks and other

330 Office Berlin, new scenery of the Subway-station triangle line. Cable railway, three dressmen in changing figurations. April 3, 1980. Photos: R. Grief.

public sites bore little relation to their place.

In 1972, the city of Munich was preparing to host the 1972 Olympic Games. The organizers invited the American land art artist Walter de Maria to contribute a work. De Maria envisioned boring a 400-foot (129-meter) hole in front of a local landfill, which would have only been visible through a metal cover. The project was not realized; evidently it did not satisfy the more traditional tastes of the organizers. In this sense, the postwar program had not advanced very far beyond the Reichskulturkammer, and "Art in Construction" was running well behind international artistic development, while the public had become used to sculpture as a decora-

tive addition to their surroundings, rather than as an integral element.

While the provincial governments remained adamant in their adherence to outdated aesthetics, the city governments at least reacted to the anachronistic "Art in Construction" program and established new models: Bremen in 1974, Hamburg in 1979, and Berlin in 1980. Bremen introduced "Art in Public Spaces," dismissing the primacy of the architecture, and projects—from sculptural

331 "documenta" 2, 1959 in Kassel: sculptures in front of the ruin of the Orangerie.

Art in Public Spaces

Fritz Rahmann (1989):
"Through projects that emerge freely and anarchically, ... less is about artistic self-assertion, but more about finding a possible overall language."

symposia to performance festivals— were made possible independently of construction provisions. It was still necessary, however, to legitimate the mostly pedagogical works judged by negotiation on the basis of prevailing social concerns, and the inherent redeeming social value (as it were) could still allow for some fairly mediocre art.

The Berlin artists' organization sued for greater participation in negotiations on awards for "Art in Construction," without particularly questioning the value of the program itself. They managed to extract an agreement from the city for the establishment of an office responsible for publicizing projects; this office would work with the national organization of sculptural artists and would seek more openness in competitions.

In 1981, the Hamburg city administration officially introduced its "Art in Public Spaces" policy. The policy still favored monumental, permanent works, since financial considerations made everyone doubtful of the wisdom of funding temporary installations.

332 Richard Serra, *Trunk*, 1987. Erbdrosten Palace, Münster.

The "Art in Construction" discussion finally began to show signs of budging from its obsolete positions after the reunification of East and West Germany in 1989–90. At this time Berlin replaced Bonn as the capital city, and at the newly planned federal construction at Spreebogen, the organization of sculptural artists was not allowed to participate—the planning had been "privatized." In a logical next step, the cabinet abolished the "Art in Construction" guideline in the summer of 1994 at the federal level.

Sculpture in the open air
Sculpture parks have sprung up regardless of the availability of community support for the arts. Notable

333 Joseph Beuys, *Tallow*, 1977. Installation in the atrium of the Westphalian Landesmuseum in Münster.

334 Jochen Gerz and Esther Shalev-Gerz, *Harburg Memorial against Fascism* at its dedication in 1986.

337 After the seventh sinking in 1992.

335 Passersby signing, 1986.

336 Detail 1992.

338 Observation platform, with door to the underground space, 1993.

among these are the Middelheim Free Light Museum at Antwerp and the Storm King Art Center, an hour's drive north of New York City, in a hilly, rural setting. More often, sculpture gardens are attached to a museum, as in the case of the Danish Lousiana Museum, the Kröller-Müller Museum in the Dutch Otterloo, the Wilhelm Lehmbruck Museum in Duisburg, Germany, or the DeCordova Museum in Lincoln, Massachusetts. These sculpture gardens house permanent as well as temporary works, many of which have been specifically created for the environment in which they are placed. Another positive advantage of many of these outdoor museums is that they allow touching—even climbing, swinging, and other actions which the particular sculpture may invite, thus allowing viewers of all ages a fully engaged experience.

Münster sculpture projects

While the possibilities for sculpture parks remain limited in some parts of the world, and while "Art in Construction" competitions in Germany remain fairly stodgy and unstimulating, Klaus Bussmann, the director of the Westphalian Landesmuseum in Münster, and curator Kasper König were moved to organize "Sculpture 1977." This exhibition demonstrated the historic positions of sculptors from Rodin to Brancusi, a cross-section of "freestanding outdoor sculptures," from volumes to space

sculpture, as well as one project domain tended by König. Bussmann and König invited artists to develop a place-specific work. Joseph Beuys' *Tallow* (**333**) was a wedge-shaped corner of a footpath crossroads, built up and filled with liquid tallow. Cut up into individual parts, the molded corner was placed in the museum courtyard.

Ten years later, at "Sculpture Projects 1987," the artists decided themselves where their work would be placed: American sculptor Richard Serra (b. 1939) reacted to the Baroque architecture in the forecourt of the Erbdrosten Palace with his sculpture *Trunk* (**332**).

In a two-piece work, American minimalist Sol LeWitt referred to the axial nature of the castle architecture. While *White Pyramid* marks the place where a Baroque observation pavilion had not been completed, *Black Form* accentuated the castle courtyard. With the subtitle "Dedicated to the Missing Jews," LeWitt offered the work as a memorial; it is interesting that the artist had chosen—as far as anyone knows, unconsciously—the exact place where an equestrian statue of Wilhelm I had stood until 1939.

Rebecca Horn installed her work on historical ground, in old "Zwinger," a Baroque prison, which had been the site of Nazi executions in the final years of the war. Münster is planning another city space project for 1997.

Monuments and memorials

The orientation of artists since the 1960s toward outdoor space has made it possible to build timely monuments and memorials. In 1994, for example, Dani Karavan created a monument in Port Boua, on the French–Spanish border. The edifice is built architecturally into the rock, commemorating the philosopher Walter Benjamin who had committed suicide when fleeing from the Nazis.

In 1979 the administrative district of Harburg decided to erect a memorial against war, power, and fascism. Seven years later the winners of the competition, Jochen Gerz and Esther Shalev-Gerz, were able to begin the work. The memorial is composed of a pillar with a lead sheath that offers a place for 60,000

340 *Memorial for the Sacrifices to Fascism and Militarism* after interior remodeling, 1968–69.

signatures (**334 –338**). The pillar is inscribed with "We invite the citizens of the city of Harburg and visitors to the city to sign their names here. This should obligate us to be and to remain vigilant. The more signatures the 12-meter-high pillar of lead bears, the more it sinks into the ground. So long, until it sinks after an indefinite time and the Harburg memorial against fascism becomes empty. Then can nothing in the duration on our place hold up injustice." The pillar finally disappeared at the end of 1993 into the earth and is now visible only through an observation window.

The memorial sunken into the ground is equated with the power of memory, which bends to it, to efface their tracks. The memorial provides with its own effacement, what a memorial should provide: It stands for a process, not for speechless sympathy.

339 New Guard, 1895, with the statues of Generals von Bülow and Scharnhorst by C.D. Rauch. In the interior, a guardroom was found for the castle and king's guard.

Art in Public Spaces

341 German Chancellor Helmut Kohl and Russian President Boris Yeltsin at the wreath-laying in the New Guard, Berlin, 1994, now a memorial for the victims of totalitarianism.

One of the most moving memorials of the latter part of this century is the *Vietnam Veteran's Memorial* in Washington, D.C. The participation this memorial offers visitors is of a somewhat different, yet equally affecting kind. The memorial was designed by Maya Ying Lin (b. 1960) when she was an undergraduate architecture student at Yale University in 1981. Her design was chosen out of 1,425 entries in a competition for a public work to honor this controversial war. The memorial consists of two polished, black granite walls, each 250 feet long, meeting at an oblique angle. At their intersecting point, they are ten feet high, and their height diminishes as they stretch away from their center. Inscribed on the two monolithic tablets are the names of the 57,692 American servicemen and women killed in the Vietnam War. The names are listed in chronological order, from first to last killed, to suggest the time frame of the war.

Dedicated on Veteran's Day in 1982, Lin's memorial represents a refreshing and moving change from the plethora of Neoclassical monuments (including the Lincoln Memorial) that populate the city. In so doing, and in its appropriateness to the actual topography of its site, it notes the particularly emotional reverberations of this war with neither sentiment nor glorification.

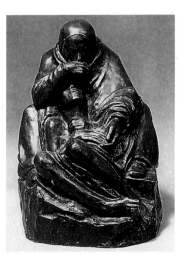

342 Käthe Kollwitz, *Pietà (Mother with Dead Son)*, 1937-38. Bronze, 11 1/4″ (28 cm) high. A gigantic version of this statue—the original of which is in the Käthe Kollwitz Museum, Berlin—now is the center piece of the New Guard.

Glossary

Glossary

Assemblage: sculpture made by fastening found or created objects together

Bust: from Latin *bustum* = body burning site; originally a shoulders-up sculpture of a deceased person, later conceived as a partial portrait

Capital: the head of a column, often bearing sculptural ornamentation

Casting: a method of reproducing a three-dimensional object or relief by pouring a hardening liquid or molten metal into a mold

Construction: architecturally bound sculpture, such as the portal figures of Romanesque churches, capitals, or gargoyles

Contrapposto: the positioning of different parts of the body in opposite directions, as if around a central vertical axis

Façade: the front or principal face of a building

Figura serpentinata: see *Torsion figure*

Free sculpture: free-standing sculpture often conceived for a particular architectural or topographical setting

Gothic swing: position of the figure in sculpture; in contrast to *contrapposto*, from the 13th century the horizontal axes (pelvis, shoulders) face in the same direction. The head is inclined to the raised shoulder, producing an upward-sloping S-curve

Head: a sculpture of a person—usually a portrait—from the neck up

Jamb: the vertical pieces forming the side of a doorway; often, especially in Romanesque and Gothic churches, the jambs were especially thick to allow for sculptural ornamentation

Kernel sculpture: sculpture that concentrates on the volume of the materials

Modeling: building a three-dimensional form out of a soft substance (e.g., clay or wax); modeling is traditionally the first step in creating a mold for *casting*, especially in bronze

Plinthe: From Greek *plinthos* = bricks; rectangular or square foot plate under a statue or column

Ponderation: equalized, harmonious distribution of a figure's weight on the legs

Puncture: a method for the transfer of clay and plaster models; the puncture method rests on the geometric principle using three points in one plane allowing one to determine a fourth in space. A portrait head uses up to 400 holes

Ready-made: "sculpture" consisting of objects previously or otherwise manufactured, assembled or simply presented as a work of art

Relief: sculpture that is not freestanding but projects outward from its background; the degree to which it projects determines whether it is an *incised relief, low*

relief (commonly called "bas-relief"), or high relief.

Sculptor's drawing: sketch, draft, construction or autonomous drawing created with regard to a work or a sculptural theme

Sculpture: from the Latin sculpere = cut, clip, carve; generally consists of two methods of creating a three-dimensional form: the additive method, modeling, in which a form is built up, and the subtractive method, carving (out of wood or stone, etc.), in which a form is created by cutting the basic material. A new kind of sculpture is assemblage, where materials are joined by various means

Statue: from Latin statua, also called an image column; a fully worked out individual figure, as distinct from the portrait or head

Taille directe: direct processing of stone or wood

Torsion figure (also figura serpentinata): positioning of figures in a statue or group as if coiled around an axis, in a serpentine fashion

Torso: from Italian for the stalk or stump of a tree; in sculpture, a figure without limbs: introduced by Rodin as a theme in art, torsos have also been preserved in fragments of antique sculptures; since the modern, the torso has been used to suggest the endangered person, the beautiful body by which everything can become a neglected accessory, or in the formation of the human body in comparison to vegetable or mineral forms

Brief overview of the history of sculpture

35,000–28,000 B.C. Lion Man; first sculptural representation of the human form

28,000–20,000 B.C. Venus of Willendorf, best-known Stone Age Venus figure with realistic and stylized details

2690–2660 B.C. Limestone sitting figure of Zoser; oldest life-sized sculpture

1340 B.C. Model bust of Nefertiti; reference to production methods of the stonemasons in the Amarna period

600 B.C. the Kouros of New York, a typical example of the Archaic

480 B.C. Kritios Boy, figure from the Athens Acropolis; early example of the introduction of contrapposto

440 B.C. Doryphoros. This figure attributed to Polykleitos serves as the measure for his new proportional canon

190 B.C. Nike of Samothrace; display of victory for the bow of a ship; larger-than-life Hellenistic sculpture, before

Brief overview of the history of sculpture

the time of the *Pergamon Altar*

20–17 B.C. *Augustus of Primaporta*; first ruler portrait with legible political iconography after the model of the *Doryphoros*

212–217 A.D. The Caracalla bust; peak of the realistic Caesar portraits

300 A.D. Porphyrus group of the *Tetrarchs*; deindividualization, statuary simplification of the figures

600–700 *Cologne Bronze Crucifix* and *Mainz Crucifix* (life-size); first known sculptural crucifixion image

980 The *Essen Golden Madonna*; establishment of a type; strongly derived from reliquary figures

1015–22 *Bernward Door, Bernward Column* in Hildesheim; bronze reliefs inspired by Christian manuscripts on ancient images

1120 Tympanum of the *South Portals* of *St. Pierre* in Moissac; structural sculpture; expressive scene of the Apocalypse

1145–55 The *Royal Portal of Chartres Cathedral*; figures architecturally bound, but with realistic details

1250 Ekkehard and Uta of the Naumburg Cathedral; individual representation; the function as supporting columns is hidden

1260–74 Portal figures of Reims Cathedral; antiquated garment representations

1400 *Beautiful Madonna of Cesky Krumlov*; widespread type of disembodied Madonna wrapped in cascading drapery; Gothic S-swing

1401 Competition reliefs of Lorenzo Ghiberti (1378–1455) and Filippo Brunelleschi (1377–1446) for the Baptistery doors in Florence; the artists sold the order

independently; high relief

1430 The *David* of Donatello (1386–1466); first freestanding nude since the Antique

1501–04 The *David* of Michelangelo (1475–1564); monumental marble statue as a symbol of state power

1519 Michelangelo's *Slaves*; unfinished sculptures (*non finito*) attain recognition

1581–82 *Rape of the Sabine Women* by Giambologna (1529–1608); development the Mannerist *figura serpentinata*

1645–52 *The Vision of St. Theresa* of Gianlorenzo Bernini (1598–1680); scenic display of ecstasy; the architecture serves as backdrop

1667–1700 *The Great Elector* of Andreas Schlüter (1660–1714); Baroque equestrian statue

Brief overview of the history of sculpture

1759 The *Bather* of Etienne-Maurice Falconet (1716–91); the classically calm nude figure is reproduced in the china factory of Sèvres

1795–97 *Princess Group* of Johann Gottfried Schadow (1764–1850); friendship image; combination of classicism and realism

1869 *The Dance* of Jean-Baptiste Carpeaux (1827–75); sculpture group for the historic Parisian opera of Garbier; break with the conventions of the architectural sculpture; unleashes public scandal

1884–85 *The Burghers of Calais* of Auguste Rodin (1840–1917); first monument conceived with no base; the original, as planned by the artist, was installed in 1924 in Calais; previously it had been mounted on an extraneous base

1890–91 *Lust* of Paul Gauguin (1848–1903); wooden sculpture inspired by ethnographic art

1897 The *Balzac* of Auguste Rodin; the author's statue becomes a symbol of his work

1906 Autumn Salon with the *Mediterranée* of Aristide Maillol (1861–1944); wood works of Paul Gauguin

1909 *Head of Fernande* of Pablo Picasso (1881–1973); first Cubist sculpture

1912 *Development of a Bottle in Space* of Umberto Boccioni (1882–1916); a manifestation of Futuristic sculpture

1913 *Head Construction* of Alexander Archipenko (1887–1964); the empty space of the sculpture changes in volume. The "Armory Show" in New York intro-

duces the American public to the works of the Cubists and others of the Modern era breaking with Impressionism

1915 *Corner Counter-Relief* of Wladimir Tatlin (1885–1953); immaterial assemblage stretched over a corner of a room

1917 *Fountain* of Marcel Duchamp (1887–1968): first ready-made, displayed in New York

1918 First *Endless Column* of Constantin Brancusi (1876–1957); the base itself becomes the sculpture

1919–20 *Kinetic Construction*, Naum Gabo (1890–1977): pure movement is sculpture

1921 The *Cadeau* of Man Ray (1890–1976); surrealistically strange ready-made

1922 "First Russian Art Exhibition" in the Gallery van Diemen, Berlin;

Brief overview of the history of sculpture

Russian Constructivism first seen in Western Europe

1928 The *Apollinaire Monument* of Picasso; first monumental wire sculpture

1930 *Hovering Ball* of Alberto Giacometti (1901–66); mysterious surrealistic work, alluding to sexuality and power

1940–41 *Adieu* of Henri Laurens (1885–1954); emphasizing the massive, heavy figure pressing into the floor

1942 Nazi sculptor Arno Breker (1900–91) exhibits in Paris during the German occupation

1943 *Woman on the Car I* of Alberto Giacometti; concept of the memory image

1949–50 *Blackburn—A Song of an Irish Blacksmith* of David Smith (1906–65); Julio González takes up iron sculpture (1876–1942)

1953 "Sculpture in the Open," first outdoor exhibition in Hamburg

1959 "documenta" 2; section for sculpture organized by E. Trier

1962 *Early One Morning* of Anthony Caro (b. 1924); freestanding scrap assemblage; a new generation of British sculptors finds its formal language

1964 *Fat Chair* of Joseph Beuys (1921–86); object of sculpture becomes the processing of the material; expansion of artistic ideas

1966 Exhibition "Primary Structures" at the Jewish Museum in New York; breakthrough of minimal art

1969 "Live in Your Head. When Attitudes Become Form;" first retrospective exhibition of process art of H. Szeemann in Bern, London, and Krefeld

1969/70 Television videos *Land Art* and *Identifications* of Gerry Schum (1938–73); oscillating process art

1970 Robert Smithson constructs the *Spiral Jetty* in the Great Salt Lake in Utah

1976 Beuys enters the environment *Streetcar Stop* in the German pavilion of the biannual Venice Film Festival

1982 "Zeitgeist," breakthrough of the "Wild Painting"; display of Christos Joachimides in the Martin Gropius Building in Berlin

1986 "Qu'est-ce que la sculpture moderne?" in the Georges Pompidou Center, Paris

1987 Sculpture projects, exhibitions in public space in Münster

1995 Christo and Jeanne-Claude (both b. 1935) after 23 years of preparation, "wrap" the Reichstag in Berlin

Museums and sculpture gardens

Museums and sculpture gardens

Belgium
Antwerp
Openluchtmuseum
voor Beeldhouwkunst,
Middelheim
Middelheimlaan 61
2020 Antwerp
Tel.: 3/82 71 534

Denmark
Copenhagen
Ny Carlsberg
Glyptothek
Dantes Plads 7
1556 Copenhagen
Tel.: 33 91 10 65

Thorvaldsens Museum
Porthusgade 2
1213 Copenhagen
Tel.: 33 32 15 32

Humblebaek
Louisiana Museum of
Modern Art
Gl Strandvej 13
3050 Humblebaek
Tel.: 42 19 07 19

France
Britanny
Le Domaine de Kergue-
hennec, Centre d'art
56500 Locminé Bignan
Tel.: 97 60 44 44
Fax: 97 60 44 00

Meudon
Musée Rodin
19, av. Auguste Rodin
Villa des Brillantes
92190 Meudon
Tel.: 1/40 27 13 09

Paris
Musée Auguste Rodin
77, rue de Varenne,
Hôtel Biron
75007 Paris
Tel.: 1/47 05 01 34

Musée du Louvre
34-36 Quai Louvre
75058 Paris
Tel.: 1/40 20 50 09

Musée d'Orsay
62 rue de Lille
75007 Paris
Tel. 1/45 49 11 11

Musée National d'Art
Moderne, Georges
Pompidou Center
19 Rue du Renard
75191 Paris
Tel.: 1/44 78 12 33

Germany
Berlin
Antikensammlung
Pergamonmuseum
Bodestr. 1–3
10178 Berlin
Tel.: 030/2 03 55–0

Skulpturensammlung
Arnimallee 23/27
14195 Berlin
Tel.: 030/83 01 252

Duisburg
Wilhelm Lehmbruck
Museum
Düsseldorfer Str. 51
47051 Duisburg
Tel.: 0203/32 70 23

Frankfurt/Main
Liebieghaus
Schaumainkai 71
60596 Frankfurt/M.
Tel.: 069/21 23 86 17

Munich
Staatliche Kunstsamm-
lungen und Glyptothek
Königsplatz 1–3
80333 Munich
Tel.: 089/59 83 59

Great Britain
London:
British Museum
Great Russell Street
London WC1B 3DG
Tel.: 171/63 61 555

National Gallery
Trafalgar Square
London WC2N 5DN
Tel.: 171/83 93 231

Tate Gallery
Millbank
London SW1P 4RG
Tel.: 171/88 78 000

Oxford
Ashmolean Museum of
Art and Archaeology
Beaumont Street
Oxford OX1 2PH
Tel.: 1865/27 80 00

Museums and sculpture gardens

Italy
Rome
Galleria Nazionale
d'Arte Moderna
Viale Belle Arti 131
00197 Rome
Tel.: 05/322 41 52

Florence
Uffizi Gallery
Piazza degli Uffizi
50122 Florence
Tel.: 055/23 88 561/2

Japan
Hakone-machi,
(Kanagawa-ken)
Hakone Open-Air-
Museum
1121 Ninotaira
25004 Hakone
Tel.: 460/21 161

The Netherlands
Amsterdam
Rijksmuseum
Stadhouderskade 42
1070 DN Amsterdam
Tel.: 20/67 32 121

Stedelijk Museum of
Modern Art
Paulus Potter Str. 13
Postbus 5082
1070 AB Amsterdam
Tel.: 20/57 32 911/737

Otterlo
Kröller-Müller Museum
De Hoge Veluwe
Postbus 1
6730 AA Otterlo
Tel.: 83 82 12 41

Russia (Saint Peters-
burg)
Hermitage
Dworzowaja
Nabereshnaja 34-36
191065 St. Petersburg
Tel.: 212 95 45

Switzerland
Kunsthaus Zürich/
Giacometti-Stiftung
Heimplatz 1
8024 Zürich
Tel.: 1/25 16 765

United States
California
Los Angeles County
Museum of Art
5905 Wilshire
Boulevard
Los Angeles, CA
90036
Tel.: 213/857-6111

J. Paul Getty Museum
17985 Pacific Coast
Highway
Malibu, CA 90265
Tel.:310/459-7611
and 458-2003
(Reservation and
Information)

Museum of
Contemporary Art
250 S. Grand Ave.
California Plaza
Los Angeles, CA
90012
Tel.: 213/626-6222

Illinois
Chicago Art Institute
111 South Michigan
Avenue
Chicago, IL 60603-
6110
Tel.: 312/443-3600
Fax: 312/443-0849

Massachusetts
Museum of Fine Arts
465 Huntington Ave.
Boston, MA 02115
Tel.: 617/267-93 00

Institute of
Contemporary Art
955 Boylston Street
Boston, MA 02115-
3194
Tel.: 617/266-5152

DeCordova Museum
51 Sandy Pond Road
Lincoln, MA 01773
Tel.: 617/259-8355

Isabella Stewart
Gardner Museum
280 The Fenway
Boston, MA 02115
Tel.: 617/566-1401

Minnesota
Walker Art Center and
the Minneapolis
Sculpture Garden
Vineland Place
Minneapolis, MN
55403
Tel.: 612/375-7622

New York

Metropolitan Museum
of Art
1000 Fifth Avenue
New York, NY 10028-
0198
Tel.: 212/535-7710

Museum of Modern Art
11 West 53 St.
New York, NY 10019
Tel.: 212/708-9480

The Brooklyn Museum
200 Eastern Parkway
Brooklyn, NY 11238
Tel.: 718/638-5000

Solomon R.
Guggenheim Museum
1071 Fifth Avenue
New York, NY 10012
Tel.: 212/423-3500

Jewish Museum
1109 Fifth Avenue
New York, NY 10128
Tel.: 212/423-3200

The Frick Collection
One East 70 St.
New York, NY 10021
Tel.: 212/288-0700

Whitney Museum of
American Art
945 Madison Avenue
New York, NY 10021
Tel.: 212/570-3633

Storm King Art Center
Information under
Tel. 914/534-3115

Ohio

Cleveland Museum of
Art
11150 East Boulevard
Cleveland, OH 44106
Tel.: 216/421-7340

Texas

Chinati Foundation
Marfa, Texas
Information under:
Tel.: 915/729-4362

Washington, D.C.

Hirshhorn Museum and
Sculpture Garden
Smithsonian Institution
Seventh St. & Inde-
pendence Ave. S.W.
Washington, D.C.
Tel.: 202/357-2700

Bibliography

Agard, Walter R. *The Greek Tradition in Sculpture*. North Stratford: Ayer Co. Publishers, Inc. 1979.

Albright-Knox Art Gallery staff & Steven A. Nash. *Painting & Sculpture from Antiquity to Nineteen Forty-Two*. Buffalo: Buffalo Fine Arts Academy, 1979

Alexander, Robert L. *The Sculpture & Sculptors of Yazili-kaya*. Cranbury: University of Delaware Press, 1986.

Alroth, Brita. *Greek Gods & Figurines: Aspects of Anthropomorphic Dedications*. Philadelphia: Coronet Books, 1989.

Anderson, Ross and Barbara Perry. *The Diversions of Keramos: American Clay Sculpture, 1925-1950*. Syracuse: Everson Museum of Art, 1983.

Armi, C. Edson. *The Headmaster of Chartres & the Origins of Gothic Sculpture*. University Park: Pennsylvania State University Press, 1994.

Avery, Charles. *Florentine Renaissance Sculpture*. North Pomfret: Trafalgar Square, 1989.

Barron, Stephanie. *German Expressionist Sculpture*. Chicago: University of Chicago Press.

Bascom, William R. *African Art in*

Bibliography

Cultural Perspective: An Introduction. New York: W.W. Norton & Co., Inc., 1973.

Bassani, Ezio and William Fagg. *Africa & the Renaissance: Art in Ivory.* New York: te Neues Publishing Co, 1988.

Bassie-Sweet, Karen. *From the Mouth of the Dark Cave: Commemorative Sculpture of the Late Maya.* Norman: University of Oklahoma Press, 1991.

Baxandall, Michael. *The Limewood Sculptures of Renaissance Germany 1475-1525.* New Haven: Yale University Press, 1982.

Beardsley, John, et al. *Hispanic Art in the United States: Thirty Contemporary Painters & Sculptors.* New York: Abbeville Press, Inc., 1987.

Beattie, Susan. *The New Sculpture.* New Haven: Yale University Press, 1985.

Bieber, Margarete. *The Sculpture of the Hellenistic Age.* New York: Hacker Art Books, 1980.

Blier, Suzanne P. *African Vodun: Art, Psychology, & Power.* Chicago: University of Chicago Press, 1995.

Blindheim, Martin. *Norwegian Romanesque Decorative Sculpture, 1090-1210.* Albuquerque: Transatlantic Arts, Inc.

Boardman, John. *Greek Sculpture: The Archaic Period.* New York: Thames & Hudson, 1985.

Boardman, John. *Greek Sculpture: The Classical Period.* New York: Thames & Hudson, 1985.

Boime, Albert. *Hollow Icons: The Politics of Sculpture in Nineteenth Century France.* Kent: Kent State University Press, 1987.

Brett-Smith, Sarah C. *The Making of Bamana Sculpture: Creativity & Gender.* New York: Cambridge University Press, 1995.

Brooklyn Institute of Arts & Sciences Museum Staff, et al. *Egyptian Sculpture of the Late Period,* 700 B.C. to A.D. 100. North Stratford: Ayer Co. Publishers, Inc. 1969.

Brown, Blanche R. *Royal Portraits in Sculpture & Coins: Pyrrhos & the Successors of Alexander the Great.* New York: Peter Lang Publishing, Inc., 1995.

Brown University, Bell Gallery Staff. *Flying Tigers: Painting & Sculpture in New York, 1939-1946.* Providence: Brown University, David Winton Bell Gallery, 1985.

Buitron-Oliver, Diana. *The Greek Miracle: Classical Sculpture from the Dawn of Democracy: The Fifth Century B.C.* New York: Harry N. Abrams, Inc., 1993.

Caffin, Charles H. *American Masters of Sculpture.* New York: Gordon Press Publishers, 1980.

Canaday, John E. *What is Art? An Introduction to Painting, Sculpture, & Architecture.* New York: Alfred A. Knopf, Inc., 1980.

Bibliography

Casson, Stanley. *Twentieth Century Sculptors*. North Stratford: Ayer Co. Publishers, Inc. 1977.

Castriota, David. *The Ara Pacis Augustae & the Imagery of Abundance in Later Greek & Early Roman Imperial Art*. Princeton: Princeton University Press, 1995.

Chalmers, Patrick. *Ancient Sculptured Monuments of the County of Angus*. New York: AMS Press, Inc., 1973.

Chandra, Pramod. *The Sculpture of India, Three Thousand B.C. – A.D. Thirteen Hundred*. Cambridge: Harvard University Press, 1985.

Chattopadhyaya, B.P. *Gods, Guardians & Lovers: Temple Sculpture from North India*. Seattle: University of Washington Press, 1993.

Chutiwongs, Nandana and Denise P. Leidye. *Buddha of the Future: An Early Maitreya from Thailand*. Seattle: University of Washington Press, 1994.

Connor, Janis and Joel Rosenkrantz. *Rediscoveries in American Sculpture: Studio Works, 1893 – 1939*. Austin: University of Texas Press, 1989.

Cox, J. Halley and William H. Davenport. *Hawaiian Sculpture*. Honolulu: The University of Hawaii Press, 1988.

Craven, Wayne. *Sculpture in America*. 2nd ed. Cranbury: Associated University Presses, 1984.

Cummings, Paul. *Sculpture in Stone*. Boynton Beach: Tree Gallery, 1989.

DeLippe, Aschwin. *Indian Medieval Sculpture: About 550 – 1250 A.D.* New York: Elsevier Science, Inc., 1978.

Desai, Devangana. *Erotic Sculpture of India: A Socio-Cultural Study*. Philadelphia: Coronet Books.

Donohue, Alice A. *Xoana & the Origins of Greek Sculpture*. Georgia: Scholars Press, 1988.

Elsen, Albert. *Modern European Sculpture 1918 – 1945: Unknown Beings & Other Realities*. New York: George Braziller, Inc., 1979.

Elsen, Albert E. *Origins of Modern Sculpture: Pioneers & Premises*. New York: George Braziller, Inc., 1974.

Esdaile, Katherine A. *English Monumental Sculpture Since the Renaissance*. New York: Hyperion, 1985.

Fabri, Charles. *Discovering Indian Sculpture*. Glastonbury: Ind – U.S., Inc., 1970.

Feldman, Jerome A., ed. *The Eloquent Dead: Ancestral Sculpture of Indonesia & Southeast Asia*. Los Angeles: Univ. of California, L.A., Fowler Museum of Cultural History, 1985.

Felten, Wolfgang and Martin Lerner. *Thai & Cambodian Sculpture: From the 6th to the 17th Centuries*. New York: Sothebys Publications, 1989.

Folliott, Sheila. *Civic Sculpture in the Renaissance: Montor-*

Bibliography

soli's *Fountains at Messina*. Ann Arbor: Books on Demand, 1984.

Fine, Elsa H. *Women and Art: A History of Women Painters & Sculptures from the Renaissance to the 20th Century*. Boulder: Westview Press, 1991.

Fort, Ilene S. *The Figure in American Sculpture: A Question of Modernity*. Seattle: University of Washington Press, 1995.

Frank, Robin J., ed. *A Checklist of American Sculpture at Yale University*. New Haven: Yale University Art Gallery, 1992.

Frankfort, Henri. *The Art & Architecture of the Ancient Orient*. 4th ed. New Haven: Yale University Press, 1989.

Fullerton, Mark D. *The Archaistic Style in Roman Statuary*. Kinderhook: E.J. Brill, U.S.A., Inc., 1990.

Gardner, Albert T. *Yankee Stonecutters*. North Stratford: Ayer Co. Publishers, Inc., 1977.

Getz-Preziosi, Pat. *Early Cycladic Sculpture: An Introduction*. 2nd ed. Santa Monica: J. Paul Getty Trust Publications, 1994.

Getz-Preziosi, Pat. *Sculptors of the Cyclades: Individual & Tradition in the Third Millennium B.C.* Ann Arbor: University of Michigan Press, 1987.

Gillerman, Dorothy. *Enguerrand de Marigny & the Church of Notre-Dame at Ecouis: Art & Patronage in the Reign of Philip the Fair*. University Park: Pennsylvania State University Press, 1994.

Glass, Dorothy F. *Romanesque Sculpture in Campania: Patrons, Programs, & Style*. University Park: Pennsylvania State University Press, 1992.

Gupta, S.P., ed. *Kushana Sculptures from Sanghol: 1st–2nd Century A.D.* Flushing: Asia Book Corp. of America, 1985.

Hamilton, George H. *Painting & Sculpture in Europe: 1880–1940*. New Haven: Yale University Press, 1989.

Hannestad, Niels. *Tradition in Late Antique Sculpture: Conservation, Modernization, Production*. Philadelphia: Coronet Books, 1994.

Harding, Jonathan P. and Harry Katz. *The Boston Athenaeum Collection: Pre-Twentieth Century American & European Painting & Sculpture*. Boston: Boston Athenaeum Library, 1984.

Hargrove, June. *Statues of Paris: Open Air Pantheon*. New York: The Vendome Press, 1990.

Hartt, Frederick. *Art: A History of Painting, Sculpture, Architecture*, 4th ed. New York: Harry N. Abrams, 1993.

Haskell, Francis and Nicholas Penny. *Taste & the Antique: The Lure of Classical Sculpture 1500–1900*. New Haven: Yale University Press, 1981.

Havelock, Christine M. *The Aphrodite of Knidos & Her Suc-

Bibliography

cessors: A Historical Review of the Female in Greek Art. Ann Arbor: University of Michigan Press, 1995.

Henig, Martin, ed. Architecture & Architectural Sculpture in the Roman Empire. Oakville: David Brown Book Co., 1990.

History of Sculpture. New York: Gordon Press Publishers, 1991.

Hoghammar, Kerstin. Sculpture & Society: A Study of the Connection Between the Free-Standing Sculpture & Society on Kos in the Hellenistic & Augustan Period. Philadelphia: Coronet Books, 1993.

Hunisak, John M. Carvings, Casts & Replicas: Nineteenth-Century Sculpture from Europe & America in New England Collections. Middlebury: Middlebury College Museum of Art, 1994.

Huth, Nancy M. and Alain G. Joyaux. European & American Paintings & Sculpture, Selected Works: Ball State University Museum of Art. Muncie: Ball State University Art Gallery, 1994.

Jacob, Mary J., et al. A Quiet Revolution: British Sculpture Since 1965. Chicago: Museum of Contemporary Art, Chicago, 1987.

James, Josef, ed. Contemporary Indian Sculpture: The Madras Metaphor. New York: Oxford University Press, Inc., 1994.

Janson, H.W. Nineteenth Century Sculpture. New York: Harry N. Abrams, Inc., 1985.

Jones, G. Harvey. The Golden Era: The American Dream. 2nd ed. Houston: Somerset House Publishing, 1992.

Jones, Gerald H. The Golden Era: A Celebration of Light. Houston: Somerset House Publishing, 1990.

Kasson, Joy S. Marble Queens & Captives: Women in Nineteenth-Century American Sculpture. New Haven: Yale University Press, 1990.

Kenaan-Kedar, Nurith. Marginal Sculpture in Medieval France: Towards the Deciphering of an Enigmatic Pictorial Language. Brookfield: Ashgate Publishing Co., 1995.

Kerchache, Jacques, et al. Art of Africa. New York: Harry N. Abrams, Inc., 1993.

Kleiner, Diana E. Roman Sculpture. New Haven: Yale University Press, 1994.

Koplos, Janet. Contemporary Japanese Sculpture. New York: Abbeville Press, Inc.

Kuhn, Charles L. German & Netherlands Sculpture, 1280–1800, the Harvard Collections. Ann Arbor: Books on Demand, 1966.

Lane, John R. and Susan C. Larsen, eds. Abstract Painting & Sculpture in America 1927–1944. Pittsburgh: The Carnegie Museum of Art, 1983.

Lang, James T. Corpus of Anglo-Saxon Stone Sculpture. Vol. III: York & Eastern Yorkshire. New York: Oxford Uni-

Bibliography

versity Press, Inc., 1991.

Laskin, Myron, Jr., ed. *European & American Painting, Sculpture, & Decorative Arts in the National Gallery of Canada, Vol I: 1300–1800.* Chicago: University of Chicago Press, 1987.

Liebmann, M. *Western European Sculpture from Soviet Museums: 15th & 16th Centuries.* New York: State Mutual Book & Periodical Service, Ltd., 1988.

Lines, Marianna. *Sacred Stones, Sacred Places.* New York: St. Martin's Press, Inc., 1993.

Lyman, Thomas W. and Daniel Smartt. *French Romanesque Sculpture: An Annotated Bibliography.* Old Tappan: Macmillan Publishing Co., Inc., 1987.

Lynn, Martha D. *Clay Today: Contemporary Ceramists & Their Work.* San Francisco: Chronicle Books, 1990.

Malla, Bansilal. *Sculptures of Kashmir.* Columbia: South Asia Books, 1990.

Marble: Art Historical & Science Perspectives on Ancient Sculpture. Santa Monica: J. Paul Getty Trust Publications, 1990.

Martin, F. David. *Sculpture & Enlivened Space: Aesthetics & History.* Lexington: University Press of Kentucky, 1981.

Mathiesen, Hans E. *Sculpture in the Parthian Empire.* 2 vols. Philadelphia: Coronet Books, 1992.

Mattusch, Carol C. *Greek Bronze Statuary: From the Beginnings Through the Fifth Century B.C.* Ithaca: Cornell University Press, 1988.

Mayor, A. Hyatt, *Intro. A Century of American Sculpture: Treasures from Brookgreen Gardens.* New York: Abbeville Press, Inc., 1988.

McHam, Sarah B. *The Chapel of St. Anthony at the Santo & the Development of Venetian Renaissance Sculpture.* New York: Cambridge University Press, 1994.

McSpadden, Joseph *Famous Sculptures of America.* North Stratford: Ayer Co. Publishers, Inc. 1977.

Meilach, Dona Z. *Contemporary Stone Sculpture.* Atglen: Schiffer Publishing, Ltd., 1987.

Metraux, Guy P. *Sculptures & Physicians in Fifth-Century Greece: A Preliminary Study.* Cheektowaga: University of Toronto Press, 1995.

Montagu, Jennifer. *Roman Baroque Sculpture: The Industry of Art.* New Haven: Yale University Press, 1989.

Montagu, Jennifer. *Gold, Silver, & Bronze: Metal Sculpture of the Roman Baroque.* New Haven: Yale University Press, 1996.

Mori, Hisashi. *Sculpture of the Kamakura Period.* New York: Weatherhill, Inc., 1974.

Mukhopakhyaya, Mihir M. *Sculptures of the Ganga-Yamuna Valley.* Columbia: South Asia Books, 1986.

Bibliography

Muller, Theodor. *Sculpture in the Netherlands, Germany, France, & Spain: 1400–1500.* New Haven: Yale University Press.

Munman, Robert. *Sienese Renaissance Tomb Monuments.* Philadelphia: American Philosophical Society, 1993.

Nagaswamy, R. *Masterpieces of Early South Indian Bronzes.* Flushing: Asia Book Corp. of America, 1983.

Nalin, David R. *Medieval Sculpture from Eastern India: Selections from the Nalin Collection.* West Chester: Nalini International Publications, 1985.

Nishikawa, Kyotaro and Emily J. Sano. *The Great Age of Japanese Buddhist Sculpture* A.D. *600–1300.* Seattle: University of Washington Press, 1983.

Northern Poles: Breakways & Breakthroughs in Nordic Painting & Sculpture of the 1970s–1980s. Philadelphia: Coronet Books, 1986.

Oliphant, Patrick. *Oliphant: The New World Order in Drawing & Sculpture, 1983–1993.* Kansas City: Andrews & McMeel.

Olson, Roberta. *Italian Renaissance Sculpture.* New York: Thames & Hudson, 1992.

Pal, Pratapaditya. *The Ideal Image: The Gupta Sculpture Tradition & Its Influence.* New York: Asia Society, Inc., 1978.

Pal, Pratapaditya. *Indian Sculpture.* Vol. 1. Berkeley: University of California Press, 1987.

Pal, Pratapaditya. *Indian Sculpture.* Vol. 2. (700–1800). A Catalog of the Los Angeles County Museum of Art Collection. Berkeley: University of California Press, 1989.

Reedy, G.V. *Erotic Sculptures of Ancient India.* Columbia: South Asia Books, 1991.

Paludan, Ann. *The Chinese Spirit Road: The Classical Tradition of Stone Tomb Statuary.* New Haven: Yale University Press, 1991.

Paris, Pierre. *Manual of Ancient Sculpture.* New Rochelle: Aristide D. Caratzas Publisher, 1984.

Parsons, Lee A. *Origins of Maya Art: Monumental Stone Sculpture of Kaminaljuyu, Guatemala, & the Southern Pacific Coast.* Washington, D.C.: Dumbarton Oaks, 1986.

Pope-Hennessy, John. *The Study & Criticism of Italian Sculpture.* Princeton: Princeton University Press, 1981.

Powers, Martin J. *Art & Political Expression in Early China.* New Haven: Yale University Press, 1992.

Proske, Beatrice G. *Castilian Sculpture: Gothic to Renaissance.* New York: The Hispanic Society of America, 1988.

Radcliffe, Anthony, et al. *Renaissance & Later Sculpture: The Thyssen-Bomemisza Collection.* New York: Sothebys Publications, 1992.

Radford, Georgia F. and Warren H.

Bibliography

Radford. *Sculpture in the Sun: Hawaii's Art for Open Spaces*. Honolulu: The University of Hawaii Press, 1978.

Read, Benedict. *Victorian Sculpture*. New Haven: Yale University Press, 1984.

Read, Benedict, ed. *Pre-Raphaelite Sculpture: Nature & Imagination in British Sculpture 1848–1914*. Wappingers Falls: Antique Collectors' Club.

Read, Herbert E. *Modern Sculpture*. New York: Thames & Hudson, 1985.

Reynolds, Gary A. *American Bronze Sculpture: 1850–Present*. Newark: The Newark Museum Association, 1984.

Reynolds, Donald M. *Masters of American Sculpture: The Figurative Tradition*. New York: Abbeville Press, Inc., 1993.

Ricco, Roger, et al. *American Primitive: Discoveries in Folk Sculpture*. New York: Alfred A. Knopf, Inc., 1988.

Ridgway, Brunilde *Hellenistic Sculpture I: The Styles of ca. 331–200 B.C.* Madison: University of Wisconsin Press, 1990.

Ritchie, Andrew C. *Sculpture of the Twentieth Century*. North Stratford: Ayer Co. Publishers, Inc., 1972.

Rogers, Millard F. *Sketches & Bozzetti by American Sculptors, 1800–1950*. Cincinnati: Cincinnati Art Museum, 1989.

Royal Academy of Letters, History, & Antiquities Staff. *Medieval Wooden Sculpture in Sweden*. 5 vols. Philadelphia: Coronet Books, 1966.

Rubinstein, Charlotte S. *American Women Sculptures: A History of Women Working in Three Dimensions*. Old Tappan: Macmillan Publishing Co., Inc., 1990.

Russmann, Edna R. and David Finn. *Egyptian Sculpture: Cairo & Luxor*. Austin: University of Texas Press, 1989.

Saraswati, S.K. *Survey of Indian Sculpture*. Philadelphia: Coronet Books, 1975.

Schloss, Ezekiel. *Ancient Chinese Ceramic Sculpture from Han Through Tang*. Vols. I & II. New York: Castle Publishing Co., Ltd., 1977.

Seymour, Charles, Jr. *Tradition & Experiment in Modern Sculpture*. North Stratford: Ayer Co. Publishers, Inc., 1970.

Seymour, Charles, Jr. *Sculpture in Italy: 1400–1500*. New Haven: Yale University Press, 1976.

Shapiro, Michael E. *Bronze Casting & American Sculpture, 1850–1900*. Cranbury: University of Delaware Press, 1985.

Sharp, Rosemary. *Chacs & Chiefs: the Iconography of Mosaic Stone Sculpture in Pre-Conquest Yucatan, Mexico*. Washington, D.C.: Dumbarton Oaks, 1981.

Slatkin, Wendy, et al. *Art Through History, Level I: An Introduction to Painting, Sculpture & Architec-

Bibliography

ture. Upland: Art Through History Partnership, 1986.

Smith, Jeffrey C. *German Sculpture of the Late Renaissance c.1520–1580: Art in the Age of Uncertainty*. Princeton: Princeton University Press, 1994.

Snyder, James C. *Medieval Art: Painting Sculpture, Architecture 4th Thru 14th Century*. Englewood Cliffs: Prentice Hall, 1988.

Snyder, James C. *Northern Renaissance Art: Painting, Sculpture, the Graphic Arts from 1350 to 1575*. New York: Harry N. Abrams, Inc., 1985.

Souchal, Francois. *French Sculptures*. Vol 2. Winchester: Faber & Faber, Inc., 1981.

Souchal, F. *French Sculptures of the 17th & 18th Centuries: The Reign of Louis XIV, Vol III, M–Z*. Winchester: Faber & Faber, Inc., 1987.

Souchal, F. *French Sculptures of the 17th & 18th Centuries: The Reign of Louis XIV*. Illustrated

Catalogue Supplementary Volume A–Z, Vol 4. Winchester: Faber & Faber, Inc., 1992.

Spahr, P. Andrew. *Abstract Sculpture in America 1930–1970*. New York: The American Federation of Arts, 1991.

Stewart, Andrew. *Greek Sculpture: An Exploration*. 2 vols. New Haven: Yale University Press, 1993.

Steyaert, John W. *Late Gothic Sculpture: The Burgundian Netherlands*. New York: Harry N. Abrams, Inc., 1994.

Stone, Lawrence. *Sculpture in Britain: The Middle Ages*. 2E. New Haven: Yale University Press, 1988.

Strong, Eugene S. *Roman Sculpture from Augustus to Constantine*. North Stratford: Ayer Co. Publishers, Inc. 1979.

Taft, Lorado. *History of American Sculpture*. Temecula: Reprint Services Corp., 1993.

Trapp, Frank, et al. *Masterworks of*

European Sculpture. Amherst: Amherst College, Mead Art Museum, 1983.

Van Buren, E. Douglas. *Clay Figurines of Babylonia & Assyria*. New York: AMS Press, Inc., 1978.

Vitry, P. *French Sculpture During the Reign of St. Louis*. New York: Hacker Art Books, 1973.

Von Der Osten, Gert and Horst Vey. *Painting & Sculpture in Germany & the Netherlands: 1500–1600*. New Haven: Yale University Press, 1979.

Warner, Langdon. *Japanese Sculpture of the Tempyo Period: Masterpieces of the Eighth Century*. Ann Arbor: Books on Demand, 1965.

Weismann, Elizabeth W. *Art & Time in Mexico: the Architecture & Sculpture of Colonial Mexico*. New York: Harper Collins Publishers, Inc., 1987.

Whinney, Margaret. *Sculpture in Britain: 1530–1830*. 2d ed. New Haven:

Bibliography ... Index

Yale University Press, 1988.

Wiggins, Walt. *Ernest Berke: Paintings & Sculptures of the Old West.* Ruidoso Downs: Pintores Press, 1980.

Wilk, Sarah B. *Fifteenth Century Italian Sculpture: An Annotated Bibliography.* Old Tappan: Macmillan Publishing Co., Inc., 1986.

Williamson, Paul. *Medieval Sculpture & Works of Art.* New York: Sothebys Publications, 1989.

Winning, Hasso von. *Anecdotal Sculpture of Ancient West Mexico.* Los Angeles: Natural History Museum of Los Angeles, 1972.

Wood, B. Roman *Portrait Sculpture (217–260 A.D.). The Transformation of an Artistic Tradition.* Kinderhook: E.J. Brill, U.S.A., Inc., 1986.

Subject index

abstraction 131, 135
Altar of Pergamon 25
Angel's pietà 69
animal sculpture 10
Antiquity, Classical 24–41, 61, 64, 75, 94, 97, 98, 100
–late 42, 43, 47, 74
Archaic 24, 28
architecture 58
art in construction 161
–in public spaces 160–169
–Byzantine 41, 61
–early Christian 41–47
assemblage 145
avant-garde 135, 161, 163

Baroque period 51, 84–93, 108
bozzetto 51, 88
Bronze/Hallstein Age 14, 15

Cathedra Petri 93
Christianity 40, 62, 75
Cinquecento 64
Classical period 16, 24, 25, 28, 36, 45, 66, 94–101, 113
classicism 106
concetto 88, 93
Costrucivism, Russian 123, 126, 128, 135

costume war 105, 113
Council of Basel 67
–of Chalkedon 46
–of Ephesus 46
counter-Reformation 84
court artist 84
crucifix 42, 46, 47, 52
cubic figure 16, 20, 22
cubic stool 23
Cycladean culture 13

devotional image 69
dual nature of Christ doctrine 46

Earth Art 160
Egypt, Archaic Period 16
–Middle Empire 16, 19, 20, 22
–New Empire 16, 18
–Old Empire 16, 17, 18, 19
Environmental Art 160
equestrian statue 48–51, 78, 97, 110
existentialism 141
expressionism 57, 121
–abstract 145, 152
expressionist 121

figura serpentinata 85, 86, 89, 93, 122
figured capital 56, 57, 58
futurism 118

golden mean 31
Gothic period 47, 56, 59–65, 78
–late 66–74

Index

Hellenistic period 24
humanism 59, 74

Ice Age 8–15
idealism 99, 107
idol 13, 15
immaterial 149

justice of the material 118

Latène culture 24

Mannerism 84, 85, 87, 93, 122
Mary/Madonna 54, 66, 67, 68
memorial 160, 166
menhir 14, 15
Middle Ages 52–65, 59, 74, 75
minimal art 151
Modern, Classic 114–135
monument 32, 102–113, 160, 167, 168
–, national 102

naturalism 13
neo-Baroque 113
Neoclassicism 169
Neolithic period 13, 14
Non-Site 160

Paleolithic period 13
Pergamon Museum 26
portal 58
portrait 27, 37, 49, 63
–tradition 41

–head 22, 33
primitive art 56, 119
proportion, canon of Polykleitos 30, 31

Quattrocento 64

ready-made 118, 133ff.
realism 94–101, 106, 108, 112, 114
Realism, New 23
Reformation 72–73
relief, flattened 77
reliquary statue 53, 54
Renaissance 16, 24, 25, 51, 59, 73, 74–83, 84, 87
–early 74, 75, 80
–high 80, 85, 93
–late 84
Revolution, French 94
Romanesque era 47, 52, 53, 56, 57, 58

Sculptural frieze 32
Sculpture in the Third Reich 136–139
–constructive 126
–free-standing rounded 43
–social 151
seat of grace 69
Site 160
sitting figure 16, 18, 22, 23
–motif 18
standing-striding figure 16, 17, 22, 23
–motif 27
Stone Age 8
stone monolith/stele 14, 15

style, angular 70
–international 67, 69, 70
–softened 67, 70, 76, 77
–strict 28
–wet 29
surrealism 133, 141

taille directe 119
tomb monument 78
–sculpture 48
–statue 27
torso 117, 127, 143
Trecento 65, 78
triumphal column 55

Uomo universale 80, 84

Venus statuette 10, 11, 12, 13

Writing figure 16, 20, 22

Index of names

Abelard, Peter 52, 60
Akhenaten 18, 22
Albert, Leon Battista 74
Albiker, Karl 137, 138
Alembert, Jean Le Rond d' 96
Alexander the Great 24, 31, 40

Index

Amenemhet III 22
Anacreon 33
André, Carl 152, 153
Anhalt-Dessau, Leopold von 106
Anselm of Canterbury 60
Archipenko, Alexander 118, 127
Arnolfo di Cambio 64, 65
Arp, Hans 134, 143
Augustus 31, 36, 37, 39

Baldung, Hans, called Grien 66
Banco, Nanni di 76, 80
Bandel, Ernst von 102
Barberini, Maffeo, cardinal 88 see also Urban VIII
Barlach, Ernst 122, 137
Bartholdi, Frédéric-Auguste 103
Begas, Reinhold 108–110
Belling, Rudolf 137
Bernard, Emile 120
Bernini, Gianlorenzo 48, 50, 51, 87–91, 101
Bernward 54
Beuys, Joseph 148, 165, 167
Bill, Max 143, 144
Bismarck, Otto von 102, 108, 109
Bleyl, Fritz 121
Blumenthal, Hermann 136, 137

Boccioni, Umberto 118
Bologna, Giovanni da see Giambologna
Borghese, Scipione 88, 89
Born, Max 114
Borromini, Francesco 88
Brancusi, Constantin 129, 131–133, 135, 167
Breker, Arno 136, 138ff.
Breton, André 134
Brunelleschi, Filippo 77
Bruni, Leonardo 79
Bülow, Bernhard von 107, 168
Bussmann, Klaus 167

Caesar, Gaius Julius 34, 38
Calder, Alexander 147
Canaletto, born Giovanni Antonio Canale 49
Canova, Antonio 98
Caracalla, Marcus Aurelius Antonius 40
Caro, Anthony 125, 147
Carpeaux, Jean-Baptiste 100
Castagno, Andrea del 51
Cellini, Benvenuto 84
Chamberlain, John 152, 153
Charles V 66, 80, 84
Chephren 19
Chillida, Eduardo 125
Christo, born Christo Javachef 161

Claudel, Camille 115, 116
Claudius, Tiberius Nero Germanicus 37
Clemens VII 84
Colleoni, Bartolomeo 49
Colonna, Vittorio 83
Confucius 24
Constantine I the Great 41, 42
Constantius Chlorus 41, 43
Coysevox, Charles-Antoine 94

Deacon, Richard 157, 158
Degas, Edgar 117, 124
Derain, André 129
Diderot, Denis 94–96
Diocletian, Gaius Aurelius Valerius 43
Doesburg, Theo van 143
Donatello see Donato di Niccolò
Donato di Niccolò di Betto Bardi, called Donatello 48, 49, 75, 76, 77, 81, 85
Douvermann, Heinrich 73
Doyle, Tom 154
Droste, Thorsten 57, 58
Du Barry, Marie Jeanne 96
Duchamp, Marcel 118, 129, 133, 135, 157
Duquesnoy, François 88

Index

Ecker, Bogomir 163, 165
Edward III 111
Eiffel, Gustave 103
Ekkehard 63, 64
Empedocles 24
Epicurus 33
Epstein, Jacob 130
Erhart, Michel 68
Ernst, Max 134

Falconet, Etienne-Maurice 51, 94, 96
Ferdinand 74
Ficino, Marsilio 75
Fischer, Konrad 153
Flavin, Dan 152
Francis I 80
Frederick II of Hohenstaufen 64
Frederick II of Prussia 94, 98, 104
Frederick III 71, 92
Frederick William of Brandenburg 92, 109
Frederick William II of Prussia 98
Freundlich, Otto 137

Gabo, Naum 126, 143
Galerius, Gaius Valerius Maximianus 43
Gaudier-Brzeska, Henri 130
Gauguin, Paul 56, 119
Gerhaert van Leyden, Nicolaus 71, 72
Gerhard, Hubert 87
Gero 52
Gerz, Jochen 167, 168

Ghiberti, Lorenzo 75, 76, 77
Giacometti, Alberto 134, 141, 142
Giacometti, Diego 142
Giambologna see Giovanni Bologna
Giotto di Bondone 65
Giovanni Bologna, called Giambologna 84, 87
Giovanni di Cambio 64, 65
Girardon, François 91, 92
Goethe, Johann Wolfgang von 59, 105, 106, 109, 136, 137
Gogh, Vincent van 119
González, Julio 124, 125, 144, 145
Graham, Dan 160
Guazzoni, Valerio 83

Haas, Peter 106
Hadrian, Publius Aelius 39, 40
Hathor 22
Hatshepsut 21
Heckel, Erich 121
Hegel, Georg Wilhelm Friedrich 105
Henry VIII 66
Hermann 34, 102
Hesse, Eva 149, 154
Hildebrand, Adolf von 110, 118, 136
Hitler, Adolf 137
Horn, Rebecca 167
Houdon, Jean-Antoine 94, 97
Hussmann, Albert 110

Imad, bishop 54
Imdahl, Max 149

Jacobus of Voragine 52
Janson, Horst 74
Jantzen, Hans 53, 55
Jappe, Georg 163
Judd, Donald 152, 157
Julia Titi 39
Julius II 83
Junius Bassus 44, 45
Jupiter 37
Justinian 42

Karavan, Dani 167
Kasper, Ludwig 137
Keith, James von 106
Kirchner, Ernst Ludwig 120, 121
Kleomenes 101
Kobro, Katarzyna 127, 128
Kolbe, Georg 136
Kollard, Rob 153
Kollwitz, Käthe 137, 169
König, Kasper 167
Kooning, Willem de 145
Kricke, Norbert 125, 147

Laurens, Henri 118, 140, 141
Lehmbruck, Wilhelm 121
Lemoyne, Jean-Baptiste 94–96
Leonardo da Vinci 48, 50, 51, 80
LeWitt, Sol 152, 167

Index

Lin, Maya Ying 169
Lipchitz, Jacques 118
Livia Drusilla 37, 39
Lodovico il Moro 50
Loeb, Pierre 134
Lomazzo, Giovanni
 Paolo 85, 86
Louis XIII 91
Louis XIV 51, 84, 90
Lucian 25
Ludwig I 32
Luther, Martin 66, 73

Maillol, Aristide 118,
 140
Mâle, Emile 56
Malewitsch, Kasimir
 126
Malouel, Jean 69, 70
Marcks, Gerhard 139
Marcus Aurelius 48,
 50
Maria, Walter de 164
Martini, Simone 48
Mary 67, 68, 70
Matarés, Ewald 150
Matisse, Henri 122
Matta-Clark, Gordon
 160
Maximianus, Marcus
 Aurelius Valerius
 Herculius 43
Maximilian II 84
Medici 75, 80, 82
–Cosimo de' 76, 84
–Giuliano de' 82, 83
–Lorenzo de' 83
Melano, Fra 64
Mentuhotep II 19
Mercator, Gerhard 84
Michelangelo Buonar-
 roti 80, 81–83, 85,
 93, 116, 117, 139

Minne, Georges 121
Mochi, Francesco 88
Modigliani, Amedeo
 129
Moholy-Nagy, László
 128, 129
Mondrian, Piet 131
Moore, Henry 143,
 144, 147, 157
Morris, Robert 149,
 151
Multscher, Hans 69,
 70
Myron of Eleutherai
 29

Nauman, Bruce 155,
 156
Necker, Suzanne 96
Nefertiti 16, 18
Nefrare 21
Nevelson, Louise 146
Nofret 20

Olivier, Fernande 122
Oppenheim, Meret
 133
Ottonian era 53

Pacher, Michael 72
Paik, Nam June 151
Parler, Peter 70, 72
Paul III 66
Pausanius 33
Perrault, Claude 90
Peter I 51, 97
Pevsner, Anton 126,
 143
Phidias 24, 25, 29,
 101
Philip the Arabian 40,
 41
Philip 70

Phillips, Gwen 150
Picasso, Pablo 56, 113,
 114, 122–124
Pigalle, Jean-Baptiste
 94–96
Pilgram, Anton 72
Pisano, Andrea 77
–Nicola 64
Pizarro, Francisco 66
Pollock, Jackson 145
Polykleitos 30, 31, 34,
 36, 61
Porter, A. K. 56
Poussin, Nicolas 91
Praxiteles 34, 36, 101
Puget, Pierre 90

Quercia, Jacopo della
 78, 81

Rabelais, François 74
Rahmann, Fritz 165
Rahotep 20
Rauch, Christian Daniel
 97, 104, 107, 108,
 168
Ray, Man 133, 134
Reuter, Erich Fritz 161
Richier, Germaine
 142, 143
Richter, Gerhard 159
Rickey, George 147
Riegl, Alois 35
Rietschel, Ernst 105
Robbia, Luca della 80
Rodin, Auguste 96,
 111, 113–117,
 123, 129, 130,
 167
Rossellini, Antonio 79
Rossellini, Bernardo 79
Rubens, Peter Paul 50
Rude, François 101

Index

Saint-Pierre, Eustache de 111
Sandrart, Joachim of 88
Sauerländer, Willibald 60, 61
Schadow, Gottfried 51, 97–100, 106, 107
Scharnhorst, Gerhard Johann David von 107, 168
Scharoun, Hans 162
Scheibe, Richard 139, 147
Scheidt, F. A. 154
Schinkel, Karl Friedrich 107
Schlemmer, Oskar 128, 129
Schlüter, Andreas 92, 93, 109
Schmidt-Rottluff, Karl 121
Schnütgen, Alexander 46
Schum, Gerry 162
Schütte, Thomas 158, 159
Schwanthaler, Ludwig von 103
Schwerin, Kurt Christoph von 106
Senmut 20
Serra, Richard 149, 165, 167
Serrurier, Louis 106

Seydlitz, Friedrich Wilhelm von 106
Sforza, Francesco 50
Shalev-Gerz, Esther 166, 168
Siemering, Rudolf 104
Sintenis, René 161
Sluter, Claus 70
Smith, David 125, 144
Smithson, Robert 160, 161
Steichen, Edward 131
Stevenson, George 102
Stoss, Veit 72, 73
Strzeminski, Wladislaw 128
Sulzer, Johann G. 59

Tassaert, Jean Pierre Antoine 97, 98
Tatlin, Wladimir 123, 128
Thorak, Josef 138
Thorwaldsen, Berthel 97
Tinguely, Jean 147
Tino di Camaino 65
Titus, Flavius Vespasianus 39
Tiy 22
Tolentino, Niccolò da 51
Trajanus Decius 40, 41
Trivulzio, Gian Giacomo 50

Uhlmann, Hans 125, 147, 148, 162
Urban VIII 88

Van Eyck, Hubert and Jan, brothers 74
Vasari, Giorgio 49, 83
Verrocchio, Andrea del 48, 49, 50
Voltaire, born François Marie Arouet 74, 94, 96, 97
Volterra, Daniele da, born Ricciarelli 80

Wackenroder, Wilhelm Heinrich 59
Wahington, George 102, 103, 104, 105
Westheim, Paul 126
Weyden, Rogier van der 71
Whiteread, Rachel 158
William I 108, 167
William II 109, 110
Winckelmann, Johann Joachim 35, 95, 98
Winterfeldt, Hans Karl von 106
Witten, Hans 73

Zieten, Joachim von 106
Zoser 18, 19

Picture credits

Adriani, Franziska, Stuttgart 301
Annely Juda Fine Art, London (reconstructed by Martyn Chalk) 232
Ägyptisches Museum, Berlin 22, 25, 26, 32, 35, 37, 38
Archiv für Kunst und Geschichte, Berlin 39, 45, 41, 62, 138
Acropolis Museum, Athens 49
Antikensammlung, Berlin 43, 44, 59, 60, 68-72, 75
Archaeologica Venatoria e. V., Tübingen 1, 2
Archaeol. Museum, Delphi 50
Archeological Institute, Brno 15
Archeological Institute, Nitra 13
Archivi Alinari, Firenze 88, 137, 140-147, 149, 151, 153, 155, 156, 158
Art Institute of Chicago 261
Ashmolean Museum, Oxford 18
Berlinische Galerie, Landesmuseum für Kunst, Photographie und Architektur 239, 241, 243
Beyer, Klaus G., Weimar 135
Bibliotheek der Rijksuniversiteit, Utrecht 100
Bildarchiv Foto Marburg 93
Bildarchiv Preussischer Kulturbesitz, Berlin 19, 79, 83, 125, 131, 178, 179, 180 (Klaus Göken), 188, 192 (Klaus Göken), 195, 199 (Sibylle Einholz)
British Museum, London 52
Bündner Kunstmuseum, Chur 224
Capitolinian Museum, Rome 74
Church treasury Conques, France 95
City Art Gallery, Leeds 285
Conservator Palace, Rome 76
Deutsches Archäologisches Institut, Rome 66, 67
Domschatzkammer, Essen 96
dpa, Frankfurt/Main 341
Egyptian Museum, Cairo 24, 25, 27-30, 33, 36
Fischer, Dorothee 315
Fogg Art Museum, Harvard University, Cambridge, Ma. (Gift: William A. Coolidge) 161, 252
Fotoarchiv Hirmer, München 113, 114
Galleria Borghese, Rome 90, 163, 164
Gerz, Jochen & Shalev-Gerz, Esther, Paris 334-338
Giraudon, Paris 132
Graphische Sammlung Albertina, Wien 132
Halle für neue Kunst, Schaffhausen 312, 313
Heremitage, St. Petersburg 181
Hessisches Landesmuseum, Darmstadt (Foto: Eva Beuys) 299
J. F. Willumsens Museum, Frederikssund, Dänemark 221
Kaiser-Wilhelm-Museum, Krefeld (Foto: Volker Döhne) 317
Karl Ernst Osthaus Museum, Hagen 226
Kaspers, Ottilie 268

Kunsthaus Zürich 214
Kunsthistorisches Museum, Wien 123
Kupferstichkabinett, Staatliche Museen Preusslischer Kulturbesitz, Berlin 298
Landesbildstelle Berlin 340
Landesdenkmalamt Baden-Württemberg, Stuttgart 7
Les Musées de la Ville de Strasbourg 115, 133
Liebieghaus, Frankfurt/Main 127
Lippard, Lucy R., New York 311
Lisson Gallery, London 316
Martin von Wagner-Museum, Würzburg 47
Martínez, Carmen, and Grimminger, Vivianne, Paris 237
Metropolitan Museum of Art, New York, Fletcher Fund, 1932 24, 219
Moravské muzeum, Brno 4, 8, 11, 14, 17
Musée Archéologique, Dijon 130
Musée Cluny, Paris 81I.
Musée d'Orsay, Paris 183
Musée du Louvre, Paris 31, 41, 42, 128, 154, 167, 172, 174, 175
Musée Fabre, Montpellier 17
Musée Fenaille (Coll. Société des Lettres Sciences et Arts de l'Aveyron), Rodez 20
Musée Henri Matisse, Nizza 227
Musée Nat. d'Art Moderne, Centre Georges Pompidou, Paris 216, 231, 251, 254, 256, 264, 310
Musée Picasso, Paris 235
Musée Rodin, Paris 202-211, 249
Museo de Arte Cataluña, Barcelona 94
Museo delle opere del Duomo, Firenze 92
Museo Nacional del Prado, Madrid 63
Museo Nazionale, Naples 61
Museo Pio Christiano, Vatican 80
Museul de Artã, Craiova, Rumania 248
Museum für Ur- und Frühgeschichte, Freiburg 13
Museum of Decorative Art, Copenhagen/Denmark 218
Museum of Fine Arts, Boston/Mass. 220
Muzeum Sztuki, Lódz 244
National Gallery of Scotland, Edinburgh 169
Naturhistorisches Museum, Wien 9
Neue Pinakothek, München 196
Neumeister, W. München 160, 166
Ny Carlsberg Glyptotek, Copenhagen 56
Orsanmichele, Florenz139
Pfarrkirche St. Wolfgang 134
Phillips, Gwen, New York 300
Pierpont Morgan Library, New York 162
Private collection 212, 223, 255, 262, 303
Private collection, Berlin 242
Private collection, Switzerland 229, 309

Réunion des Musées Nationaux, Paris 10
Rheinisches Bildarchiv, Köln 84, 97
Rijksmuseum Kröller-Müller, Otterlo 306
Robert Miller Gallery, New York 308
Rosgartenmuseum, Konstanz 16
Ruhr-Universität Bochum 296
S. Maria della Vittoria, Rome 165
Collection Burden, New York 284
Collection Mary A. H. Rumsey 253
Collection Oskar Reinhart, Winterthur 217
Scala, Florenz 158
Shunk-Kender 307
Skira-Archiv 129
Sorbonne, Paris 168
Sprengel Museum, Hannover 215, 276, 277
St. Marien, Cracow 136
Staatliche Antikensammlungen und Glyptothek, München 58
Staatsgalerie, Stuttgart (Foto: Erich Lessing, Wien) 246
Stedelijk Museum, Amsterdam 222
Stedelijk Van Abbe Museum, Eindhoven 247
Stiftskirche Reichenhofen 126
Suermondt-Ludwig-Museum, Aachen 116, 124
Tate Gallery, London 213, 240, 250, 290
The Cleveland Museum of Art, John L. Sever-ance Fund. 65.238, Cleveland/Ohio 78
Thermenmuseum, Rome 57
Transglobe Agency, Hamburg 186
Ulmer Museum, Ulm Foto: Thomas Stephan 6
Vatican Museum, Rome 48, 64, 65, 73, 82
Victoria and Albert Museum, London 81r.
VISUM: Foto Dirk Reinartz, Buxtehude 302, 319
Wehmeyer, Hildesheim 99
Westfälisches Landesmuseum, Münster 291, 333
Wilhelm Lehmbruck Museum, Duisburg 225, 238, 288, 292, 293, 297
Williams, Nina, Ashford, Kent 126, 17
Württembergisches Landesmuseum, Stuttgart 3
© VG Bild-Kunst, Bonn 1996 208, 215, 217, 227-231, 233-237, 247, 248, 251-265, 270, 274, 276-284, 287-289, 292, 293, 297-302, 304-306, 312-315, 320-322, 325, 329, 332, 333, 342
© Ingeborg und Dr. Wolfgang Henze-Ketterer, Wichtrach 222, 224
© ADAGP, Paris 1995, Fotos: Bruno Jarret 207, 209, 210, 249 Adam Rzepka 205, 206
© Nachlaß Oskar Schlemmer, I - Oggebbio